World AND Web

Artsguide

Second Edition

Dennis J. Sporre

Upper Saddle River, New Jersey 07458

Library of Congress Cataloging-in-Publication Data
Sporre, Dennis J.
 Artsguide : world and web : a guide to the arts on the Internet and in the
world / Dennis J. Sporre.
 p. cm.
 Includes bibliographical references and index.
 ISBN 0-13-177526-X
 1. Arts--Handbooks, manuals, etc. 2. Arts--Computer network resources--
Handbooks, manuals, etc. I. Title.
NX620.S678 2003
700—dc21
 2003045999

VP, Editorial Director: Charlyce Jones Owen
Director of Marketing: Beth Gillett Mejia
Executive Editor: Sarah Touborg
Assistant Editor: Kimberly Chastain
Editorial Assistants: Sasha Anderson, Keri Molinari
Managing Editor: Lee Shenkman, Victory Productions, Inc.
Production Editor: Arny Spielberg, Victory Productions, Inc.
Prepress and Manufacturing Buyer: Sherry Lewis
Cover Director: Jayne Conte
Cover Designer: Bruce Kenselaar
Marketing Manager: Chris Ruel
Composition/Full-Service Project Management: Victory Productions, Inc.
Printer/Binder: Courier/Stoughton. The cover was printed by Phoenix Color Corp.

Pearson Education LTD.
Pearson Education Singapore, Pte. Ltd
Pearson Education, Canada, Ltd
Pearson Education–Japan
Pearson Education Australia PTY, Limited
Pearson Education North Asia Ltd
Pearson Educación de Mexico, S.A. de C.V.
Pearson Education Malaysia, Pte. Ltd
Editora Prentice-Hall do Brasil, Ltda., Rio de Janeiro
Pearson Education, Upper Saddle River, NJ

10 9 8 7 6 5 4 3 2

ISBN 0-13-177526-X

To the Arts and Humanities Faculty at Elon University

CONTENTS

v

5

AT THE CONCERT HALL—MUSIC AND OPERA 81

6

DANCE 101

7

AT THE CINEMA—FILM 113

8

STYLE 121

PREFACE

During a discussion with some humanities faculty members, I was asked why I didn't write a short, inexpensive, pocket-sized book that students could carry with them on study abroad or for culturally related courses that involve traveling to metropolitan museums, concert halls, theatres, and so on. The idea was intriguing, and suggestions on what such a project might include gave ample opportunity for development.

Further thought, however, led to the conclusion that there exists today more than one way to "travel" to the arts. There is the actual experience of physically traveling to museums and concert halls at home and in distant cities. There is also imaginary travel that can occur when reading a book about the arts. In addition, there is cyber travel in which access to distant works of art is immediate. This book attempts to assist in all three types of travel and to be equally useful as a pocket guide or instructional text.

Those who suggested that this book be written were adamant about it not being copiously illustrated. They wanted something small in size, inexpensive, and general enough in nature that would have equal usefulness in Paris or Prague, London or Lisbon. Recognizing that this book can also serve as an introduction to humanities courses, I have included a few illustrations. Additional historical information and illustrations can be found on the World Wide Web, and the URLs for doing so are indicated. Terms in bold also appear in the Glossary. The ultimate intent here is to broaden access to the world of the arts in a simple, inexpensive, and portable manner.

In this edition a number of changes have been made in the text to clarify concepts and terms, update websites, and more readily engage the reader. Included in the changes are significant changes in Chapters 1 and 2 and three pictorial features: "Style Spot," "Question," and "Key Term." "Style Spot" is a graphically highlighted, brief definition of an important artistic style with a reference to the more fully developed treatment of that style in Chapter 8. This feature is designed to draw the reader to think about style while study-

ing basic terminology and to integrate the material in Chapter 8 into the rest of the book. "Question" is a feature that introduces an important question that a viewer or listener can ask about a work of art. Its purpose is to stimulate thinking about relating to works of art. Finally, "Key Term" visually highlights fundamental artistic concepts. It helps the reader to focus on a few of the most important ideas about the arts among the many concepts and terms defined in the text.

Dennis J. Sporre

Getting Started

EXPERIENCING THE ARTS

Driving a car for the first time usually requires preoccupation with mechanics and intense concentration on keeping the car moving in a straight line. As technical details become habitual, drivers can relax and, for the most part, let the car drive itself.

Experiencing the arts is much like driving a car. When the experience is new and when studious attempts are made at doing it "right," or amassing materials for a classroom assignment, the details often can interfere with the experience. Obsession with finding specific details—what a book or a teacher has indicated should be the objects of looking and listening—frequently robs the occasion of its pleasure and meaning. Nonetheless, with practice, the details do fall into place, and the payment in heightened enjoyment and sense of personal achievement—sophistication, some might say—expands exponentially.

Getting to that point, however, requires a beginning. Perceiving anything requires understanding of what there is to perceive, and one purpose of this book is to provide a usable outline of the basics: things that can be seen and heard in works of visual and performing art and architecture. In addition, this book can serve as a reference for understanding the fundamental qualities of artistic style. The section treating style comprises a chronological outline of selected, major artistic styles listing internet hyperlinks to examples of those styles. In museums, theatres, and concert halls, where the date and the style of a work is given, the descriptions of style can add to understanding the artwork. This is a practical guide—that is, small enough to carry in a pocket to a museum, play, concert, or on the street—and straightforward in its organization so that what you need can be found easily. It is also a guide to finding and focusing on important works of art and architecture when visiting major cities and culturally rich areas in the United

States and Europe. This book will have done its job when, at some time in the future, its references are no longer needed because its contents have become, like the aesthetic experiences they treat, old friends and comfortable companions.

HOW TO USE THIS BOOK

This book can be used in the "cyber" and "real" worlds. The illustration program of the book is intentionally limited because of its purpose as a compact, inexpensive, and a general purpose reference. Styles and principles do, however, have URL links to examples on the Web. There also is a music CD available from Prentice Hall, and the CD tracks noted in the music section refer to it. In addition to the specific Web addresses listed in the text, some general sites can provide a wealth of additional information. Music tends to be problematic because difficulties in securing reproduction rights to performances have, as yet, not been solved by Web providers. A very large music library is at http://www.prs.net/midi.html#index. Although these examples are all instrumental and digitally synthesized, the available selections are impressive. An easy and vast reference for visual artworks is the Artcyclopedia at http://www.artcyclopedia.com/index.html. Here, individual artists can be referenced along with their artworks, as can searching by style, medium, subject, and nationality. A good architectural archive is "Mary Ann Sullivan's Digital Imaging Project" at http://www.bluffton.edu/~sullivanm/index/index2.html#P, although this site is among the redirects located in the Artcyclopedia just mentioned. "Art History Resources on the Net," http://witcombe.sbc.edu/ARTHLinks.html

When using the book with the "cyber" world, URLs to connect with the World Wide Web serve as springboards for further investigation. On one hand, they lead to actual artworks, and these can illustrate the principles or styles noted. On another hand, many of the websites yield more detailed information about artists, styles, periods, general history, and so on. With regard to URLs, however, a warning is necessary. First, things change. A website active when this book went to press may no longer exist. Second, an initial attempt to link to a site may prove unsuccessful: "Unable to connect to remote host." A rule of thumb is to try to connect to the site three successive times before trying another URL. Be careful to type the URL exactly. Any incorrect character will cause the connection to fail (capital letters matter). When all else fails, go to the Artcyclopedia site noted previously or use a good search engine such as Google to locate the artist and/or work in question.

When the book is used as a guide in the "real" world, it may be best to begin at the back of the book. The sections titled "101 Must-See Works of Architecture" and "200 Masterworks of Painting and Sculpture" are organized by city. Referencing a city can quickly assemble an organized itinerary. Using the material in these sections as a roadmap to identify specific targets will make discovering a city and its museums a pleasure. Probably nothing is more confusing than entering a large museum and wandering from gallery to

gallery, "rubbernecking" hundreds of paintings and sculptures. Whereas, seeking a few specific examples gives the museum experience a purpose. When engaging a specific work, reference the section "258 Major Artists, playwrights, Composers, Architects, and Choreographers and Their Styles." Learn the period of the artwork and artist and then reference the section "Style" to learn something about the style of the work. Then go to the appropriate chapter on the art itself—for example, "In the Museum-Painting and Sculpture"—for cues as to what to see or hear in works of that medium.

The realm called "art" holds potential for great personal enrichment and excitement. Hopefully, this small book will stimulate your curiosity and lead you to find so much in artistic things that you no longer see the world the way you saw it before. Enjoy!

What Are the Arts and How Do We Describe and Evaluate Them?

PUTTING THE ARTS IN CONTEXT

For centuries scholars, philosophers, and aestheticians have debated without general resolution a definition of "art." The challenging range of arguments encompasses, among other considerations, opposing points of view that insist on one hand that "art" must meet a criterion of functionality—that is, be of some societal use—and, on the other hand, that "art" exists for its own sake. In this book we will not solve the dilemma of art's definition, despite the energizing effect that such a discussion might engender. Rather, we will examine some characteristics of the arts that can enhance our understanding and relationships with works of art.

Art has and has had a profound effect on the quality of human life, and its study requires seriousness of purpose. Nonetheless, we must not confuse seriousness of purpose in the study of art with a sweeping sanctification of works of art. Some art is serious, some art is profound, and some art is highly sacred. On the other hand, some art is light, some humorous, and some downright silly, superficial, or self-serving for its artists. Which is which may be debatable, but eventually we will desire to make judgments, and one of the purposes of this book is to help sort out the details so that informed judgment might be made when called for.

The remainder of this section—that is, "Putting the Arts in Context"—treats five general subjects: (1) *The Arts and Ways of Knowing*, (2) *What Concerns Art?*, (3) *To What Purposes and Functions?*, and (4) *How Do We Live With Art?* The chapter closes with a section on *How Do We Evaluate Works of Art?*

THE ARTS AND WAYS OF KNOWING

Humans are a creative species. Whether in science, politics, business, technology, or the arts, we depend on our creativity almost as much as anything

else to meet the capabilities we already have. Applying our current abilities to perceive will develop confidence in approaching works of art. Second, starting where we are means learning how art fits into the general scheme of the way people examine, communicate, and respond to the world around them. For example, a course in the arts, designed to fulfill a requirement for a specific curriculum, means that the arts fit into an academic context that separates the way people acquire knowledge. Consequently, our first step in this exploration of the arts will be to place them in some kind of relationship with other categories of knowledge. Visual art, architecture, theatre, music, dance, and film belong in a broad category of pursuit called the "humanities," and that is where we begin.

The humanities, as opposed, for example, to the sciences, can very broadly be defined as those aspects of culture that look into what it means to be human. The sciences seek essentially to describe reality whereas the humanities seek to express humankind's subjective experiences of reality, to interpret reality, to transform our interior experience into tangible forms, and to comment upon reality, to judge and evaluate. Yet despite our desire to categorize, there really are few boundaries between the humanities and the sciences. The basic difference lies in the approach that separates investigation of the natural universe, technology, and social science from the search for truth about the universe undertaken by artists.

Within the educational system, the humanities traditionally have included the fine arts (painting, sculpture, architecture, music, theatre, dance, and cinema), literature, philosophy, and, sometimes, history. These subjects are all oriented toward exploring what it is to be human, what human beings think and feel, what motivates their actions and shapes their thoughts. Many answers lie in the millions of artworks all around the globe, from the earliest sculpted fertility figures to the video and cyber art of today. These artifacts and images are themselves expressions of the humanities, not merely illustrations of past or present ways of life.

In addition, change in the arts differs from change in the sciences, for example, in one significant way: New scientific discovery and technology usually displaces the old; but new art does not invalidate earlier human experience. Obviously, not all artistic approaches survive, but the art of Picasso cannot make the art of Rembrandt a curiosity of history the way that the theories of Einstein did the views of William Paley. Nonetheless, much about art has changed over the centuries. Using a spectrum developed by Susan Lacy in *Mapping the Terrain: New Genre Public Art* (1994), we learn that at one time an artist may be an *experiencer*, at another, a *reporter*, at another, an *analyst*, and at still another time, an *activist*. Further, the nature of how art historians see art has changed over the centuries—for example, today we do not credit an artist's biography with all of the motivations for his or her work, and we now include works of art from previously marginalized groups such as women and minorities. These shifts in the disciplines of art history itself are important considerations as we begin to understand the nature of art.

In addition, works of art can be approached with the subtleties we normally apply to human relationships. We know that people cannot simply be

categorized as "good" or "bad," as "friends," "acquaintances," or "enemies." We relate to other people in complex ways. Some friendships are pleasant but superficial, some people are easy to work with, and others (but few) are lifelong companions. Similarly, when we have gone beyond textbook categories and learned how to approach art with this sort of sensitivity, we find that art, like friendship, has a major place in the growth and quality of life.

WHAT CONCERNS ART?

Among other concerns, art has typically concerned creativity, aesthetic communication, symbols, and the fine arts and crafts. Let's look briefly at each of these.

Creativity

Art has always evidenced a concern for creativity—that is, the act of bringing forth new forces and forms. How creativity functions is subject to debate. Nonetheless, something happens in which humankind takes chaos, formlessness, vagueness, and the unknown and crystallizes them into form, design, inventions, and ideas. Creativity underlies our existence. It allows scientists to intuit that there is a possible path to a cure for cancer, for example, or to invent a computer. The same process allows artists to find new ways to express ideas through processes in which creative action, thought, material, and technique combine in a medium to create something new, and that "new thing," often without words, triggers human experience—that is, our response to the artwork.

In the midst of this creative process is the art medium. Although most people can readily acknowledge the traditional media—for example, painting, traditional sculpture, and drawing—sometimes when a medium does not conform to expectations or experiences, the work's very artistry may be questioned: for example, a field full of large blue umbrellas that an artist may consider an artwork but others may not.

Aesthetic Communication

Art usually involves communication. Arguably, artists need other people with whom they can share their perceptions. When artworks and humans interact, many possibilities exist. Interaction may be casual and fleeting, as in the first meeting of two people, when one or both are not at all interested in each other. Similarly, an artist may not have much to say, or may not say it very well. For example, a poorly written or produced play will probably not excite an audience. Similarly, if an audience member is so preoccupied that he or she finds it impossible to perceive what the play offers, then at least that part of the artistic experience fizzles. On the other hand, all conditions may be optimum, and a profoundly exciting and meaningful experience may occur: The play may treat a significant subject in a unique manner, the production artists' skills in manipulating the medium may be excellent, and the audience may be receptive. Or the interaction may fall somewhere between these two extremes.

KEY TERM

AESTHETICS Throughout history, artistic communication has involved *aesthetics*. Aesthetics is the study of the nature of beauty and of art and comprises one of the five classical fields of philosophical inquiry—along with epistemology (the nature and origin of knowledge), ethics (the general nature of morals and of the specific moral choices to be made by the individual in relationship with others), logic (the principles of reasoning), and metaphysics (the nature of first principles and problems of ultimate reality). The term aesthetics (from the Greek for "sense perception") was coined by the German philosopher Alexander Baumgarten (1714–1762) in the mid-eighteenth century, but interest in what constitutes the beautiful and in the relationship between art and nature goes back at least to the ancient Greeks. Both Plato and Aristotle saw art as *imitation* and beauty as the expression of a universal quality. For the Greeks, the concept of "art" embraced all handcrafts (see p. 124), and the rules of symmetry, proportion, and unity applied equally to weaving, pottery, poetry, and sculpture. In the late eighteenth century, the philosopher Immanual Kant (pronounced kahnt; 1724–1804) revolutionized aesthetics in his *Critique of Judgment* (1790) by viewing aesthetic appreciation not simply as the perception of intrinsic beauty, but as involving a judgment—subjective, but informed. Since Kant, the primary focus of aesthetics has shifted from the consideration of beauty per se to the nature of the artist, the role of art, and the relationship between the viewer and the work of art.

Symbols

Art is also concerned with symbols. Symbols are usually a tangible emblem of something abstract: a mundane object evoking a higher realm. Symbols differ from signs, which suggest a fact or condition. Signs are what they indicate. Symbols carry deeper, wider, and richer meanings. Look at Figure 1. Some people might identify this figure as a plus sign in arithmetic. But the figure might also be a Greek cross, in which case it becomes a symbol because it suggests many images, meanings, and implications. Artworks use a variety of symbols to convey meaning. Symbols make artworks into doorways leading to enriched meaning.

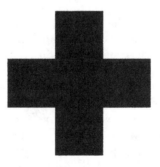

Figure 1 Greek cross.

Symbols occur in literature, art, and ritual. Symbols can be based on conventional relationships such as a rose standing for courtly love in a medieval romance. A symbol can suggest physical or other similarities between the symbol and its reference (the red rose as a symbol for blood) or personal associations. Symbols also occur in linguistics wherein words are considered arbitrary symbols and in psychoanalysis where symbols, particularly images in dreams, are regarded as repressed, subconscious desires and fears. In Judaism, the contents of the feast table and the ceremony performed at the Jewish Passover seder (the feast celebrating the exodus from slavery in Egypt) are symbolic of those events surrounding the Israelites' deliverance from Egypt. In Christian art, the lamb, for example, symbolizes the sacrifice of Christ.

Fine and Applied Art

Our last consideration in understanding art's concerns involves the difference between *fine art* and *applied art*. The "fine arts"—generally meaning painting, sculpture, architecture, music, theatre, dance, and, in the twentieth century, cinema—are prized for their purely aesthetic qualities. During the Renaissance (c. 1350–1530), these arts rose to superior status because Renaissance values lauded individual expression and unique aesthetic interpretation of ideas. The term "applied art" sometimes includes architecture and the "decorative arts" and refers to art forms that have a primarily decorative rather than expressive or emotional purpose. The decorative arts (a name first used in 1791) include handicrafts by skilled artisans, such as ornamental work in metal, stone, wood, and glass, as well as textiles, pottery, and bookbinding. They may also encompass aspects of interior design, and personal objects such as jewelry, weaponry, tools, and costumes. Even mechanical appliances and other products of industrial design can be considered part of the category. Many decorative arts, such as weaving, basketry, and pottery, are also commonly considered to be "crafts," but the definitions of the terms are somewhat arbitrary and without sharp distinction.

TO WHAT PURPOSES AND FUNCTIONS?

Another way we can expand our understanding of art is to examine some of its purposes and functions. In terms of the former—its purposes—we are asking, "What does art do?" In terms of the latter—its functions—, we are asking "How does it do it?" Basically, art serves, and has served, four purposes: (1) It provides a record; (2) it gives visible or other form to feelings; (3) it reveals metaphysical or spiritual truths; and (4) it helps people see the world in new or innovative ways. Art can do any or all of these. They are not mutually exclusive.

Until the invention of the camera, one of art's principle purposes was to enact a record of the world. Although we cannot know for sure, very likely cave art of the Ice Age did this. Ancient Egyptian art, ancient Greek art, Roman art, and so on until the invention of the camera, all undertook to record its time in pictorial form.

Art can also give form to feelings. Perhaps the most explicit example of this comes in the Expressionist style of the early twentieth century. Here feelings and emotions of the artist toward content formed a primary role in the work.

> ### STYLE SPOT
> **Expressionism:** A movement in which artists attempt to express emotional experience rather than impressions of the external world. See p. 134.

"Feelings" can be referenced in works of art through technique—for example, brush stroke—and through color (to isolate two visual examples), both of which have long associations with emotional content.

A third purpose of art can be the revelation of metaphysical or spiritual truths. Here, for example, we can turn to the plainchant (Gregorian chant) and Gothic cathedrals of medieval Europe (see p. 126), whose light and space perfectly embodied medieval spirituality. Tribal totems from Africa or Native America deal almost exclusively in spiritual and metaphysical revelation.

Finally, as a fourth purpose, most art, if it is well done, can assist us in seeing the world around us in new and surprising ways. Art that has, for example, abstract content (we do not recognize the subject matter) may reveal a new way of understanding the interaction of life forces or relationships.

A QUESTION TO ASK
In what ways does this artwork make me think or feel differently than I did before I experienced it?

In addition to its purposes, art also has many functions, including (1) enjoyment; (2) use as a political and social weapon, (3) therapy, and (4) artifact. Again, one function is no more important than the others, nor are they mutually exclusive. One artwork may fulfill many functions. Nor are the four functions just mentioned the only ones; rather, they serve as indicators of how art has functioned in the past and can function in the present. Like the types and styles of art that have occurred through history, these three functions and others are options for artists and depend on what artists wish to do with their artworks—as well as how we perceive and respond to them.

Enjoyment

Paintings, plays, concerts, and so on can provide escape from everyday cares, treat us to a pleasant time, and engage us in social occasions; they entertain us. They also give us insights into our hopes and dreams, likes and dislikes,

as well as exposure to other cultures; and we can find healing therapy in enjoyment.

The function of any one piece of artwork depends on us. A work of art in which one individual finds only enjoyment may function as a profound social and personal comment to another. A Mozart symphony, for instance, can relax us, but it may also comment on the life of the composer and/or the conditions of eighteenth-century Austria.

Political and Social Commentary

Art may have political or social functions, such as influencing the behavior of large groups of people. In ancient Rome, for example, the authorities used music and theatre to keep masses of unemployed people preoccupied to quell urban unrest. Roman playwrights used plays to attack incompetent or corrupt officials. The ancient Greek playwright Aristophanes used comedy in plays such as *The Birds* to attack the political ideas of the leaders of Athenian society. In *Lysistrata*, he attacked war by creating a story in which all the women of Athens go on a sex strike until Athens is rid of war and warmongers.

In nineteenth-century Norway, Henrik Ibsen used the play *An Enemy of the People* as a platform for airing the issue of whether a government should ignore pollution to maintain economic well-being. In the United States in the new millennium, many artworks act as vehicles to advance social and political causes or to sensitize viewers or listeners to particular cultural situations like racial prejudice and AIDS. Art can also function as propaganda and often has a relationship with technology, economics, values, and institutions.

Therapy

As therapy, art can help treat a variety of illnesses, both physical and mental. Role playing, for example, frequently acts as a counseling tool for treating dysfunctional family situations. Mentally ill patients act out their personal circumstances to find and cure the cause of their illness (psychodrama). The focus of this use of art as therapy is the individual. However, art in a much broader context acts as a healing agent for society's general illnesses as well. Artworks can illustrate society's failings and excesses in hopes of saving us from disaster. The laughter caused by comedy can release endorphins, which are chemicals produced by the brain that strengthen the immune system.

Artifact

Art also functions as an **artifact:** a product that represents the ideas and technology of time and place. Artifacts, such as plays, paintings, poems, and buildings, connect us to our past and give us insights into the present.

When we examine art in the context of cultural artifact, one of the issues we face is the use of artworks in religious ritual. We could consider ritual as a separate function of art. Although we might not think of religious ritual as "art," in the broad context we have adopted for this text, ritual often meets our definition of human communication using an artistic medium. Music, for

example, when part of a religious ceremony, meets the definition, and the-atre—if seen as an occasion planned and intended for presentation—would include religious rituals as well as events that take place in theatres. Often, it is difficult to discern when ritual stops and secular production starts—for example, Greek tragedy seems clearly to have evolved from ritual. When ritual, planned and intended for presentation, uses traditionally artistic media like music, dance, and theatre, we can study it as an "art" or artifact of its particular culture.

HOW DO WE LIVE WITH ART?

Artworks make some people uncomfortable, probably because dealing with an artwork represents stepping into unfamiliar territory. Unfortunately, that discomfort is heightened by some artists and a few, self-proclaimed sophisti-cates who try to keep the arts confusing and hidden to all but a select few. Nonetheless, this book is about empowerment—accessing works of art comfortably and with the understanding that art and life are irrevocably intertwined. Knowledgeable interaction with works of art makes life better: We see more of what there is to see, and we hear more of what there is to hear. Our entire existence grows richer and deeper.

Recognizing the artistic principles and influences all around us makes our world more interesting and habitable. For example, Figure 2 is a line drawing of an eighteenth-century chest-of-drawers. The high chest was designed to meet a practical need: the storage of household goods in an easily accessible, yet hidden, place. However, while designing an object to accommodate that practical need, the cabinetmakers pursued the additional need of providing an interesting and attractive object.

Careful observation and imagination can enhance our experience of this piece of furniture. First, the design is controlled by a **convention** that dictated a consistent height for tables and desks. Therefore, the lower portion of the highboy, from point A to point B, designs space within a height that will harmonize with other furniture in the room. If we look carefully, we also can see that the parts of the highboy are designed with an intricate and interesting series of proportional and progressive relationships. The distance from A to B is twice the distance from A to D and is equal to the distance from B to C. The distances from A to F and C to E bear no recognizable relationship to the previous dimensions but are, however, equal to each other and to the distances from G to H, H to I, and I to J. In addition, the size of the drawers in the upper section decreases at an even and proportional rate from bottom to top. None of these interrelationships is accidental.

Much of what we experience daily employs similar artistic devices: Colors and labels on food cans, advertising, building exteriors, automobiles, and patio furniture use artistic principles to make products more attractive and to manipulate us into buying them or following a prescribed course of action when we make contact with them.

Art interacts significantly with culture. Think for a moment about how people worship—that is, the environment or architecture of worship—in

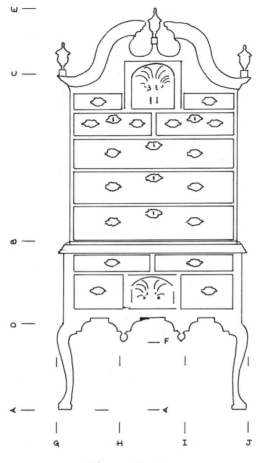

Figure 2 High chest.

churches, synagogues, mosques, and temples. Here, probably more than anywhere else, culture merges with art in a fundamental life experience. If we think about it, we can find innumerable ways in which art and culture feed and reinforce each other.

HOW DO WE EVALUATE WORKS OF ART?

One of the questions we all seem to want to ask about a work of art is, "Is it any good?" Whether it is rock music, a film, a play, a painting, or a classical symphony, judgments about the quality of a work often vary from one extreme to the other, ranging from "I liked it" and "It was interesting," to specific reasons why the artwork is considered effective or ineffective.

The evaluation of works of art is called *art criticism*. The word *criticism*, however, implies many things to many people. For our purposes, we will regard criticism as a detailed process of analysis for gaining understanding. It may or may not include making value judgments, which are intensely person-

al. Some opinions are more informed than others. Sometimes even knowledgeable people disagree. Disagreements about quality, however, can enhance the experience of a work of art when they lead to thought about why the differences exist, resulting in a deeper understanding of the artwork. Nonetheless, evaluation—or criticism—can be exercised without involving any judgment. We can thoroughly dissect any work of art by describing its parts—recounting and analyzing, for example, plot, character, language, harmony, melody, line, color, and form, to name a few of the characteristics of the arts we will examine later—and noting how the parts affect a viewer or listener. We can spend a significant amount of time doing this and never pass a judgment at all.

Does this mean that all artworks are equal in value? Not at all. It means that in order to understand what criticism involves, we must separate descriptive analysis, which can be satisfying in and of itself, from the act of passing value judgments. Analysis necessarily leads to enhanced understanding. We may not like the work we have analyzed, but we have understood something that we did not understand before. One important value of criticism is the sharing process: Our mutual agreement is less important than the enhanced perception that results from going through the process of understanding and sharing it with someone else.

Now that we have examined briefly what criticism is and why we might do it, what criteria or approaches can we use?

Types of Criticism

Of the possible types of criticism, we will examine four: *formal criticism, contextual criticism, structuralism,* and *deconstruction.*

FORMAL CRITICISM

In formal criticism, we are interested primarily in the artwork itself. We can allow the work to stand by itself, applying no external conditions or information. We analyze the artwork just as we find it: If it is a painting, we look only within the frame; if it is a play, we analyze only what we see and hear. Formal criticism approaches the artwork as an entity within itself. As an example, we will do a brief analysis of Molière's (mohl-YAIR) comedy *Tartuffe* (tahr-TOOF; 1664):

> Orgon, a rich bourgeois, has allowed a religious con man, Tartuffe, to gain complete control over him. Tartuffe has moved into Orgon's house and tries to seduce Orgon's wife at the same time he is planning to marry Orgon's daughter. Tartuffe is unmasked, and Orgon orders him out. Tartuffe seeks his revenge by claiming title to Orgon's house and blackmailing him with some secret papers. At the very last instant, Tartuffe's plans are foiled by the intervention of the king, and the play ends happily.

We have just described a story. Were we to go one step further and analyze the plot, we would look for points at which *crises* occur and cause impor-

tant decisions to be made by the characters. We would also want to know how those decisions moved the play from one point to the next. In addition, we would try to locate the extreme crisis—the *climax*. Meanwhile, we would discover auxiliary parts of the plot such as *reversals*—for example, when Tartuffe is discovered and the characters become aware of the true situation. Depending on how detailed our criticisms were to become, we could work our way through each and every aspect of the plot. We might then devote some time to describing and analyzing the driving force—the *character*—of each person in the play and how the characters interrelate. Has Molière created fully developed characters? Are they types or do they seem to behave more or less like real individuals? In examining the *thematic* elements of the play, we would no doubt conclude the play deals with religious hypocrisy and that Molière had a particular point of view on that subject. In this approach, information about the playwright, previous performances, historic relationships, and so on is irrelevant.

CONTEXTUAL CRITICISM

On the other hand, *contextual criticism* seeks meaning by examining related information "outside" the artwork, such as the artist's life, his or her culture, social and political conditions and philosophies, public and critical responses to the work, and so on. These can all be researched and applied to the work to enhance perception and understanding. This approach tends to view the artwork as an artifact generated from particular contextual needs, conditions, and/or attitudes. If we carry our criticism of *Tartuffe* in this direction, we would note that certain historical events help clarify the play. For example, the object of Molière's attention probably was the Company of the Holy Sacrament, a secret, conspiratorial, and influential society in France at the time. Like many fanatical religious sects—including some in our own time—the society sought to enforce its own view of morality by spying on others and seeking out heresies—in this case, in the Roman Catholic Church. Its followers were religious fanatics, and they had considerable effect on the lives of the citizenry at large. Thus, if we were to follow this path of criticism, any and all contextual matters that might illuminate or clarify what happens in the play would be pursued.

STRUCTURALISM

Structuralism applies to the artwork a broader significance, insisting that individual phenomena—in this case works of art—can be understood only within the context of the overall structures of which they are a part. These structures represent universal sets of relationships which derive meaning from their contrasts and interactions within a specific context. Structuralist criticism, associated with Roland Barthes (bahrt; 1915–1980), derives by analogy from structural linguistics, which sees a "text" as a system of signs whose meaning is determined from the pattern of their interactions rather than from any external references. This approach opposes critical positions that seek to determine an artist's intent, for example. Thus, the meaning of

Molière's *Tartuffe* lies not in what Molière may have had in mind, but in the patterns of contextual relationships that work within the play. Structuralism opposes approaches, such as deconstruction, that deny the existence of uniform patterns and definite meanings.

DECONSTRUCTION

Deconstruction, associated with the French philosopher Jacques Derrida (dare-ee-DAH; b. 1930), was also originally associated with literary criticism, but has been applied to other disciplines. Derrida used the term *text*, for example, to include any subject to which critical analysis can be applied. Deconstructing something means "taking it apart." The process of deconstruction implies on the one hand drawing out all the threads of a work to identify its multitude of meanings and, on the other hand, undoing the "constructs" of ideology or convention that have imposed meaning on the work. All of this leads to the conclusion that there is no such thing as a single meaning in a work of art, nor can it claim any absolute truth. Inasmuch as a work can outlast its author, its meanings transcend any original intentions. In other words, the viewer or listener brings as much to the work as the artist; thus, there are no facts, only interpretations. The story of *Tartuffe*, for example, becomes only a sidebar to the interpretation that we bring to it based on our own experiences and circumstances.

Both structuralism and deconstruction are much more complex and philosophically and sociologically involved than the limited space available in this text allows us to discuss in detail. However, they do illustrate the diversity of theories and approaches that are possible when encountering works of art. These theories—as well as the processes of formal and contextual criticism—merit further exploration and classroom discussion as ways in which we can engage, analyze, come to know as best we can and, ultimately, judge works of art.

Making Judgments

Now that we have made a rough definition of criticism and noted some approaches criticism can take in pursuit of understanding and enjoyment of works of art, we can make a few brief comments about making judgments. While artworks may be judged on many levels and by many criteria, two particular characteristics stand out: artisanship and communication. Judgment of a work of art's quality should include consideration of both of these.

ARTISANSHIP

Judging a work's artisanship means judging how it is crafted or made. Generally, such judgments require knowledge about the medium of the artwork. It is, for example, difficult to judge how a musical symphony is crafted without having some knowledge of musical composition. The same may be said of judging how well a painting, sculpture, building, or play is made. Nonetheless, some criteria exist that allow general judgment of artisanship. These criteria include *clarity* and *interest*.

Applying the standard of clarity means deciding whether the work has coherence. Even the most complex works of art need handles that allow us to approach them and begin to understand how they work. This standard of judgment has stood the test of time. Artworks have been compared to onions in that the well-made ones allow respondents to peel away translucent layers, with removal of each layer moving us closer to the core. Some people are able to peel away all the layers, and some people are able to peel away only one of two, but a masterfully crafted work of art will have a coherence that allows virtually anyone to grasp on some layer, if only the outer one.

Applying the standard of interest is similar to, and perhaps overlaps, applying the standard of clarity in that artists use layers of devices or qualities to capture and hold our interest. Masterfully crafted works of art employ such devices and qualities as (1) universality (the artist's ability to touch a common experience or feeling within us), (2) carefully developed structures or focal points that lead us where the artist intends us to go, and (3) freshness of approach that makes us curious to investigate further. When we watch a tired and trite mystery, we know what is going to happen: The characters are stale clichés, and we lose interest in them almost immediately. A masterfully crafted work will hold us—even if we know the story. Such is the case with plays like Sophocles' *Oedipus the King* or Shakespeare's *Hamlet*.

If a work of art does not appear clear or interesting, we may wish to examine whether the fault lies in the work or in ourselves before rendering judgment.

COMMUNICATION

Evaluating what an artwork is trying to say offers more immediate opportunity for judgment and less need for expertise. Johann Wolfgang von Goethe (GER-tuh), the nineteenth-century poet, novelist, and playwright, set out a basic, commonsense approach to communication. Goethe's approach provides an organized means for discovering an artwork's communication by progressing from analytical to judgmental functions and thus is a helpful way in which to end our discussion on criticism. Goethe posed three questions: What is the artist trying to say? Does he or she succeed? Was the artwork worth the effort? These questions focus on the artist's communication by making us identify, first, what was being attempted and, second, the artist's success in that attempt. Whether or not the project was worth the effort asks us to decide if the communication was important. Was it worthwhile? In other words, part of the value of communication lies not only in saying something clearly but also in saying something *meaningful.*

Structures—Architecture

FUNCTION

Every street in every city represents a museum of ideas and engineering. The houses, churches, and commercial buildings we pass each day reflect ideas that originated thousands of years ago. In approaching architecture as an art, one really cannot separate aesthetic properties from practical or functional properties. In other words, architects first have a practical function to achieve in their buildings. The aesthetics of a building are important, but they must be tailored to overall functional considerations. For example, when architects design a 110-story skyscraper, they are locked into a vertical rather than horizontal form. They may attempt to counter verticality with strong horizontal elements, but the physical fact that the building will be taller than it is wide is the basis from which the architect must work. Their structural design must also take into account the practical needs implicit in the building's use. Nonetheless, room for aesthetics remains. Treatment of space, surface textures, and proportion can yield buildings of unique style and character or buildings of uninspired sameness.

Architecture often is described as the art of sheltering, using this term very broadly. There can be types of structures considered as architecture within which people do not dwell and under which they might have difficulty escaping the rain. We can, however, consider architecture as the art of sheltering if we consider both physical and spiritual sheltering from the raw elements of the natural world.

In a larger sense, architecture is the design of three-dimensional space to create practical enclosures. Its basic forms are residences, churches, commercial buildings, bridges, walls, and monuments. Each of these forms can take innumerable shapes, from modest single-family houses to ornate palaces of kings and high-rise condominiums; from convenience marts to skyscrapers.

STRUCTURE

Many systems of construction exist for supporting a building. Let us examine a few of the most prominent: *post and lintel, arch, cantilever, bearing wall,* and *skeleton frame.*

Post-and-Lintel Structure

Post-and-lintel structure (Figure 3) consists of horizontal beams (lintels) laid across the open spaces between vertical supports (posts). In this architectural system, the traditional material is stone. Historically, perhaps the most easily recognizable examples of post-and-lintel structure occurred in the ancient Greek orders illustrated in Figure 14 (see p. 27). Post-and-lintel

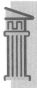

STYLE SPOT

Greek Classicism: A mid-5th century *BCE* style resting on the principles of simplicity, harmony, restraint, proportion, and see p. 124.

structures are similar to *post-and-beam* structures, in which horizontal members, traditionally of wood, join vertical posts. Nails or pegs fasten the members of post-and-beam structure.

Because stone lacks *tensile strength* (the ability to withstand twisting and sagging), post-and-lintel structure has a limited ability to create open space. If we lay a slab of stone across an open space and support it only at each end, we can span only a narrow gap before the slab cracks in the middle. However, stone has great *compressive strength* (the ability to withstand crushing). Thus, fairly slender columns of stone can support massive lintels.

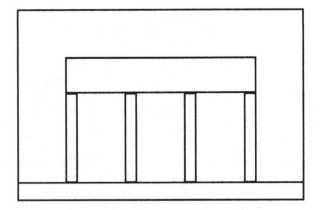

Figure 3 Post-and-lintel structure.

Arch

The arch, in contrast to post-and-lintel structure can define large open spaces because its stresses are transferred outward from its center (the keystone) to its legs. Thus, it does not depend on the tensile strength of its materials.

There are many different kinds and styles of arches, some of which are illustrated in Figure 4. The characteristics of different arches may have structural as well as decorative functions.

BUTTRESS The transfer of stress from the center of an arch outward to its legs dictates the need for a strong support to keep the legs from caving outward. Such a refinement is called a *buttress* (Figure 5). The designers of Gothic cathedrals sought to achieve a sense of lightness. Because stone was their basic building material, they recognized the need for a system that would overcome the bulk of a stone buttress. Therefore, they developed a system of buttresses that accomplished structural ends but were light in appearance. These structures are called *flying buttresses* (Figure 6).

Arches placed back to back to enclose space form a *tunnel vault* (Figure 7). Several arches placed side by side form an *arcade* (Figure 8). When two tunnel vaults intersect at right angles, they form a *groin vault* (Figure 9). The protruding masonry indicating the diagonal juncture of arches is a *ribbed vault* (Figure 10).

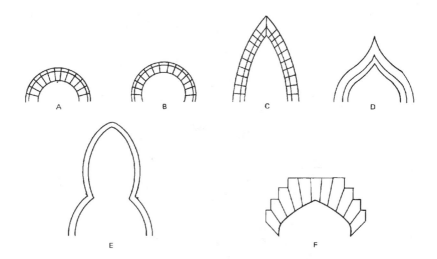

Figure 4 The Arch. A. Round (Roman) arch; B. Horseshoe (Moorish) arch; C. Lancet (pointed, Gothic) arch; D. Ogee arch; E. Trefoil arch; F. Tudor arch.

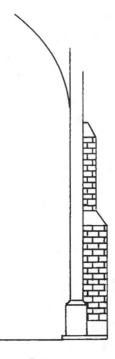

Figure 5 Buttress.

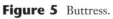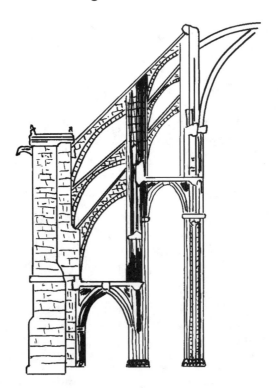

Figure 6 Flying buttresses.

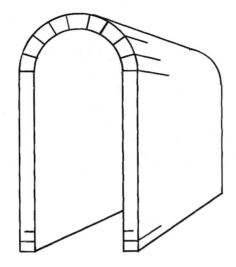

Figure 7 Tunnel vault.

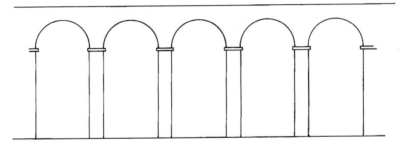

Figure 8 Arcade.

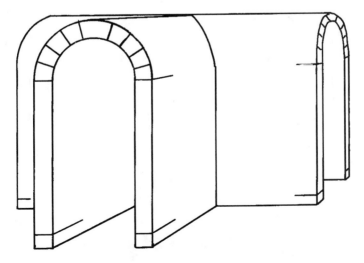

Figure 9 Groin vault.

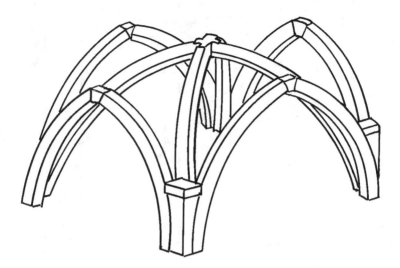

Figure 10 Ribbed vault.

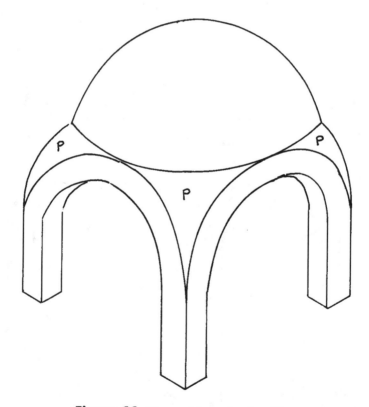

Figure 11 Dome with pendentives (P).

When arches are joined at the top with their legs forming a circle, the result is a **dome**. The dome, through its intersecting arches, allows for more expansive, freer space within the structure. However, if the structures supporting the dome form a circle, the result would be a circular building. To permit squared space beneath a dome, the architect can transfer weight and stress through the use of **pendentives** (Figure 11).

Cantilever

A **cantilever** is an overhanging beam or floor supported only at one end (Figure 12). Perhaps the simplest example of a cantilever is a diving board. Although not a twentieth-century innovation—many nineteenth-century barns in the central and eastern parts of the United States employed it—the most dramatic uses of cantilever have emerged with the introduction of modern materials such as steel beams and prestressed concrete.

Figure 12 Cantilever.

 BEARING WALL In the **bearing-wall** system, the wall supports itself, the floors, and the roof. Log cabins are examples of bearing-wall construction; so are solid masonry buildings in which the walls are the structure. In variations of bearing wall such as poured concrete, the wall material is continuous—that is, not jointed or pieced together. This variation is called **monolithic construction.**

Skeleton Frame

When a **skeleton frame** is used, a framework supports the building; the walls are attached to the frame, thus forming an exterior skin. When skeleton framing is wood, as in traditional home construction, the technique is called **balloon construction.** When metal forms the frame, as in skyscrapers, the technique is known as **steel cage construction.**

A QUESTION TO ASK
In what ways does this building express its basic structure? Is the expression of structure hidden or overt?

BUILDING MATERIALS

Historic and contemporary architectural practices and traditions often center on specific materials. To understand architecture in more depth, we will discuss several of these materials.

Stone

The use of stone as a material leads us back to post-and-lintel systems. When stone is used with mortar, for example, in arch construction, that combination is called *masonry construction*. The most obvious example of masonry is the brick wall. Stones, bricks, or blocks are joined together with mortar, one on top of the other, to provide basic, structural, weight-bearing walls of a building, a bridge, and so forth (Figure 13). There is a limit to what can be accomplished with masonry because of the pressures on the joints between blocks and mortar and the foundation on which they rest. However, when one considers that Chicago's Monadnock Building (http://members.aol.com/dahlia773/monad.htm), an early skyscraper, has a completely masonry structure (there are no steel reinforcements in the walls), it becomes obvious that much is possible with this elemental combination of stone and mortar.

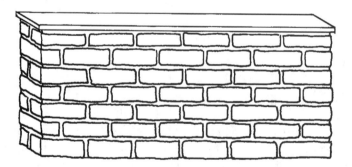

Figure 13 Masonry wall.

Concrete

Although the use of concrete is widely recognized as central to much contemporary architectural practice, it was also significant as far back in history as ancient Rome. One of Rome's great buildings, the Pantheon (http://www.nga.gov/cgi-bin/pinfo?Object=168+0+none), comprises a master-

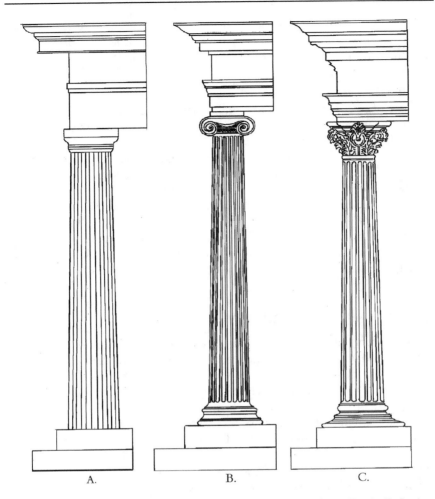

A. B. C.

Figure 14 Greek architectural orders, columns, and capitals. A. Doric; B. Ionic; C. Corinthian.

ful structure of concrete with a massive concrete dome, 142 feet in diameter, resting on concrete walls 20 feet thick. In contemporary architecture, we find **precast concrete,** which is concrete cast in place using wooden forms around a steel framework. We also find **ferroconcrete** or **reinforced concrete,** which utilizes metal reinforcing embedded in the concrete. Such a technique combines the tensile strength of metal with the compressive strength of the concrete. **Prestressed** and **post-tensioned concrete** use metal rods and wires under stress or tension to cause structural forces to flow in predetermined directions. Both comprise extremely versatile building materials.

Wood

Whether in balloon framing or in laminated beaming, wood has played a pivotal role in the building industry, especially in the United States. As new

technologies emerge in making engineered beams from what once was scrap wood, wood's continuation as a viable building product will probably remain—with less negative impact on the environment.

Steel

The use of steel comprises nearly endless variation and almost limitless possibilities for construction. Its introduction into the nineteenth-century industrial age forever changed style and scale in architecture. We discussed cantilever earlier. *Suspension construction* in bridges, superdomes, aerial walkways, and so on, has carried architects to the limits of space spansion. The **geodesic dome** is a unique use of materials invented by an American architect, R. Buckminster Fuller (www.wnet.org/archive/bucky/dome.html). Consisting of a network of metal rods and hexagonal plates, the dome is a light, inexpensive, yet strong and easily assembled building. Although it has no apparent size limit (Fuller claimed he could roof New York City, given the funds), its potential for variation and aesthetic expressiveness seems somewhat limited.

SCALE AND PROPORTION

Scale in architecture refers to a building's size and the relationship of the building and its decorative elements to the human form. Scale may range from the intimacy of a domestic bungalow to the towering power of a skyscraper. *Proportion*, or the relationship of individual elements to each other, also plays an important role in a building's visual effect. In this case, the elements of concern are the elements of the building juxtaposed to each other and their intended effects—for example, the sizes of pipes and openings in the façade of the Pompidou Centre (http://www.bc.edu/bc_org/avp/cas/fnart/arch/pompidou.html). Proportion and scale are tools with which the architect can create relationships that may be straight forward or deceptive. We must decide how these elements are used and to what effect. In addition, proportion in many buildings is mathematical: The relationships of one part to others (as in the high chest in Figure 2 on p. 13) are often based on ratios of three to two, one to two, one to three, and so on. Discovering such relationships in a building is one of the fascinating challenges that face us whenever we encounter a work of architecture.

CONTEXT

An architectural design usually takes into account its *context*, or environment. In many cases, context is essential to the statement made by the design. Throughout Europe we find cathedrals sitting at the center of and on the highest point in a city. Their placement in that particular location had a purpose for the medieval artisans and clerics responsible for their design. The centrality of the cathedral to the community was an essential statement of the

centrality of the Church to the life of the medieval community. Context also has a psychological bearing on scale. A skyscraper in the midst of skyscrapers has great mass but does not appear as massive in scale when overshadowed by another, taller, skyscraper. A cathedral, when compared to a skyscraper, is relatively small in scale. However, when standing in the center of a community of small houses, it appears quite large.

Two additional aspects of context concern the shapes and textures of the physical environment and their reflection in a building. On one hand, the environment can be shaped according to the compositional qualities of the building, as occurs in the landscape designs of many palaces in Europe.

In contrast, a building may be designed to reflect the natural characteristics of its environment. Such an idea has been advanced by many architects and can be seen especially in residences in which large expanses of glass allow us to feel a part of the outside while we are inside. The interior decoration of such houses often adopts the theme of colors, textures, lines, and forms in the environment surrounding the home. Natural fibers, earth tones, delicate wooden furniture, pictures that reflect the surroundings, large open spaces— together they form the core of the design, selection, and placement of nearly every item in the home, from walls to furniture to silverware.

SPACE

It seems almost absurdly logical to state that architecture must concern space—for what else, by definition, is architecture? However, the world is overwhelmed with examples of architectural design that have not met that need. Design of space essentially means the design and flow of contiguous *spaces* relative to function. *Traffic flow* is another term often used to describe this concept. Take, for example, a sports arena. Of primary concern is the space necessary for the sports intended to occupy the building. Will it play host to basketball, hockey, track, football, and/or baseball? Each of these sports restricts the architectural design, and curious results can occur when functions not intended by the design are forced into its parameters. For example, when the Brooklyn Dodgers first moved to Los Angeles, they played for a time in the Los Angeles Coliseum, a facility designed for the Olympic Games and track and field events, and reasonably suited for football (although spectators in the peristyle end zone seats may not have agreed). However, the imposition of baseball strained credulity. The left-field fence was only slightly more than 200 feet from home plate!

In addition to the requirements of the game, a sports arena must also accommodate the requirements of the spectators. Pillars that obstruct spectators' views do not create good will nor stimulate the sale of tickets. The same may be said for seats that lack sufficient legroom. Determining where to draw the line between more seats (and more dollars) and fan comfort is not easy. The now-demolished old Montreal Forum, in which anyone taller than 5 foot 2 inches was forced to sit with knees rubbing their chin, did not prove deleterious to the sale of tickets for the Montreal Canadiens hockey

team. Such a design of space, however, might be disastrous for a franchise in a less hockey-oriented city.

Finally, the design of space must concern the relationship of various needs peripheral to the primary function of the building. Again, in a sports arena, the sport and its access to the spectator are primary. In addition, the relationship of access to spaces such as restrooms and concession stands must also be considered. I once had season basketball tickets in an arena seating 14,000 people in which access to the two concession stands required standing in a line that, because of spatial design, intersected the line to the restroom. If the effect was not chaotic, it certainly was confusing, especially during half time of an exciting game.

CLIMATE

Climate always has been a factor in architectural design in zones of severe temperature, either hot or cold. As the world's energy supplies diminish, this factor will grow in importance. In the temperate climate of much of the United States, systems and designs that make use of the sun and earth are common. These are *passive systems* (their design accommodates natural phenomena rather than adding technological devices such as solar collectors). For example, in the colder sections of the United States, a building can be made energy efficient by using a design that eliminates or minimizes glass on the north-facing side. Windows facing south can be covered or uncovered to catch existing sunlight, which even in midwinter provides considerable warmth. Houses built into the sides of hills or below ground require less heating or cooling than those standing fully exposed—regardless of climate extremes—because space as shallow as four feet below the ground maintains a temperature of fifty degrees.

MODEL ANALYSIS

You can analyze a work of architecture using the following outline as a guide and answering the accompanying questions.

- *Structure.* What is the structure of the example? How do the elements you can see suggest how the building is supported?
- *Materials.* What materials have been used in the construction? How have various materials been combined to form the structure and decorative elements?
- *Scale and proportion.* How does the size of the example relate to the human form? What emotional sensations result from scale? How do each of the elements of the example relate to each other in terms of their proportions?
- *Context.* How does the example explore its context? What is the environment in which the example stands? Do the buildings and terrain around the structure harmonize or conflict with the design elements?

■ *Space.* How are interior spaces designed? How are the interior spaces reflected in the exterior design of the building—if at all? In what manner does the design of the interior result in traffic patterns that may be advantageous or disadvantageous to the intent of the structure?

■ *Climate.* Does the example make any accommodation to climate? How does the example create shelter from the elements?

■ *Reaction.* How do the previous elements combine to create a reaction in you? In other words, what draws your attention? What is your emotional response to the architectural work, and what causes that response?

FURTHER READING

Bacon, Edmund N. *Design of Cities*. New York: Viking Press, 1976.

Ching, Frank D. K. and Francis D. K. Ching. *Architecture: Form, Space, and Order* (2nd ed). New York: John Wiley & Sons, 1996.

Frampton, Kenneth. *Modern Architecture: A Critical History* (3rd ed.). London: Thames and Hudson, 1992.

Giedion, Sigfried. *Space, Time and Architecture: The Growth of a New Tradition* (5th ed.). Cambridge, MA: Harvard University Press, 1967.

Heyer, Paul. *Architects on Architecture: New Directions in America*. New York: Walker and Company, 1978.

Hyman, Isabelle, and Marvin Trachtenberg. *Architecture: From Prehistory to Post-Modernism/The Western Tradition*. New York: Harry N. Abrams, 1986.

Le Corbusier, *Towards a New Architecture*. New York: Dover, 1986.

Nesbitt, Kate (Ed). *Theorizing a New Agenda for Architecture: An Anthology of Architectural Theory 1965—1995*. New Haven, CT: Princeton Architectural Press, 1996.

Rasmussen, Steen E. *Experiencing Architecture*. Cambridge, MA: MIT Press, 1984.

Summerson, John N. *Classical Language of Architecture*. Cambridge, MA: MIT Press, 1984.

In the Museum—
Pictures and Sculptures

GENERAL MUSEUM DECORUM

We will begin our discussion of how to make the most out of a museum visit by touching on several basic logistical and orientation issues. These quick tips are applicable to most museums, and are designed to make your visit more enjoyable and fulfilling.

First, unlike churches and libraries, museums allow the opportunity for visitors to discuss their reactions to the artwork out loud. That having been said, however, and despite the fact that museum tour guides may be lecturing loudly to groups, the volume and tone of conversation should reflect sensitivity to others' needs to study without undue distraction.

Second, trips to museums require some advance planning with regard to personal items. Usually, purses, umbrellas, briefcases, cameras—that is, all items not transportable in a pocket—must be checked at the museum entrance area prior to entering the galleries. Thus, valuable items, usually carried in a purse, for example, should be left in the hotel safe. In addition, many museums do not allow the taking of pictures. There are exceptions to this rule of course, but they are rare. In the event that a museum does allow photography, it probably will prohibit flash photography because light from the flash can have a deleterious effect on artworks.

Third, some museums are so careful about vandalism that note taking can be done only in pencil. Consequently, pocket-sized pads and pencils rather than notebooks (which may need to be checked at the door) and pens are suggested as one of the best options for museum study gear.

Finally, most museums have electronic security systems that monitor the spaces around its paintings. As a result, reaching toward a work to point out some detail may set off an alarm. Under no circumstances should museum artworks be touched, unless a sign by a particular work indicates that touching is acceptable.

IN THE GALLERY—AN ORIENTATION

Entering a museum presents visitors with many choices. For instance, some larger museums may take hours (and possibly days) to traverse. With this in mind, a general review of the physical layout and organization of a museum can be useful.

The rooms in a museum are called *galleries*. The general layout of a museum is usually by historical period or style, with a logical progression from earliest to most modern works of art.

The museum may also have special galleries devoted to *collections*. Typically, collections represent the accumulation of art by one individual who, subsequently, has donated his or her collection to the museum. Collections often represent significant groups of works in one particular style or from one particular region or country. Many collections are substantial in size and value. As a tribute to the interest, ability, taste, and generosity of the individual donor, the museum displays the collection as a single display in its own gallery (or sometimes, an entire wing!), rather than dispersing the paintings and/or sculptures throughout the museum with the rest of the holdings. Such collections offer a special reward to the viewer because they provide appreciation of both the art and its acquisition by the individual collector.

Special exhibitions, which typically display a selected group of works for short periods of time, also merit attention—even if they require a special fee to see them. The curators of such shows have gone to great lengths to select these works. For instance, they may represent a retrospective on the total life and work of a single artist, or they may represent an overview of a particular style, with masterworks in that style by a number of its most gifted adherents. Again, part of the reward in viewing specially curated shows lies in admiring the effort of bringing it off. In a special exhibition, notation of the museums and individuals from whom the works are borrowed provides an interesting bonus. Special exhibitions can entail months or years of negotiation, preparation, and logistics in order to assemble the works in one place at one time. It takes a unique combination of artistic sense, political negotiating skills, and administrative discipline to curate a special exhibition.

The bulk of the museum, however, as can be noted from a map acquired at the Information desk, comprises works from the museum's own holdings. As stated earlier, these holdings typically are arranged by era or style, allowing wandering at a relaxed pace from gallery to gallery, to witness a broad spectrum of human artistic endeavor. Of course, each museum is different. Some museums specialize only in art from a specific period or nation. Others treat the entire history of art. Whatever the case, we find ourselves faced with a plethora of styles and periods that can be sampled later in this book.

Getting the most out of a trip to a museum, however, requires some knowledge about the techniques and qualities of the art itself. The remainder of this chapter examines visual art in three sections: two-dimensional art, specifically drawing, painting, printmaking, and photography; three-dimensional art, specifically, sculpture; and decorative art.

TWO-DIMENSIONAL ART: DRAWINGS, PAINTINGS, PRINTS, AND PHOTOGRAPHS

Pictures of family, friends, rock and sports stars, copies of artistic masterpieces, and original paintings and prints adorn our own personal spaces. Dorm rooms, bedrooms, living rooms, and other places seem coldly empty and depersonalized without pictures of some kind in them. Pictures have always been important to humankind. For instance, people of the Paleolithic period, more than 20,000 years ago, drew pictures on the walls of caves. The information that follows discusses many ways in which pictures can be made and how artists use the characteristics of two-dimensional art to speak to others.

Paintings, photographs, and prints are pictures, differing primarily in the technique of their execution. They are two-dimensional, and their subjects might be landscapes, seascapes, portraits, religious pictures, nonobjective (nonrepresentational) or abstract pictures, still lifes, or something else. Usually, one's initial reaction to a picture is to its content. Content can prove to be a powerful device for effecting intellectual and emotional response and an artist's use of lifelikeness or nonobjectivity (not lifelike) is a noticeable stimulant in this regard. It would seem logical for individuals to respond intellectually to nonobjective pictures, because the subject, being nonrecognizable, should be neutral. However, quite often just the opposite occurs. When asked if they feel more comfortable with the treatment of subject matter in a lifelike manner or in a nonobjective manner, most people prefer the lifelike. That leaves us to ponder several important questions. Does an explicit appeal cause a more profound response? Or, does the stimulation provided by the unfamiliar (i.e., the nonobjectivity) cause us to think more deeply and respond more fully because our imagination is left free to wander? When considering which artworks appeal most readily to us, a good question to ask is Why? Let us begin to answer these questions by exploring the various choices of medium in which a two-dimensioned work of art may be produced.

Medium

Drawings and paintings are pictures made by a variety of media.

DRAWING

Drawing, considered the foundation of two-dimensional art, involves a wide variety of materials traditionally divided into two groups: *dry media* and *wet media*. In the discussion that follows we will note the dry media of chalk, charcoal, graphite, and pastel, and the wet media of pen and ink and wash and brush.

Dry media. *Chalk* developed as a drawing medium by the middle of the sixteenth century. Artists first used it in its natural state, derived from ocher hematite, white soapstone, or black carbonaceous shale, placing it in a holder and sharpening it to a point. Chalk is a fairly flexible medium. A wide variety of tonal areas can be created, with extremely subtle transitions between them.

Chalk can be applied with heavy or light pressure. It can be worked with the fingers once it is on the paper to create the exact image the artist desires.

Charcoal, a burnt wood product (preferably hardwood), is like chalk in that it requires a paper with a relatively rough surface—tooth—for the medium to adhere. Charcoal has a tendency to smudge easily, which dampened its early use as a drawing medium. It found wide use, however, as a means of drawing details, for example, on walls, and for murals that were eventually painted or frescoed. Today, resin fixatives sprayed over charcoal drawings can eliminate smudging, and charcoal has become a popular medium because artists find it extremely expressive. Like chalk, charcoal can achieve a variety of tonalities. The medium appears in a range of shapes and densities—for example, in sharpened sticks that work like pencils either hard or soft.

Graphite is a form of carbon, like coal, and is most commonly used in pencil leads. As a drawing medium it can be manufactured in various degrees of hardness. The harder the lead, the lighter and more delicate its mark.

Pastel, essentially a chalk medium, combines colored pigment and a non-greasy binder. Typically, pastels come in sticks about the diameter of a finger and in degrees of hardness: soft, medium, hard. Hardness is increased by adding more binder, with the result that the harder the stick, the less intense its color. In fact, the name "pastel," implies pale colors. Intense colors require soft pastels, but soft pastels are quite difficult to work with. A special ribbed paper helps to grab the powdery pastel, and a sprayed fixative holds the powder in place permanently on the paper.

Liquid Media. *Pen and ink* is a fairly flexible medium compared to graphite, for example. Although linear, pen and ink gives the artist the possibility of variation in line and texture. Shading can be achieved by diluting the ink, and the overall qualities of the medium are fluidity and expressiveness.

Wash and brush is created by diluting ink with water and applying it with a brush. Its characteristics are similar to watercolor, which we discuss in the next section on painting media. Difficult to control, wash and brush must be worked quickly and freely. It has a spontaneous and appealing quality.

In addition to the media just described (which may be combined in infinite varieties), there exists a wide range of possibilities of an experimental and innovative nature. An example, includes the computer, when used as an electronic sketchpad.

PAINTING

Like drawing media, painting media each have their own particular characteristics and, to a great extent, this dictates what the artist can or cannot achieve as an end result. In the following section we will examine seven painting media: oils, watercolor, tempera, acrylics, fresco, gouache, and ink.

Oils. Oils are perhaps the most popular of the painting media, and have been since their development near the beginning of the fifteenth century. Their popularity stems principally from the great variety of opportunity they give painters. Oils offer a wide range of color possibilities. This is because

oils dry slowly, they can be reworked, they present many options for textural manipulation, and they are durable (Example: François Boucher, *Venus Consoling Love*; http://www.nga.gov/cgi-bin/pinfo?Object=12205+0+none).

Watercolor. Watercolor is a broad category that includes any color medium that uses water as a thinner. However, the term has traditionally referred to a transparent paint usually applied to paper. Because watercolors are transparent, artists must be very careful to control them. If one area of color overlaps another, the overlap will show as a third area combining the previous hues. Yet, one of the major appeals and popularity of watercolors is that their very transparency offers a delicacy that cannot be produced in any other medium (Example: William Blake, *Evening*; http://www.nga.gov/cgi-bin/pimage?70189+0+0).

Tempera. Tempera is an opaque watercolor medium whose use spans recorded history. It was employed by the ancient Egyptians and is still used by artists today. Tempera refers to ground pigments and their color binders such as gum or glue, and is best known for its egg tempera form. It is a fast-drying medium that virtually eliminates brush strokes and gives extremely sharp and precise detail. Colors in tempera paintings appear almost gemlike in their clarity and brilliance (Example: Fra Angelico and Filippo Lippi, *The Adoration of the Magi*; http://www.nga.gov/cgi-bin/pinfo?Object=41308+0+none).

Acrylics. Acrylics, in contrast with tempera, are modern synthetic products. Most acrylics are water-soluble (that is, they dissolve in water), and the binding agent for the pigment is an acrylic polymer. Acrylics are flexible media offering artists a wide range of possibilities in both color and technique. An acrylic paint can be either opaque or transparent, depending on dilution. It is fast drying, thin, and resistant to cracking under temperature and humidity extremes. It is perhaps less permanent than some other media, but adheres to a wider variety of surfaces. It will not darken or yellow with age, as will oil (Example: Gene Davis, *Narcissus III*; http://www.nga.gov/cgi-bin/pinfo?Object=57251+0+none).

Fresco. Fresco is a wall-painting technique in which pigments suspended in water are applied to fresh wet plaster. Michelangelo's Sistine Chapel frescoes are the best known examples of this technique. Because the end result becomes part of the plaster wall itself rather than just being painted on it, fresco provides a long-lasting work. However, it is an extremely difficult process, and once the pigments are applied, no changes can be made without replastering an entire section of the wall (Example: Michelangelo, The Sistine Chapel ceiling; http://metalab.unc.edu/wm/paint/auth/michelangelo/michelangelo.creation-of-sun-and-moon.jpg).

Gouache. Gouache is a watercolor medium in which gum is added to ground opaque colors mixed with water. Transparent watercolors can be made into gouache by adding Chinese white to them, a special, opaque, water-soluble paint. The final product, in contrast to watercolor, is opaque.

Ink. Ink as a painting medium has many of the same characteristics as transparent watercolor. It is difficult to control, yet its effects are nearly impossible to achieve in any other medium. Because it must be worked with quickly and freely, it has a spontaneous and appealing quality.

PRINTS

Prints fall generally into three main categories that are based essentially on the nature of the printing surface. The first category would be *relief printing* such as woodcut, wood engraving, and linoleum cut. The second category consists of *intaglio*, which includes etching, aquatint, and drypoint. And the third category is the *planographic process*, which includes lithography and serigraphy (silkscreen) and other forms of stenciling. In addition, printmakers also use other combinations and processes.

To begin, however, we need to ask: What is a print? A *print* is a hand-produced picture that has been transferred from a printing surface to a piece of paper. The artist personally prepares the printing surface and directs the printing process. The uniqueness and value of a print reside in the fact that the block or surface from which the print is made is usually destroyed after making the desired number of prints. In contrast, a *reproduction* is not an original. It is a copy of an original painting or other artwork typically reproduced via a photographic process. As a copy, the reproduction does not bear the handiwork of an artist. With this in mind, in purchasing prints we must be sure we are buying an actual print (which has value as an artwork) and not a reproduction (which lacks such value) disguised by obscure or misleading advertising.

Every print has a number. On some prints the number may appear as a fraction—for example, $36/100$ The denominator indicates how many prints were produced from the plate or block. This number is called the *issue number* or *edition number*. The numerator indicates where in the series the individual print was produced. If only a single number appears, such as 500 (also called an issue number), it simply indicates the total number of prints in the series. The former kind of numbering carries a misconception that the relationship of the numerator to the issue total has a bearing on the print's value, monetarily or qualitatively. The issue number does have some value in comparing, for example, an issue of 25 with one of 500, and usually is reflected in the price of a print. However, the edition number is not the sole factor in determining the value of a print. The quality of the print and the reputation of the artist are more important considerations.

Relief Printing. In relief printing, the image is transferred to the paper by cutting away nonimage areas and inking the surface that remains. Therefore, the image protrudes, in relief, from the block or plate and produces a picture that is reversed from the image carved by the artist. This reversal is characteristic of all printmaking media. **Woodcuts** and **wood engravings** are two popular techniques. A woodcut, one of the oldest techniques, is cut into the plank of the grain while a wood engraving is cut into the butt of the grain (Figure 15) (Example: Albrecht Dürer, *The Four Horsemen of the Apocalypse*; http://www.artchive.com/artchive/D/durer/4horse.jpg.html).

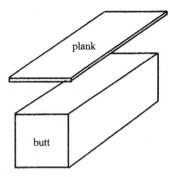

Figure 15 Wood plank and butt.

INTAGLIO The intaglio process is the opposite of relief printing. The ink is transferred to the paper not from raised areas but rather from grooves cut into a metal plate. *Line engraving, etching, drypoint,* and *aquatint* are some of the methods of intaglio (Example: Edward Hopper, *Night in the Park*; http://www.nga.gov/cgi-bin/pinfo?Object=46571+0+none).

LINE ENGRAVING. Line engraving involves cutting grooves into the metal plate with special sharp tools. It requires great muscular control because the pressure must be continuous and constant if the grooves are to produce the desired image. The print resulting from the line-engraving process is very sharp and precise. This form of intaglio is the most difficult and demanding (Example: Albrecht Dürer, *Angel with the Key to the Bottomless Pit*; http://sunsite.auc.dk/cgfa/durer/p-durer5.htm).

ETCHINGS. In the etching process, the artist removes the surface of the plate by exposing it to an acid bath. First the artist covers the plate with a thin, waxlike, acid-resistant substance called a *ground* and then scratches away the ground to produce the desired lines. Next, an acid burns away the exposed areas. The longer a plate is left in the acid, the deeper the resulting etches; the deeper the etch, the darker the final image. Artists wishing to produce lines or areas of differing darkness must cover the lines they do not want to be more deeply cut before further immersions in the acid. Repetition of the process yields a plate producing a print with the desired differences in light and dark lines.

DRYPOINT. Drypoint is a technique in which the artist scratches the surface of the metal plate with a needle. Unlike line engraving, which results in a clean, sharp line, drypoint technique leaves a ridge, called a *burr*, on either side of the groove, resulting in a somewhat fuzzy line.

AQUATINT. Aquatint can create a range of values from lightest gray to black, and, thus is useful for shading. The intaglio methods noted thus far consist of various means of cutting lines into a metal plate. On occasion, however, an artist may wish to create large areas of subdued tonality. Such shadow-like areas cannot be produced effectively with lines. Therefore, the artist dusts the

plate with a resin substance, heats the plate, which affixes the resin, and then puts the plate into an acid bath. The result yields a plate with a rough surface texture, like sandpaper, and a print whose tonal areas reflect that texture.

Once the plate is prepared, whether by line engraving, etching, aquatint, drypoint, or a combination of methods, the artist moves to the printing process by covering the plate with a special dampened paper and placing it in a press. Padding is placed on the paper and passing a roller over it, forces the plate and the paper together with great pressure. The ink, which has been carefully applied to the plate (note: the plate itself has been carefully wiped as well, so that the ink only remains in the grooves), transfers as the paper is forced into the grooves by the roller of the press. Even if no ink had been applied to the plate, the paper would still receive an image. This *embossing* effect marks an intaglio process with a very obvious three-dimensional *platemark*.

Planographic Processes. In a planographic process, the artist prints from a plane surface (neither relief nor intaglio).

LITHOGRAPHY. Lithography (the term's literal meaning is "stone writing") rests on the principle that water and grease do not mix. To create a lithograph, artists begin with a stone, usually limestone, and grind one side until absolutely smooth. They then draw an image on the stone with a greasy substance. Artists can vary the darkness of the final image by the amount of grease they use (i.e., the more grease applied, the darker the image). After artists have drawn the image, they treat the stone with gum arabic and nitric acid and then rinse it with a petrol product that removes the image. However, the water, gum, and acid have impressed the grease on the stone, and when the stone is wetted it absorbs water (limestone being porous) only in those areas that were not previously greased. Finally, a grease-based ink is applied to the stone. It, in turn, will not adhere to the water-soaked areas. As a result, with ink adhering only to the areas on which the artist has drawn, the stone can be placed in a press and the image transferred to the waiting paper. Lithographs often have a crayon-drawing appearance because the lithographer usually draws with a crayonlike material on the stone (Example: Robert Indiana, *South Bend*; http://www.nga.gov/cgi-bin/pimage?56441+0+0)

SERIGRAPHY. The serigraphic process (**serigraphy**) or silkscreening is the most common of the stenciling processes. Silkscreens are made from a wooden frame covered with a finely meshed silk fabric. Artists block the non-image areas by a variety of methods including glue or cut paper. They place a stencil in the frame and apply ink. By means of a rubber instrument called a squeegee, they force ink through the openings of the stencil, through the screen, and onto the paper below. This technique allows the printmaker to achieve large, flat, uniform color areas.

It is not always possible to discern the technique used in executing a print, and some prints reflect a combination of techniques. However, in seeking the method of execution, we add another layer of potential response to a work.

PHOTOGRAPHY

Photographic images (and the images of its subsequent developments—motion pictures and video) are primarily informational in nature. Cameras record the world, yet, through the editing process, a photographer has the ability to take the camera's image and change the literal reality of life as we see it to a figurative, symbolic reality of the imagination. In one sense, photography is a simplification of reality that substitutes two-dimensional images for the three-dimensional images of life. However, for the purposes of this discussion, it can be seen as an amplification of reality such that a photographer can take a snapshot of one moment in time and transform it, by altering the photographic image and/or artificially emphasizing one of its parts into something quite different.

In truth, some photography is merely a matter of personal record executed with equipment of varying degrees of expense and sophistication. Certainly photography as a matter of pictorial record, or even as photojournalism, may lack the qualities that we believe are requisite to art. For instance, a photograph of a baseball player sliding into second base or of Aunt Mabel cooking hamburgers at the family reunion may trigger expressive responses, but it is doubtful the photographers had aesthetic communication in mind when they snapped the shutter. Even with these insights, keep in mind that a carefully composed and sensitively designed and executed photograph can contain every attribute of human expression possible in any art form.

Ansel Adams believed the photographer to be an interpretive artist; he likened a photographic negative to a musical score, and the print to a performance (Example: Ansel Adams, *North Dome;* http://nmaa-ryder.si.edu/collections/exhibits/helios/AmericanPhotographs/obadama01.html). Despite all the choices an artist may make in committing an image to film, they are only the beginning of the artistic process. A photographer still has the choice of size, texture, and value contrast or tonality. A photo of the grain of a piece of wood, for example, has an enormous range of aesthetic possibilities depending on how an artist employs and combines these three elements.

These differing views lead to the often asked question concerning photography, "Is it art?" While there is no simple answer to this query, the quality of our aesthetic repayment from the photographic experience rises if we view photography in the same vein as we do the other arts—as a visualization of reality expressed through a technique and resulting in an aesthetic effect.

Composition

Understanding how artworks are put together centers on how they are composed. The *elements and principles of composition* are building blocks whose definitions and applications help clarify experiences with the arts.

ELEMENTS OF COMPOSITION

In the next few pages we will examine the elements of line, form, color, mass (space), and texture.

LINE The basic building block of a visual design is the line. To most people, a line is a thin mark:_____. In two-dimensional art, line is defined by its three physical characteristics. Line is (1) a linear form in which length dominates over width, (2) a color edge, and (3) an implication of continued direction. Line as a linear form in which length dominates over width can be seen in the line defining the sunburst shape in Figure 16. Second, line is an edge: The place where one object or plane stops and another begins. Again in Figure 16, the edges where the black forms stop and the background begins are lines. The third aspect of line is implied rather than physical. The three rectangles in Figure 17 on page 43 create a horizontal line that extends across the design. No physical line connects the tops of the forms, but their spatial arrangement creates one by implication. In an even less obvious way, Jackson Pollock's *Number 1, 1950 (Lavender Mist)*, http://www.nga.gov/cgi-bin/pinfo?Object=55555+0+none, uses implied line to carry a sense of action around and through the work.

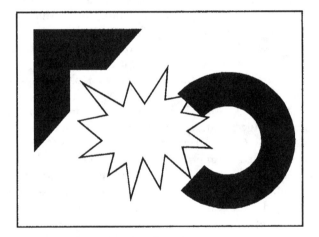

Figure 16 Aspects of lines.

Artists use line to control vision, to create unity and emotional value, and, ultimately, to develop meaning. In pursuing those ends, and by employing the three aspects of line noted earlier, artists find that line has two characteristics: It is curved or it is straight. Whether expressed as an outline, an area edge, or by implication, and whether simple or in combination, a line contains some derivative of the characteristics of straightness or curvedness.

Form. Form and line relate closely both in definition and effect. Form is the shape of an object within the composition, and "shape" often is used as a synonym for form. Literally, form is that space described by line. A building is a form. So is a tree. They appear as buildings or trees, as do their individual details, because of the line by which they are composed; hence, form cannot be separated from line in two-dimensional design.

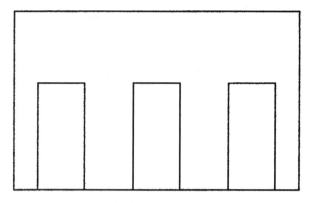

Figure 17 Outline and implied line.

COLOR Many ways exist by which to approach the compositional concept of color. We could begin with color as electromagnetic energy; we could discuss the psychology of color perception; and/or we could approach color in terms of how artists use it. The first two possibilities are extremely interesting, and the physics and psychology of color provide many potential crossovers between art and science and life. Nonetheless, we will limit our investigation to the last of these. The discussion that follows focuses on three color components: hue, value, and intensity.

HUE. Hue denotes the measurable wavelength of a specific color. The visible range of the color spectrum or range of colors we can actually distinguish extends from violet on one end to red on the other (Figure 18, p. 44). The traditional color spectrum consists of seven basic hues (red, orange, yellow, green, blue, indigo, and violet). These are *primary hues* (red, blue, and yellow) and *secondary* and *tertiary* (pronounced TUHR-shee-air-ee) *hues* that are direct derivatives of the primaries. In all, there are (depending on which theory one follows) from ten to twenty-four perceivably different hues.

Assuming, for the sake of clarity and illustration, that there are twelve basic hues, we can arrange them in a series or turn them into a "color wheel" (Figure 19, p. 44). With this visualization, artists' choices with regard to color become clearer. First, an artist can mix the primary hues of the spectrum, two at a time in varying proportions, which creates the other hues of the spectrum. For example, red and yellow in equal proportions make orange, a secondary hue. Varying the proportions—adding more red or more yellow—makes yellow-orange or red-orange, which are tertiary hues. Yellow and blue make green, and also blue-green and yellow-green. Red and blue make violet, blue- violet, and red-violet. Hues directly opposite each other on the color wheel are *complementary* colors. When they are mixed together in equal proportions, they produce gray.

Ultraviolet

Violet

4000

Blue

4500

5000 Green

5500

Yellow
Orange

6000

Red

6500

7000

Infrared

Figure 18 Basic color spectrum.

yellow

yellow-orange yellow-green

orange

green

red-orange gray blue-green

red blue

red-violet blue-violet

violet

Figure 19 Color wheel.

VALUE. Value, sometimes called key, is the relationship of blacks to whites and grays. The range of possibilities from black to white forms the value scale (Figure 20, below), which has black at one end, white at the other, and medium gray in the middle. The perceivable tones between black and white are designated light or dark. The lighter, or whiter, a color is, the higher its value. Likewise, the darker a color, the lower its value. For example, light pink is high in value, while dark red is low in value, even though they both have as their base the same primary red. Adding white to a hue (like primary red) creates a *tint* of that hue. Adding black creates a *shade*.

Figure 20 Value scale.

Some hues are intrinsically brighter than others (Figure 21, page 46), a factor we will discuss momentarily, but it is possible to have a brightness difference in the same color. The brightness may involve a change in value, as just discussed—that is, a pink versus a grayed or dull red. Brightness may also involve surface reflectance, a factor of considerable importance to all visual artists. A highly reflective surface creates a brighter color (and therefore a different response from the viewer) than does a surface of lesser reflectance, all other factors being equal. This is the difference between high gloss, semigloss, and flat paints, for example. It is highly probable that surface reflectance is more a property of texture than of color. Nonetheless, brilliance is often used to describe not only surface gloss but also characteristics synonymous with value. As just mentioned, some hues are intrinsically darker than others. That situation describes the concept we discuss next: intensity.

Figure 21 Color-value equivalents.

INTENSITY. Intensity is the degree of purity of a hue. It is also sometimes called chroma and saturation. Every hue has its own value—that is, in its pure state each hue falls somewhere on the value scale, as in Figure 21, above. The color wheel (Figure 19, p. 44) illustrates how movement around the wheel can create change in hue. Movement across the wheel also alters intensity, for example by adding green to red. When, as in this case, hues are directly opposite each other on the color wheel, mixing them will turn the original hue to medium gray. Therefore, because graying a hue is a value change, the terms intensity and value are occasionally used interchangeably. Some sources use the terms independently but state that changing a hue's value automatically changes its intensity. Graying a hue by using its complement

differs from graying a hue by adding black (or gray derived from black and white). Gray derived from complementaries, because it has hue, is far livelier than gray derived from black and white, which does not have hue.

Colors are typically referred to as warm or cool depending on which end of the color spectrum they fall. For instance, reds, oranges, and yellows are said to be warm colors. These are the colors of the sun and therefore call to mind our primary source of heat. Thus, they carry strong implications of warmth. Colors falling on the opposite end of the spectrum—blues and greens—are cool colors because they imply shade, or lack of light and warmth. These are mental stimuli with a physical basis. Tonality and color contrast can also affect the senses. Stark value contrasts yield a harsh result; gentle contrasts, the opposite. Many sense stimuli work in concert and cannot be separated from each other.

Artists' overall use of color is called *palette*. Palette can be broad, restricted, or somewhere in between, depending on whether an artist utilizes the full range of the color spectrum and/or explores the full range of tonalities—brights and dulls, lights and darks. Analyzing palette consists of deciding what uses of color have occurred. Comparisons between or among paintings can be phrased in terms of which displays a more restricted or, conversely broader palette.

A QUESTION TO ASK

Is the artist's palette broad or restricted, and in what ways does the use of color in this work trigger emotional or intellectual responses in me?

Mass (Space) *Mass* is the physical volume and density of an object. In two-dimensional art such as drawing, painting, printmaking, and photography, mass must be implied. The use of light and shade, texture, and perspective (see p. 50) can give figures and objects in a two-dimensional works the appearance of fully rounded, solid mass by creating depth of space and drawing attention away from the fact that the picture exists in only two dimensions.

Texture. The texture of a picture is its apparent roughness or smoothness. Texture ranges from the smoothness of a glossy photo to the three-dimensionality of impasto, a painting technique in which pigment is applied thickly with a palette knife to raise areas from the canvas. The texture of a picture may be anywhere within these two extremes. Texture may be illusory in that the surface of the picture may be absolutely flat, but the image gives the impression of three-dimensionality. So the term can be applied to the pictorial arts either literally or figuratively.

PRINCIPLES OF COMPOSITION

Our next step in this chapter moves us from looking at the elements of composition to discussing the principles of repetition, balance, unity, and focal area.

Repetition. Probably the essence of any design is in its *repetition;* which can be defined as how the basic elements in a picture are repeated or alternated. Repetition encompasses three concepts: rhythm, harmony, and variation.

RHYTHM. *Rhythm,* in technical language, is the recurrence of elements in a composition. In other words, rhythm is the repetition of lines, shapes, and objects in a picture. Recurrence may be regular or irregular. If the relationships among elements are equal, the rhythm is regular (Figure 17, p. 43). If not, the rhythm is irregular. However, examination of the entire composition must occur in order to discern if *patterns* of repetitions exist and whether or not the patterns are regular, as they are in Figure 22.

Figure 22 Repetition of patterns.

HARMONY. Harmony is the logic of repetition. Harmonious relationships occur when components appear to join naturally and comfortably. If an artist employs forms, colors, or other elements that appear incongruous, illogical, or out of sync, then *dissonance* occurs. In other words, the constituents simply do not go together in a natural way. However, an important point to keep in mind when considering how harmony affects an artwork's composition is that ideas and ideals relative to harmonious relationships in color or other elements often reflect cultural conditioning or arbitrary understandings (conventions).

VARIATION. Variation is the relationship of repeated items to each other; it is similar to the concepts of *theme and variation* in music. As you look at artwork, a good question to help you examine and frame this relationship is: How does an artist take a basic element in the composition and use it again with slight or major changes?

Balance. Balance is the achievement of equilibrium in a work of art. Determining whether a work is balanced or not is like dividing it into halves and evaluating whether one half or the other dominates. If the two halves seem equal, the work is balanced. Line, form, and color all affect this deter-

mination. There are two general types of balance: symmetrical (formal) and asymmetrical (informal or psychological).

SYMMETRY The most mechanical method of achieving balance is symmetry, or specifically, *bilateral symmetry*, the balancing of like forms, mass, and colors on opposite sides of the vertical axis (often referred to as the centerline) of a picture. Pictures employing absolute symmetry tend to be stable, stolid, and without much sense of motion. Many works approach symmetry, but retreat from placing mirror images on opposite sides of the centerline.

ASYMMETRY. Asymmetrical balance, sometimes referred to as *psychological balance*, carefully arranges unlike items. It might appear that asymmetrical balance is a matter of opinion. However, intrinsic response to what is balanced or unbalanced is relatively uniform among individuals, regardless of their aesthetic training. Often color is used to balance line and form. Because some hues, such as yellow, have great eye attraction, they can balance tremendous mass and activity on one side of a painting, by being placed on the other side. For instance, Hiroshige's *Bird on a Tree* (http://nga.gov/cgi-bin/pinfo?Object=48796+0+none) skillfully balances space, line, and form around the central object of the painting, which differs in color from the other elements.

Unity. In general, we could argue that artists strive for a sense of self-contained completeness in their artworks (unity). All the elements of composition work together toward meaning. Often compositional elements are juxtaposed in unusual or uncustomary fashion to achieve a particular effect. Nonetheless, that effect usually comprises a conscious attempt at maintaining or completing a unified statement, that is, a total picture. Critical analysis of the elements of a painting should lead to a judgment about whether the total statement comprises a unified one.

Discussion of unity also raises the issue of whether or not an artist allows the composition to escape the frame. People often speak of *closed composition*, or composition in which use of line and form always directs the eye back into the painting, as unified, and *open composition*, which leads the eye or allows it to wander off the canvas, or escape the frame, as disunified.

Keeping the artwork within the frame is a stylistic device that has an important bearing on the artwork's meaning. For example, painting in the classical style is predominantly kept within the frame (*The Interior of the Pantheon* http://www.nga.gov/cgi-bin/pinfo?Object=168+0+none). This illustrates a concern for self-containment in the artwork and for precise structuring. Anticlassical design, in contrast often forces the eye to escape the frame, suggesting, perhaps, a universe outside, or the individual's place within an overwhelming cosmos (*Saint Jerome*, http://nga.gov/cgi-bin/pinfo?Object=12209+0+none). In essence, unity can be achieved by keeping the composition closed, but it is not necessarily lacking when the opposite state exists.

Focal Area. Focal areas comprise the items of greatest visual appeal. A work may have a single focal area to which the eye is drawn immediately and from which it will stray only with conscious effort. Or it may have an infinite number of focal points. People often describe a picture of the latter type as "busy"; that is, the eye bounces at will from one point to another on the picture without much attraction at all.

Artists achieve focal areas in a number of ways—through confluence of line, by encirclement, or by color, to name just a few. To draw attention to a particular point in the picture, an artist may make all lines lead to that point *(confluence of line)*, may place the focal object or area in the center of a ring of objects *(encirclement)*, or may give the object a color that demands attention more than other colors in the picture. Again, for example, bright yellows attract the eye more readily than dark blues. Artists use focal areas, of whatever number or variety, to help control what images and the sequences of these images that we see when we look at a picture. For instance, in Mary Cassatt's impressionist painting *The Boating Party* (http://nga.gov/cgi-bin/pinfo?Object=46286+0+none), each of these factors has been used. The

STYLE SPOT

Impressionism: A late 19th-century style that sought to capture spontaneity, harmonious colors, and faithfulness to observed lighting in everyday subjects. See p. 132

strong yellow of the boat's gunwales fix our attention, but because of the sweeping line of the side of the boat, attention is drawn upward where the converging line of the oarsman's arm and the oar point toward the pink of the baby's clothing. Encircled by line and color, the baby's face becomes, ultimately, the painting's strongest focal area.

Other Factors

In addition to medium and composition, there are several other factors that help us analyze two-dimensional pieces of art more effectively. These include perspective, content, chiaroscuro, dynamics, Trompe l'oeil, and juxtaposition.

PERSPECTIVE Perspective is a tool for indicating spatial relationships. It is based on the phenomenon of distant objects appearing smaller and less distinct than objects in the foreground. In a painting with some degree of lifelikeness, artists may use perspective to indicate the spatial relationship between the objects in the foreground and the objects in the background. Further examination of paintings using lifelike subject matter also can indicate whether perspective relationships are rational—that is, whether or not the relationships of the objects appear as they naturally and normally would in life. For example, paintings executed prior to the Italian Renaissance (when mechanical procedures for

rendering perspective were developed) look different from later painting because, although background objects are painted smaller than foreground objects, the positioning does not adhere to scientific rationale.

There are a number of types of perspective. We will discuss three: linear, atmospheric and shifting.

Linear Perspective. Linear perspective is characterized by the phenomenon of standing on railroad tracks and watching the two rails apparently come together at the horizon (known as the *vanishing point*; see Figure below). Very simply, linear perspective is the creation of the illusion of distance in a two-dimensional artwork through the convention of line and foreshortening—that is, the illusion that parallel lines come together in the distance. Linear perspective is also called *scientific, mathematical one-point,* or *Renaissance perspective* and was developed in fifteenth-century Italy. Linear perspective is the system most people in Euro-American cultures consider as perspective because it is the visual code they are accustomed to seeing.

Figure 23 Linear perspective.

Atmospheric Perspective. Atmospheric perspective indicates distance through the use of light and atmosphere. For example, mountains or buildings in the background of a picture are made to appear distant by being painted in less detail; they seem hazy.

Shifting Perspective. Shifting perspective is found especially in Chinese landscapes and is affected by additional factors of culture and convention.

Chinese painting in vertical format utilizes a conventional approach to atmospheric perspective. The artist divides the picture into two basic units, foreground and background. The foreground consists of details reaching back toward the middle ground. At that point a division occurs, so the background and foreground are separated by an openness in what might have been a deep middle ground. The foreground represents the nearby, and its usually rich detail causes the viewer to pause and ponder the numerous elements such as brushstroke. Then there is a break, and the background appears to loom up or be suspended, almost as if it were a separate entity. Details appear indistinct. Although the foreground gives a sense of dimension—of space receding from the front plane of the painting—the background will seem flat, a factor that often serves to further enhance a sense of height, particularly if mountains are portrayed (Example: Zhu Rui, *Bullock Carts Traveling over Rivers and Mountains*; http://www.boston.com/mfa/chinese/carts.htm) The apparent shift in perspective, however, results from the concept that truth to natural appearance should not occur at the expense of a pictorial examination of how nature works. The viewer is invited to enter the painting and examine its various parts, but not to take a panoramic view from a single position. Rather, the artist reveals each part as though the viewer were walking through the landscape. *Shifting perspective* allows for a personal journey and for a strong personal, spiritual impact on the viewer.

CONTENT

Arguably, all works of art pursue **verisimilitude** (vair-ih-sih-MIHL-ih-tood), and they do so with a variety of treatments of content. We can regard treatment of content as ranging from naturalism to stylization. Included are such concepts as **abstract, representational,** and **nonobjective.** The word verisimilitude comes from the Latin word for plausibility. Aristotle, in his *Poetics*, insisted that are should reflect nature—for example, even highly idealized representations should possess recognizable qualities and that the probable should take precedence over the merely possible. This has come to mean that the search for a portrayal of truth can sometimes mean a distortion of what we observe around us in favor of an image that, while perhaps not being lifelike, better speaks to the underlying truth of human existence than mere lifelikeness does. So, the verisimilar, whether lifelike or not, becomes acceptable or convincing according to the respondent's own experience or knowledge. In some cases, this means enticing the respondent into suspending disbelief and accepting improbability within the framework of the work of art.

CHIAROSCURO

Chiaroscuro, whose meaning in Italian is "light and shade," is the suggestion of three-dimensional forms via light and shadow without the use of outline. It is a device used by artists to make their forms appear plastic—that is, three-

dimensional. Making two-dimensional objects appear three-dimensional depends on an artist's ability to render highlight and shadow effectively. Without them, all forms are two dimensional in appearance.

An interesting variation on chiaroscuro is the challenge of an artist's treatment and portrayal of flesh. Some flesh is treated harshly and appears like stone. Other flesh appears soft, warm, and true to life. Our response to either treatment is tactile; we want to touch it, believing that we know how the flesh as rendered would feel.

DYNAMICS

Although pictures are motionless, they can effectively stimulate a sense of movement and activity. They can also create a sense of stable solidity. An artist stimulates these sensations by using certain conventional devices. Composition that is principally vertical can express, for example, a sense of dignity and grandeur. A horizontal picture can elicit a sense of stability and placidity. The triangle is a most interesting form in engineering because of its structural qualities. It is also interesting in art because of its psychological qualities. A triangle whose base forms the bottom of a picture creates a sense of solidarity and immovability (Figure 24). If that triangle were a pyramid sitting on a level plane, significant effort would be required to tip it over. On

Figure 24 Upright-triangular composition.

the other hand, a triangle inverted so it balances on its apex, creates a sensation of instability (Figure 25).

The use of line also affects dynamics. Figure 26 illustrates how the use of curved line can elicit a sense of relaxation. The broken line in Figure 27 creates a more dynamic and violent sensation. We can also sense that the upright triangle in Figure 24, although solid and stable, has some activity because of its diagonal line.

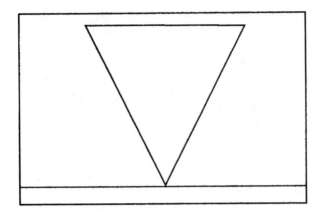

Figure 25 Inverted-triangular composition.

Figure 26 Curved line.

TROMPE L'OEIL

Trompe l'oeil (trawmp-LOY), or "trick the eye," gives the artist a varied set of stimuli by which to affect our sensory response. It is a form of illusionist painting that attempts to represent an object as existing in three dimensions at the surface of a painting (Example: Masaccio, *Holy Trinity with the Virgin, Saint John the Evangelist, and donors;* http://sunsite.auc.dk/cgfa/masaccio/p-masaccio1.htm).

JUXTAPOSITION

Simply put, juxtaposition places things side by side. Artists juxtapose colors, forms, and lines for specific effect. For example, dissimilar forms and curved

Figure 27 Broken line.

Figure 28 Juxtaposition.

and straight lines can cause a sense of dissonance or consonance. Figure 28, above illustrates juxtaposing of inharmonious forms to create instability and uncertainty.

THREE-DIMENSIONAL ART: SCULPTURE

Sculpture may take the form of whatever it seeks to represent, from pure nonobjective form to lifelike depiction. Sculptors make many choices, and we will focus on the most important below: dimensionality, methods of execution, and composition.

Dimensionality

Sculpture may be full round, relief, or linear. Full round works are free-standing and fully three-dimensional. A work that can be viewed from only one side—that is, one that projects from a background—is said to be in relief. A work utilizing narrow, elongated materials is called linear. A sculptor's choice among these options dictates to a large extent, both aesthetically and practically, what he or she can and cannot do.

FULL ROUND

Sculptural works that explore full three-dimensionality and intend viewing from any angle are called full round (Example: Rodin, *A Burgher of Calais;* http://nga.gov/cgi-bin/pinfo?Object=1009+0+none). However, some subjects and styles pose certain constraints in this area. Painters, printmakers, and photographers have virtually unlimited choice of subject matter and compositional arrangements. In contrast for instance, full round sculptures dealing with such relatively amorphous and large subjects as clouds, oceans, and panoramic landscapes pose problems for the sculptor. Because sculpture occupies real space, the use of perspective, for example, to increase spatial relationships raises obvious difficulties. In addition, because full round sculpture is freestanding and three-dimensional, sculptors must concern themselves with the practicalities of engineering and gravity. For example, they cannot create a work with great mass at the top unless they can find a way (within the bounds of acceptable composition) to keep the statue from falling over. In numerous full round works, sculptors use small animals, branches, tree stumps, rocks, and other devices as additional support to give stability to a work.

RELIEF

Sculptors who work in relief create three-dimensional pieces that need to be viewed from only one side; they protrude from a background. Their character, however, can range from nearly two-dimensional to nearly full-round. Relief sculptures that project only a small distance from their base are called *low relief.* Sculptures such as those from the Gothic style Chartres Cathedral noted momentarily, that project by at least half their depth, are termed *high relief.* The French terms *bas-relief,* for the former, and *haut-relief,* for the latter, are also used (Example: west front Chartres Cathedral; http://www.bluffton.edu/~sullivanm/chartreswest/nportal.html).

STYLE SPOT

Gothic: A style beginning in the mid-twelfth century emphasizing light, space, and in sculpture, serenity and idealism. See p. 126.

LINEAR

Linear sculpture emphasizes construction with thin, elongated items such as wire or neon tubing. Mobiles fall into this category (Example: Alexander

Calder, *Model for East Building Mobile:* http://www.nga.gov/cgi-bin/pinfo?Object=55433+0+none). Interestingly, artworks using linear materials and occupying three-dimensional space are sometimes puzzling in terms of whether they are really linear or full round. Here again, absolute definition is less important than the process of analysis and our own experience of, and response to, the artwork.

Methods of Execution

In general, we may say that sculpture uses subtractive, additive, substitution, or manipulative techniques, or any combination of these. A fifth category, called found sculpture, as we will see, may or may not be considered a method of execution. We will also briefly mention the subject of ephemeral and conceptual sculpture.

SUBTRACTION

Carved works are said to be subtractive. That is, the sculptor begins with a block, usually wood or stone, and cuts away (subtracts) the unwanted material. In previous eras, and to some extent today, sculptors have had to work with whatever materials were at hand. Wood carvings emerged from forested regions, soapstone carvings came from the Eskimos, and great works of marble came from the regions surrounding the quarries of the Mediterranean. Anything that can yield to the carver's tools can be formed into a work of sculpture. However, stone, with its promise of immortality, has proven to be the most popular material.

Three types of rock hold potential for the carver. Igneous rock, of which granite is an example, is very hard and potentially long lasting. However, it is difficult to carve and therefore not popular. Sedimentary rock such as limestone is relatively long lasting, easy to carve, and polishable. Beautifully smooth and lustrous surfaces are possible with sedimentary rock. Metamorphic rock, including marble, seems to be the sculptor's ideal. It is long lasting, a pleasure to carve, and exists in a broad range of colors (Example: *Venus of the Doves;* http://www.nga.gov/cgi-bin/pinfo?Object=41443+0+none).

Whatever the artist's choice, one requirement must be met: The material to be carved, whether wood, stone, or a bar of soap, must be free of flaws.

A sculptor who sets about to carve a work does not begin simply by imagining a finished work and then attacking the stone. He or she first creates a model, usually smaller than the intended sculpture. The model is made of clay, plaster, or some other material, and completed in precise detail—a miniature of the final product.

Once the likeness of the model has been enlarged and transferred, the artist begins to rough out the actual image ("knocking away the waste material," as Michelangelo put it). In this step of the sculpting process, the artist carves to within 2 or 3 inches of what is to be the finished area, using specific tools designed for the purpose. Then, using a different set of carving tools, she carefully takes the material down to the precise detail. Finishing work and polishing follow.

ADDITION

In contrast with carving from a large block of material, the sculptor using an additive process starts with raw material and adds element to element until the work is finished. The term "built sculpture" is often used to describe works executed in an additive technique. The materials employed in this process can be plastics, metals such as aluminum or steel, terracottas (clay), epoxy resins, or wood (Example: Tony Smith, *Spitball*; http://www.bluffton.edu/~sullivanm/baltimore/smith1.jpg). Many times, sculptors combine materials. They may combine construction methods as well. For example, built sections of metal or plastic may be combined with carved sections of stone.

SUBSTITUTION

Any material transformable from a plastic, molten, or fluid state into a solid state can be molded or cast into a work of sculpture. The creation of a piece of cast sculpture always involves the use of a mold. First, the artist creates an identically sized model of the intended sculpture (a positive). He or she then covers the positive with a material, such as plaster of paris, that when hardened and removed will retain the surface configuration of the positive. This form (a negative) becomes the mold for the actual sculpture. The molten or fluid material is poured into the negative and allowed to solidify. When the mold is removed, the work of sculpture emerges. Surface polishing, if desired, brings the work to its final form (Example: *A Burgher of Calais*; http://nga.gov/cgi-bin/pinfo?Object=1009+0+none).

Very often sculpture is cast so it is hollow. This method, of course, is less expensive because it requires less material. It also results in a work less prone to crack, since it is less susceptible to expansion and contraction resulting from changes in temperature. Finally, hollow sculpture is, naturally, lighter and thus more easily shipped and handled.

MANIPULATION

In this technique, materials such as clay are shaped by skilled use of the hands. A term of similar meaning is modeling. The difference between this technique and addition is clear when an artist takes a single lump of clay and skillfully transform it, as it turns on a potter's wheel, into a final shape.

FOUND

This category of sculpture is exactly what its name implies. Often natural objects, whether shaped by human hands or otherwise, are discovered that for some reason have taken on characteristics which stimulate aesthetic responses. They become art objects not because an artist put them together (although an artist may combine found objects to create a work), but because an artist chose to take them from their original surroundings and hold them up as vehicles for aesthetic communication. In other words, an artist decided that such an object said something beautifully and chose to present it in that vein.

Some have concern about such a category, however, because it removes *techne*, or skill, from the artistic process. As a result, objects such as driftwood and interesting rocks can assume perhaps an unwarranted place as art products or objects. This is a sensitive topic for many. However, a useful way to look at this issue is, if a found object were altered in some way to produce an artwork, then the process might fall under one of the previously noted methods, and the product might be termed an artwork in the fullest sense of the word.

EPHEMERAL AND CONCEPTUAL SCULPTURE

Ephemeral, or temporary, art has many different expressions and includes the school of artists called conceptualists, who insist art is an activity of change, disorientation, and violent lack of cohesion. Designed to be transitory, ephemeral art makes its statement and then, eventually, ceases to exist.

Composition

Composition in sculpture comprises most of the same elements and principles as composition in the pictorial arts: mass, line, form, balance, repetition, color, proportion, and unity. Sculptors' uses of these elements are significantly different, however, because they work in three dimensions.

ELEMENTS

KEY TERM

MASS (SPACE) Unlike a picture, a sculpture has literal mass. It takes up three-dimensional space, and its materials have density. In contrast, mass in pictures is relative mass: The mass of forms in a picture has application principally in relation to other forms within the same picture. In sculpture, however, mass is literal and consists of actual volume and density. Thus, the mass of a sculpture that is 20 feet high, 8 feet wide, and 6 feet deep and made of balsa wood would seem less than a sculpture 10 feet high, 4 feet wide, and 3 feet deep and made of lead. In essence, space and density must both be considered. Because sculpture has mass—that is, takes up space and has density—our senses respond to the weight and/or scale of a work. Considering the fact that sculpture can vary from a few inches to hundreds of feet in height, it holds an almost incalculable potential for impact on our senses and sensibility.

Artists sometimes disguise the material from which their work is made. For instance, marble polished to appear like skin or wood polished to look like fabric can change the appearance of the mass of a sculpture and significantly affect its effect on a viewer. In fact, disguising material may have a number of purposes. For example, the detailing of the sculpture might reflect a formal concern for design or, perhaps, a concern for verisimilitude. When sculpture deemphasizes lifelikeness in order to draw attention to the substance from which it is made, it is called **glyptic**. Glyptic sculpture emphasizes the material from which the work is created and usually retains the fundamental geometric qualities of that material.

Line and Form. As noted with regard to pictures, line and form are highly related. In two dimensions an artist uses line to define form. Thus, in painting, line is a construction tool. Without line, painters cannot reveal their forms. In sculpture, however, the case is nearly reversed. It is the form that draws attention, and discussion of line in sculpture must be done in terms of how it is revealed in form.

Sculptural elements direct the eye from one point to another, just as in pictures. In some works they direct the eye through the piece and then off into space. Such sculptures have an *open form*. If, on the other hand, they direct the eye continually back into the form, the form is *closed*. This is similar to composition kept within the frame in painting and to closed forms in music (which will be discussed in the next section). Often a work does not fit precisely into one or the other of these categories.

Obviously, not all sculptures are completely solid; they may have openings. Holes in a sculpture are called *negative space* and can be analyzed in terms of their role in the overall composition. In some works negative space is inconsequential; in others it is quite significant. Analysis of the work determines how negative space contributes to the overall piece and its effects.

A QUESTION TO ASK

In this work, how has the sculptor utilized negative space, and how does that usage contribute to the overall emotion and composition of the piece?

Color. Perhaps color does not seem particularly important in relation to sculpture. Nevertheless, color is as important to the sculptor as it is to the painter. In some cases the material itself stands out because of its color; in others, the sculpture may be painted. Still other materials may be chosen or treated so that nature will provide the final color through oxidation or weathering.

Color in sculpture creates its effects by utilizing the same universal symbols as it does in paintings, photographs, and prints. Reds, oranges, and yellows stimulate sensations of warmth; blues and greens, sensations of coolness. In sculpture, color can result from the conscious choice of the artist, either in the selection of material or in the selection of pigment with which the material is painted. Or, as indicated earlier, color may result from the artist's choice to let nature color the work through wind, water, sun, and so forth.

Weathering, of course, can create interesting patterns in sculpture. Yet, just as or even more importantly, weathering gives sculpture the quality not only of space but also of time, because the work changes as nature works on it. For instance, a copper sculpture, early in its existence, will be a different work, a different set of stimuli, than in five, ten, or twenty years. Artists cannot, perhaps, predict the exact nature of the weathering or the exact hues of the sculpture at any given time in the future, but response to a work of sculpture may, in fact, be shaped by the effects of age. For example, in many

individuals' minds ancient objects seem to possess considerable charm and character.

Texture. Texture, the roughness or smoothness of a surface, is a tangible characteristic of sculpture. Sculpture is unique in that its texture can be perceived through physical touching. However, even when sculpture cannot be touched, its textural effects can be perceived and responded to in both physical and psychological ways. Sculptors go to great lengths to achieve the texture they desire in their works. In fact, much of a sculptor's technical mastery manifests itself in the ability to impart a surface to the work.

Principles

Proportion. Proportion describes the relationship of shapes to one another, and ideals of proportion—or the ideals of relationships—has varied from one civilization or culture to another. For example, the human body, which would seem to have obvious proportions, has changed greatly in its depiction over the centuries. In fact, many sculptors have used this artistic device (proportion) to present nontraditional or unusual proportional relationship as an effective way to communicate meaning to the viewer.

Repetition. Rhythm, harmony, and variation constitute repetition in sculpture, as they do in the pictorial arts. In sculpture, however, these elements tend to appear subtly. Reducing a sculpture to its components of line and form begins to reveal how, as in music, rhythmic patterns—regular and irregular—occur. Consonance or dissonance in relationships also can be determined. Finally, analysis of sculpture should note how line and form are used in theme and variation.

Other Factors

KEY TERM

ARTICULATION When viewing sculpture, we need to note the manner by which the work carries the eye from one element to the next. That manner of movement is called *articulation*, and it applies to sculpture, painting, photography, and all the other arts. Considering human speech as a familiar example, sentences, phrases, and individual words constitute little more than sound syllables (vowels) *articulated* (that is, joined together) by consonants. Understanding what someone says results from how that individual articulates sounds. Putting the five vowel sounds side by side, Eh—Ee—Ah—Oh—Oo, does not create a sentence. But when those vowels are articulated with consonants, meaning occurs: "Say, she must go too." The nature of an artwork depends on how the artist has repeated, varied, harmonized, and related its parts and how he or she has articulated the movement from one part to another—that is, how the sculptor indicates where one stops and the other begins.

Focal Area (Emphasis)

Sculptors, like painters or any other visual artists, concern themselves with emphasizing those areas of their work central to its communication. They

also must provide means by which the eye can move around the work. Sculptors have little control over the direction from which the viewer will first perceive the piece: The entire 360-degree view contributes to the total message communicated by the work (unless the work is in relief).

Converging lines, encirclement, and color work for sculptors as they do for painters. The encircling line of a tree, for example, may help to focus the eye on a figure carved beneath it. Sculptors also have the option of placing moving objects in their works. Moving objects immediately become focal points. A mobile, for example, presents many ephemeral patterns of focus as it turns at the whim of the breezes.

Lighting and Environment

One final factor that significantly influences response to a sculpture, a factor not often considered (and which often is outside the control of the artist unless he or she personally supervises every exhibition in which the work is displayed) is that of lighting and environment. As in the realm of the theatre (Chapter 4), light plays a fundamental role in perception of, and thereby response to, three-dimensional objects. The direction and number of sources of light striking a three-dimensional work can change its entire composition. Whether the work stands outdoors or indoors, lighting affects the overall presentation of the work. For instance, diffuse room lighting allows perception of all aspects of a sculpture without external influence. However, if the work is set in a darkened room and illuminated from specific directions by spotlights, it becomes much more dramatic and affects response accordingly.

Where and how a work is exhibited also contributes to response. A sculpture can create a far different response if placed in a carefully designed environment that screens vision from distracting or competing visual stimuli than if exhibited among other works amid the bustle of a public park, for instance.

DECORATIVE ARTS

As noted earlier, "decorative arts" refer to art forms having a primarily decorative rather than expressive or emotional purpose, and includes virtually all areas of material culture not considered "fine arts."

People began to consider the decorative arts as a separate category of art at the beginning of the Industrial Revolution in the mid-nineteenth century. It quickly extended to such products as Josiah Wedgwood's stoneware (Example: http://www.sbtc.gov.bc.ca/culture/schoolnet/victoriana/objects/manufacturers/pmanu39.html) and the entire field of mechanically produced minor arts. A precise definition is somewhat elusive, and recently the words *decorative arts* have been increasingly applied to those objects that are of a relatively practical and useful nature and that exhibit a high degree of fine craftsmanship and artistic integrity.

In addition to Art Deco (see the "Major Styles" section), the most significant historical decorative arts movement came in the mid to late nineteenth century, known as the Arts and Crafts Movement, centered in Great Britain, and led by William Morris. Morris' decorating firm pro-

duced a full range of medieval-inspired objects, including cloth. Typical of his fabric designs is flattened motifs on organic subjects (Example: http://www.webmagick.co.uk/prcoll/paintings/morris/morris1.jpg). The overall purpose of the Arts and Crafts Movement was to provide relief from the urban experience of that time.

Examples of decorative arts appear in many museums of fine arts around the world, as well as in museums specifically dedicated to this area.

MODEL ANALYSIS

Pictures

You can analyze a painting, print, or photograph by using the following outline as a guide and answering the questions.

- *Medium.* What medium has the artist used? What particular qualities does use of the medium impart to the work?
- *Line.* How has the artist employed the various qualities of line? Are there implied lines and outlining as well as color edges? What is the effect of line on the work's dynamics?
- *Form.* What forms appear in the work? Are they objective or nonobjective? How does the artist's use of form contribute to what the work means?
- *Color.* How do hue, value, and contrast contribute to the overall palette employed in the work?
- *Repetition.* How do rhythm, harmony, and variation appear in the work?
- *Balance.* What kind of balance has the artist used, and how has the artist effected balance with line, form, and color?
- *Focal area.* What parts of the work draw your attention, and how is your eye drawn from one part of the work to another?
- *Deep space.* In what ways has the artist attempted to create a sense of depth in the work, if at all? How do the factors of linear and aerial perspective contribute to the work's sense of space?
- *Reaction.* How do the previous elements combine to create a reaction in you? In other words, what draws your attention? What is your emotional response to the work, and what do you think causes your response?

Sculpture

You can analyze a work of sculpture by using the following outline as a guide and answering the questions.

- *Dimensionality.* What is the dimensionality of the work? How does dimensionality contribute to the work's overall design and effect?
- *Method of execution.* What method of execution has the artist employed? How does the material used by the artist in this work relate to the method of execution the artist has chosen?

■ *Mass*. In what ways does the mass of the work contribute to its overall appearance and appeal?

■ *Line and form*. How has the artist utilized line and form? How do the line and form of the work contribute to the overall composition and appeal of the work?

■ *Texture*. In what ways does the texture of the work create an intellectual or emotional appeal to the viewer?

■ *Repetition*. How do rhythm, harmony, and variety contribute to the overall composition of this work?

■ *Articulation*. How has the artist articulated the various parts of the work to create eye movement from one element to another?

■ *Focal area*. What elements has the artist utilized to create areas of interest?

■ *Reaction*. How do the previous elements combine to create a reaction in you? In other words, what draws your attention? What is your emotional response to the work, and what do you think causes that response?

FURTHER READING

Acton, Mary. *Learning to Look at Paintings*. London: Routeledge, 1997.

Arnheim, Rudolph. *Art and Visual Perception: A Psychology of the Creative Eye*. Berkeley: University of California Press, 1989.

Canaday, John. *What Is Art?* New York: Alfred A. Knopf, 1990.

Davis, Phil. *Photography*. Dubuque, IA: William C. Brown, 1996.

Finn, David. *How to Look at Sculpture*. New York: Harry N. Abrams, 1989.

Vacche, Angela Dalle. *Cinema and Painting: How Art Is Used in Film*. Austin, TX: University of Texas Press, 1996.

Yenawine, Philip. *How to Look at Modern Art*. New York: Harry N. Abrams, 1991.

In the Theatre

THE THEATRICAL EXPERIENCE

Of all the arts, theatre comes the closest to personalizing the love, rejection, disappointment, betrayal, joy, elation, and suffering experienced in daily life. It does so because theatre uses live people acting out situations that very often look and sound like real life. Theatre once functioned like television and movies do today. Many of the qualities of all three forms are identical. In the discussion that follows, we will find out how the theatre, which frequently relies on drama (a written script), takes lifelike circumstances and compresses them into organized episodes. The result, although very much like reality, goes far beyond this realm in order to draw the audience and the actors deeply into the dramatic characters and scenarios depicted.

The word *theatre* comes from the Greek *theatron*—the part of the Greek theatre where the audience sat. Its literal meaning is "a place for seeing," but for the Greeks this implied more than the sense experience of vision (which, indeed, is an important part of the theatrical production). To the ancient Greeks, "to see" might include comprehension and understanding. Thus, witnessing—seeing and hearing—a theatrical production was felt with the emotions and mediated by the intelligence of the mind, leading to an understanding of the importance of the play. Further, for the ancient Greek, *theatron*, while a physical part of the theatre building, implied a nonphysical place—a special state of being of those who together watched the lives of the persons of the drama.

Like the other performing arts, theatre is an interpretive discipline. Between the playwright and the audience stand the director, the designers, and the actors. Although each functions as an individual artist, each also serves to communicate the playwright's vision to the audience. Sometimes the play becomes subordinate to the expressive work of its interpreters, and sometimes the concept of the director as master artist places the playwright

in a subordinate position. Nonetheless, a theatrical production always requires the interpretation of a concept through spectacle and sound.

Theatre represents an attempt to reveal a vision of human life through time, sound, and space. It provides flesh-and-blood human beings involved in human action—occasionally requiring a reminder that the dramatic experience is not reality: It is an imitation of reality, acting as a *symbol* to communicate something about the human condition. Theatre is make-believe: Through gesture and movement, language, character, thought, and spectacle, it imitates human actions.

GENRES

At a formal level, theatre comprises **genre**—or type of play—from which a production evolves. Some of the genres of theatre are tragedy, comedy, tragicomedy, melodrama and performance art. Other genres are products of specific periods of history and illustrate trends that no longer exist; others are still developing and as yet lack definite form. Response to theatre genre differs from formal response or identification in music, for example, because generic information rarely appears in the theatre program, in contrast to music programs which routinely list generic information such as "symphony" or "sonata." Some plays are well-known examples of a specific genre—for example, the tragedy *Oedipus the King* by Sophocles. In such a case, as with a symphony, part of the experience lies in seeing how the performance develops the conventions of the genre. Other plays, however, are not well known or may be open to interpretation. As a result, conclusions can be drawn only after the performance has finished.

KEY TERM **TRAGEDY** Tragedy is commonly described as a play with an unhappy ending. Aristotle (384–322 B.C.E.) treats this subject in detail in *The Poetics*. Contemporary playwright Arthur Miller describes tragedy as "the consequences of a man's total compulsion to evaluate himself justly, his destruction in the attempt posits a wrong or an evil in his environment." In the centuries since its inception, tragedy has undergone many variations as a means by which the playwright makes a statement about human frailty and failing.

Typically, tragic heroes make free choices that bring about suffering, defeat, and sometimes, triumph as a result of defeat. The hero often undergoes a struggle that ends disastrously. In Greek classical tragedy of the fifth century BCE, the hero generally was a larger-than-life figure who gained a moral victory amid physical defeat. The classical hero usually suffers from a tragic flaw—some defect that causes the hero to participate in his or her own downfall. In the typical structure of classical tragedies, the climax of the play occurs as the hero or heroine recognizes his or her role, and accepts destiny (Example: *Oedipus the King*; http://www.ibiblio.org/gutenberg/etext92/oedip10.txt). In the centuries from ancient Greece to the present, however, writers of tragedy have employed many different approaches within this genre. For example, twentieth-century playwright Arthur Miller argues the case for tragic heroes of

"common stuff," suggesting tragedy is a condition of life in which human personality flowers and realizes itself.

Comedy

The word comedy comes from the Greek *komoidia* (koh-mee-DEE-ah), which is a derivative of the Greek word for a singer in a revel, from *kômos* (KOH-mohs), meaning "a band of revelers." Comedy deals with light or amusing subjects or with serious and profound subjects in a light, familiar, or satirical manner. As a consequence it is more complex than tragedy and more complicated to define precisely. The genre dates to the fifth century BCE, when it was associated with the revelry linked to worship of the god Dionysius (dy-uh-NY-suhs). The ancient Greek comedies of Aristophanes (air-ih-STAH-fuh-neez) were mostly satires of public officials. By Roman times, comedy shifted its focus to ordinary citizens portrayed as stock characters. The plots were usually formularized. For the most part disappearing until the Middle Ages, comedy reappeared as simply a story with a happy ending. In more recent times, the genre has taken divergent paths, depending on the attitude of its authors toward their subject matter. As a result, we find, for example, satirical comedy, in which the author intends to ridicule. When the ridicule focuses on individuals, the result is *comedy of character*. When the satire is on social conventions, *comedy of manners* results (Example: Oliver Goldsmith, *She Stoops to Conquer*; http://www.bartleby.com/18/3/). Satire of conventional thinking produces *comedy of ideas*, into which category Molière's *Tartuffe* might fall. A few more types include: *romantic comedy* (the progress from troubles to triumphs in love) and *comedy of intrigue* (amusement and excitement through an intricate plot of reversals with artificial, contrived situations—for example, the Spanish comedies of Lope de Vega [vay gah] and Tirso de Molina [moh-LEE-nah]). *Sentimental comedy* entails exploitation of potentially serious issues without approaching the truly tragic aspects of the subject or examining its underlying significance.

Tragicomedy

As the name suggests, tragicomedy is a mixed form of theatre defined, like the other types, differently in different periods. Until the nineteenth century, the ending of the work determined the necessary criterion for this form. Traditionally, characters reflect diverse social standings—kings (like tragedy) and common folk (like comedy), and reversals went from bad to good and good to bad. It also included language appropriate to both tragedy and comedy. Tragicomedies were serious plays that ended, if not happily, then at least by avoiding catastrophe. In the past century and a half, the term has been used to describe plays in which the mood may shift from light to heavy, or plays in which endings are not exclusively tragic or comic.

Melodrama

Melodrama is another mixed form. It takes its name from the terms *melo*, Greek for music, and "drama." Melodrama first appeared in the late eigh-

teenth century, when dialogue took place against a musical background. In the nineteenth century, it was used to describe serious plays without music. Melodrama uses stereotypical characters involved in serious situations in which suspense, pathos, terror, and occasionally hate are all aroused. Melodrama portrays the forces of good and evil battling in exaggerated circumstances. As a rule, the issues involved are either black or white—they are simplified and uncomplicated: Good is good and evil is evil; there are no ambiguities.

Geared largely for a popular audience, the form concerns itself primarily with situation and plot. Conventional in its morality, melodrama tends toward optimism—good always triumphs in the end. Typically, the hero or heroine is placed in life-threatening situations by the acts of an evil villain, and then rescued at the last instant. The forces against which the characters struggle are external ones—caused by an unfriendly world rather than by inner conflicts. Probably because melodrama took root in the nineteenth century, at a time when scenic spectacularism was in vogue, many melodramas depend on sensation scenes for much of their effect. This penchant can be seen in the popular nineteenth-century adaptation of Harriet Beecher Stowe's novel *Uncle Tom's Cabin*, as Eliza and the baby, Little Eva, escape from the plantation and are pursued across a raging ice-filled river (http://www.bibliomania.com/0/0/48/91/frameset.html). These effects taxed the technical capacities of contemporary theatres to their maximum, but gave the audience what it desired—spectacle. Not all melodramas use such extreme scenic devices, but such use was so frequent that it has become identified with the type. If motion pictures and television are included as dramatic structures, then it can be strongly argued that melodrama is the most popular dramatic form of the twentieth century.

> **STYLE SPOT**
>
> **Post-Modern:** A late 20th-century collection of eclectic and anachronistic approaches that may reflect and comment on a wide range of stylistic expressions and cultural—historical viewpoints. See p. 140.

Performance Art

The late twentieth century produced a form of theatrical presentation called *performance art*. Performance art pushes the traditional theatre envelope in a variety of directions, some of which deny the traditional concepts of theatrical production itself. It is a type of performance that combines elements from fields in the humanities and arts, from urban anthropology to folklore, and dance to feminism. Performance art pieces called "Happenings" grew out of the pop-art movement of the 1960s (see the "Major Styles" section) and were designed as critiques of consumer culture. European performance artists were influenced by the early twentieth-century movement of Dadaism (see the "Major Styles" section) and tended to be more political than their

American counterparts. The central focus of many of the "Happenings" was the idea that art and life should be connected (a central concept in postmodernism in general).

Because of its hybrid and diverse nature, there is no "typical" performance artist or work to study as an illustration. However, three brief examples, which, if they do not typify, at least illuminate this movement. The Hittite Empire, an all-male performance art group performs *The Undersiege Stories*, which focuses on nonverbal communication and dance and includes confrontational scenarios. Performance artist Kathy Rose blends dance and film animation in unique ways. In one performance in New York, she creatively combined exotic dances with a wide variety of styles that included German Expressionism (see the "Major Styles" section) and science fiction. *The New York Times* called her performance "visual astonishments." Playwright Rezo Abdoh's *Quotations from a Ruined City*, an intense and kinetic piece, features ten actors who act out outrage in fascinating, energetic fashion. The complicated, overlapping scenes, tableaux, and dances are punctuated by loud but unintelligible prerecorded voices. The piece combines elements depicting brutality, sadism, and sexuality. In the 1990s, performance art witnessed some difficult times because many people viewed it as rebellious and controversial for its own sake.

THE PRODUCTION

Theatre consists of a complex combination of elements that form a single entity called a performance, or a production. Understanding the theatre production as a work of art can be enhanced with a few tools that come from the distant past.

Writing 2,500 years ago in the *Poetics*, Aristotle argued that tragedy consisted of plot, character, diction, music, thought, and spectacle. Aristotle's terminology is still helpful in describing the basic parts of a production, inasmuch as these Aristotelian parts—and their descriptive terminology—still cover the entire theatrical product of all genres.

In the paragraphs that follow, we reshape Aristotle's terms into more familiar language, explain what the terms mean, and learn how to use them to discover how a theatrical production works—things to look and listen for in a production. We examine first the script, and include in that discussion Aristotle's concept of diction, or language. Next we examine plot, character themes and ideas, and spectacle, which we call the visual elements. That is followed by a brief discussion of what Aristotle called music but which, to avoid confusion, we call aural elements.

The Script

A playwright creates a written document called a script, which contains the dialogue used by the actors. Aristotle called the words written by the playwright *diction*; however, we refer to this part of a production as its language. The playwright's language indicates at least part of what to expect from a

play. For example, everyday speech suggests that the action resembles every-day truth, or reality. In contrast, poetic language usually indicates less realism and perhaps stronger symbolism.

Language helps determine the implication of the words and helps reveal the overall tone and style of the play. It also can reveal character, theme, and historical context.

PLOT Plot is the structure of the play, the skeleton that gives the play shape, and on which the other elements hang. The nature of the plot determines how a play works; how it moves from one moment to another, how conflicts are structured, and how, ultimately, the experience comes to an end. In examining the workings of plot it helps to see the play somewhat as a timeline, beginning as the script or production begins, and ending at the final curtain, or the end of the script. In many plays, plot tends to operate like a climactic pyramid (Figure 29). In order to hold the audience's attention, the dynamics of the play will rise in intensity until they reach the ultimate *crisis*—the *climax*—after which they will relax through a resolution, called the *denouement* (day-noo-mawn; French for "untangling"), to the end of the play.

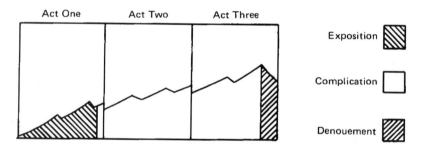

Figure 29 Hypothetical dynamic and structural development of a three-act play.

Depending on the playwright's purpose, plot may be shaped with or without some of the features described below. Sometimes plot may be so de-emphasized that it virtually disappears. However, in critical evaluation of a play, the elements of plot provide things to look for—if only to note that they do not exist in the play at hand.

EXPOSITION

Exposition provides necessary background information: Through it the playwright introduces the characters, their personalities, relationships, background, and their present situation. Exposition is frequently a recognizable section at the beginning of a play. It can be presented through dialogue, narration, setting, lighting, costume, and/or any device the playwright or director chooses. The amount of exposition in a play depends on where the playwright takes up the story, called the *point of attack*. A play told chronologically might need little expositional material; others require a good bit of prior summary.

COMPLICATION

Drama is about conflict. Although not every play fits that definition, in order to interest an audience, conflict of some sort is a fundamental dramatic device. At some point in the play, someone or something frustrates the expected course of events giving the audience a reason to be interested in what transpires. This action is sometimes called the inciting incident, and it opens the middle part of the plot—the *complication*. The complication is the meat of the play, and it comprises a series of conflicts and decisions—called crises (from the Greek word *krisis*, meaning to decide)—that rise in intensity until they reach a turning point—the climax—that constitutes the end of the complication section.

DENOUEMENT

The **denouement** is the final resolution of the plot. It is the period of time during which the audience is allowed to sense that the action is ending; a period of adjustment, downward in intensity, from the climax. Ideally, the denouement brings about a clear and ordered resolution.

Exposition, complication, and denouement comprise a time frame in which the remaining parts of the play operate. The neat structural picture of these elements may not, however, always be so neat. The fact that a play does not conform to this kind of plot structure does not make it a poorly constructed play or one of inferior quality. Nor does it mean that these concepts cannot be used as devices for describing and analyzing how a play is put together.

FORESHADOWING

Preparation for subsequent action—*foreshadowing*—helps to keep the audience clear about where they are at all times. Foreshadowing provides credibility for future action, keeps action logical, and avoids confusion. It builds tension and suspense: The audience is allowed to sense that something is about to happen, but because they do not know exactly what or when, anticipation builds suspense and tension. In the movie *Jaws*, a rhythmic musical theme foreshadows the presence of the shark. Just as the audience becomes comfortable with that device, the shark suddenly appears—without the music. As a result, uncertainty as to the next shark attack is heightened immensely. Foreshadowing also moves the play forward by pointing toward events that will occur later.

DISCOVERY

Discovery is the revelation of information about characters, their personalities, relationships, and feelings. For instance, Hamlet (http://www.bartleby.com/46/2/11.html) discovers from his father's ghost that his father was murdered by Claudius and is urged to revenge the killing, a discovery without which the play cannot proceed. The skill of the playwright in structuring the revelation of such information information determines, in large part, the overall impact of the play on the audience.

REVERSAL

Reversal is any turn of fortune; for example, Oedipus falls from power and prosperity to blindness and exile; Shakespeare's King Lear (http://www.ibiblio.org/gutenberg/etext98/2ws3310.txt) goes from ruler to disaster. In comedy, reversal often changes the roles of social classes, as peasants jump to the upper class, and vice versa.

? A QUESTION TO ASK

In this play, where are the crises—particularly the climax—and how do they shape the plot and your emotional response?

Character

Character is the psychological motivation of the persons in the play. In most plays, the audience will focus, as the plot unfolds, on why individuals do what they do, how they change, and how they interact with other individuals.

Plays reveal a wide variety of characters—both persons and motivating psychological forces. Every play consists of characters that fulfill major functions and on which the playwright wishes to focus. There also are minor characters—those whose actions may interact with the major characters, and whose actions constitute subordinate plot lines. Much of the interest created by drama lies in the exploration of how persons with specific character motivations react to circumstances. Such responses, driven by character, are the choices that drive plays forward.

The Protagonist

Inside the structural pattern of a play some kind of action must take place. A vital question in understanding a play is: How does it get from the beginning to the end? Most of the time, that journey occurs via the actions and decisions of the *protagonist*, or central personage. Deciding the protagonist of a play is not always easy, even for directors. However, understanding the play requires that the audience can identify the central character. If a production proves unclear about whose play it is, the fault may lie in the director's inability either to answer that question himself or to transmit that information through the performance to the audience.

Often in drama a character appears in order to accentuate or contrast qualities in another character, particularly the protagonist. Such a contrasting character is called a *foil*. One of the best and best-known examples is Dr. Watson in Sir Arthur Conan Doyle's Sherlock Holmes stories. Here Dr. Watson's obtuseness makes Holmes's deductions appear all the more brilliant.

Themes

Themes and ideas comprise the intellectual content of a play. Aristotle used the term "thought."

The process of coming to conclusions about meaning involves several layers of interpretation. One involves the playwright's interpretation of the ideas through the characters, language, and plot. A second layer of interpretation lies in the director's decisions about what the playwright has in mind, which will be balanced by what the director wishes to communicate, because/or in spite of the playwright. Finally and importantly, audience members must interpret what they actually see and hear in the production, along with what they might perceive independently from the script.

Visual Elements

The director takes the playwright's language, plot, and characters and translates them into action by using, among other things, what Aristotle called spectacle, or what the French call *mise-en-scène* (meez-ahn-schn), or simply, the visual elements. The visual elements of a production include, first of all, the physical relationship between actors and audience. The actor/audience relationship can take any number of shapes. For example, the audience might sit surrounding or perhaps on only one side of the stage. The visual elements also include stage settings, lighting, costumes, and properties, as well as the actors and their movements. Whatever the audience can see contributes to this part of the theatrical production.

THEATRE TYPES

Some of the audience response to a production is shaped by the design of the space in which the play is produced. The earliest and most natural arrangement is the theatre-in-the-round, or *arena* theatre (Figure 30, below), in which the audience surrounds the playing area on all sides. Whether the

Figure 30 Ground plan of an arena theatre.

Figure 31 Ground plan of a thrust theatre.

playing area is circular, square, or rectangular is irrelevant. Some argue that the closeness of the audience to the stage space in an arena theatre provides the most intimate kind of theatrical experience. A second possibility is the *thrust*, or three-quarter, theatre (Figure 31, above), in which the audience surrounds the playing area on three sides. The third actor/audience relationship, and the one most widely used in the twentieth century, is the proscenium theatre, in which the audience sits on only one side and views the action through a frame (Figure 32, below).

Figure 32 Ground plan of a proscenium theatre.

There are also experimental arrangements of audience and stage space. On some occasions acting areas are located in the middle of the audience, creating little island stages. In certain circumstances, these small stages create quite a challenging set of responses and relationships between actors and audience.

Common experience indicates that the physical relationship of the acting area to the audience has a causal effect on the depth of audience involvement. Experience has also indicated that some separation—called **aesthetic distance**—is necessary for certain kinds of emotional responses. Proper aesthetic distance allows people to become involved in what they know is fictitious and even unbelievable.

The visual elements may or may not have independent communication with the audience; this is one of the choices of the director and designers. Before the nineteenth century, there was no coordination of the various elements of a theatre production. However, for the past century, most theatre productions have adhered to what is called the *organic theory of play production*; that is, everything, visual and aural, is designed with a single purpose. Each production has a specific goal in terms of audience response, and all of the elements in the production attempt to achieve this.

SCENE DESIGN

Simply stated, the purpose of scene design in the theatre is to create an environment conducive to the production's ends. The scene designer uses the same tools of composition—line, form, mass, color, repetition, and unity—as the painter. In addition, because a stage design occupies three-dimensional space and must allow for the movement of the actors in, on, through, and around the elements of scenery, the scene designer becomes a sculptor as well.

Unlike the painter or sculptor, however, the scene designer is limited by several factors including the stage space, the concepts of the director, the amount of time and budget available for the execution of the design, and elements of practicality. For example, can the design withstand the wear and tear of the actors? The talents and abilities of the staff available to build and paint the design also limit the scene designer.

A scenic environment occurs wherever theatre takes place: Any physical surrounding for a production is a scenic design because someone makes an artistic choice in its selection. In the contemporary theatre, scene designers function as creative partners in determining the direction and appearance of a theatre production. Ultimately, scene design must have something of its own to say to the audience. Stage design is first and foremost a visual art, and the fundamental artistic tools of the scene designer are those of the visual artist we studied in Chapter 3: the elements and principles of composition such as line, form, and color.

LIGHTING DESIGN

Lighting designers are perhaps the most important of all the theatre artists in modern productions. Without their art, nothing done by the actors, costume designers, property master, director, or scene designer could be seen by

an audience. Yet lighting designers work in an ephemeral medium. They must sculpt with light and create shadows that fall where they desire them to fall; they must "paint" over the colors provided by the other designers. In doing so, they use lighting instruments with imperfect optical qualities. Lighting designers do their work in their minds, unlike scene designers, who can paint a design and then calculate in feet and inches. Lighting designers must imagine what their light will do to an actor, to a costume, to a set. They must enhance the color of a costume, accent the physique of an actor, and intensify the qualities of a setting. They must also try to reinforce the dramatic structure and dynamics of the play. Lighting designers work within the framework of light and shade. Without shadows and highlights, the human face and body become imperceptible: A face without shadows cannot be seen clearly more than a few feet away. In a theatre, such small movements as the raising of an eyebrow must be seen clearly as much as 100 feet away. The lighting designer makes this possible.

COSTUME DESIGN

The temptation exists to think of the costumes of the theatre merely as clothing that has to be researched to reflect a particular historical period and constructed to fit a particular actor. But costuming goes beyond that. Costume designers work with the entire body of the actor. They design hairstyles and clothing and, sometimes, makeup to suit a specific purpose or occasion, a character, a locale, and so forth.

The function of stage costuming is threefold. First, it *accents*—it shows the audience which characters are the most important in a scene, and it shows the relationship between characters. Second, it *reflects*—a particular era, time of day, climate, season, location, or occasion. Costume designers may merely suggest full detail or may actually provide it. Third, stage costuming *reveals*—the style of the performance, the characters of the individuals, and the individuals' social positions, professions, cleanliness, ages, physiques, and health. Costume designers work, as do scene and lighting designers, with the same general elements as painters and sculptors: the elements of composition. A stage costume is an actor's skin: It allows her to move as she must, and occasionally it restricts her from moving as she should not.

PROPERTIES

Properties fall into two general groups: *set props* and *hand props*. Set properties are part of the scenic design; this includes furniture, pictures, rugs, fireplace accessories, and so on. Along with the larger elements of the set, they identify the mood of the play and the character of those who inhabit the world they portray. Hand properties used by the actors in stage business also help to portray characters: cigarettes, papers, glasses, and so forth. The use of properties can be significant to the understanding of a play. For example, if at the opening curtain, all properties appear neat and in order, but as the play develops, the actors disrupt the properties so that the scene is in disarray at the end of the play, that simple transition might illustrate what happened in the play. As in all artworks, details make important statements.

Aural Elements

Sound also contributes to the understanding and enjoyment of a production. The aural elements, whether the actors' voices, the background music, or the clashing of swords, function importantly in a theatrical production. How a production sounds (as well as how it looks, feels, and reads) represents a series of conscious choices on the part of the artists involved: playwright, director, actors, and designers. Just as a music composer creates harmonies, dynamics, rhythms, and melodies, a stage director, working with actors and sound designer, develops a production in an aural sense to place the audience in the proper mood, draw it in the proper emotional direction, and capture it by specific attention points.

Dynamics

Every production has its own dynamic patterns (for example, see Figure 29, page 70). They make the structural patterns of a play clear and help to hold the interest of the audience. Scientific studies indicate that attention or interest functions intermittently; people are able to concentrate on specific items only for very brief periods. Therefore, holding audience attention over the two-hour span of a production requires devices that allow interest or attention to peak and then relax. However, the peaks must be carefully controlled. A production should build to a high point of dramatic interest—the climax. However, each scene or act has its own peak of development—again, to maintain interest. The rise from the beginning of the play to the high point of dramatic interest is not a steady rise, but a series of peaks and valleys. Each successive peak is closer to the ultimate one. The director controls where and how high these peaks occur by controlling the dynamics of the actors—volume and intensity, both bodily and vocal.

Actors

Although we cannot always determine easily which functions in a production are the playwright's, which the director's, and which the actor's, the main channel of communication between the playwright and the audience remains the actors. It is through their movements and speech that the audience perceives the play.

Attending to two elements in an actor's portrayal of a role can enhance understanding. The first is *speech*. *Language* should be understood as the playwright's words, and speech is the manner in which actors deliver those words. Speech, like language, can range from lifelikeness to exaggeration. If speech adheres to normal conversational rhythms, duration, and inflections, response goes one way. If speech utilizes extended vowel emphasis, long sliding inflections, and dramatic pauses, it goes in a different direction—even though the playwright's words are identical in both cases.

The second element of an actor's portrayal that aids understanding is the physical reinforcement given to the character's basic motivation. Most actors try to identify a single basic motivation for their character. That motivation is called a "spine," or "superobjective." Everything that pertains

to the decisions the person makes is kept consistent for the audience because those decisions and actions stem from this basic drive. Actors will translate that drive into something physical they can do throughout the play. For example, Blanche, in Tennessee Williams' *A Streetcar Named Desire* (http://www.gradesaver.com/ClassicNotes/Titles/menagerie/about.html) is driven by the desire to clean what she encounters because of the way she regards herself and the world around her. Ideally, the actress playing Blanche will discover that element of Blanche's personality as she reads the play and develops the role. To make that spine clear to the audience, the actress will translate it into physical action. Therefore, Blanche constantly smoothes her hair, rearranges and straightens her dress, cleans the furniture, brushes imaginary dust from others' shoulders, and so forth. Nearly every physical move she makes relates somehow to the act of cleaning. Of course, such movements will be subtle, but they exist and, if perceived by the audience, enhance understanding of the character and the play.

THEATRE AS SENSE STIMULANT

The theatre is unique in its ability to stimulate the senses, because only the theatre appeals directly to the emotions through the live portrayal of other individuals involved directly in human actions. Being in the presence of live actors provides more of life in two hours than can be experienced outside the theatre in that same time span. That phenomenon is difficult to equal. The term we use to describe reaction to, and involvement with, what we experience in a theatrical production is *empathy*. Empathy causes us to cry when individuals, whom we know are only actors, become involved in tragic or emotional situations. Empathy also makes people wince when an actor slaps the face of another actor. Empathy is mental and physical involvement in situations, in which we are not direct participants.

Below are a few more ways a production can appeal to the senses. First, in plays that deal in conventions, the language may act as virtually the entire sense stimulant. Through language the playwright sets the time, place, atmosphere, and even small details of decoration. Audience members become their own scene, lighting, and even costume designer, imagining what the playwright tells them ought to be there. The opening scene of Shakespeare's *Hamlet*, for example, reveals Bernardo and Francisco, two guards. The hour is midnight; it is bitter cold; a ghost appears, in "warlike form." In a modern production these things might be revealed through the work of the costume and set designers. But this need not be the case as shown with Shakespeare's work, which provides all this information in the dialogue. In reality, Shakespeare wrote for a theatre that had no lighting save for the sun. His theatre (such as we know of it—those visiting London will find the new reconstruction of Shakespeare's Globe Theatre fascinating) probably used no scenery. The costumes were the street clothes of the day. The theatrical environment was the same whether the company was playing *Hamlet*, *Richard III*, or *The Tempest*. So what needed to be seen needed to be imagined by the audience.

Physical action also stimulates an audience's senses. A fight performed with flashing swords, swift movements, and great bodily intensity sets audience members on the edge of their chairs. Although they know the action is staged and the incident fictitious, they (audience members) catch the excitement of the moment. In addition, events of a quite different dynamic quality can grip and manipulate audiences. Many plays indulge in character assassination, as one life after another is laid bare. The intense but subtle movements of the actors—both bodily and vocal—can pull the audience here and push it there emotionally, perhaps causing people to leave the theatre feeling emotionally and physically drained. Part of that effect is caused by subject matter, part by language—but much of it is the result of careful manipulation of dynamics.

Mood is another important factor in theatrical communication. Before the curtain goes up, stimuli designed to create a mood for what follows tickle the audience's senses. The houselights in the theatre might be very dim, or a cool or warm light might illumine the front curtain. Music fills the theatre; the raucous tones of a 1930s jazz piece or a melancholy ballad. Whatever the stimuli, they are all carefully designed to cause specific reactions. Once the curtain rises, the assault on senses continues. The scene, lighting, and costume designers' palettes help communicate the play's mood as well as other messages. The rhythm and variation in the visual elements capture interest and reinforce the rhythmic structure of the play.

The degree of plasticity, or three-dimensionality, created by the illumination of the actors and the set shapes audience reactions. If, for example, the lighting designer places the primary lighting instruments directly in front of the stage, plasticity diminishes and the actors appear washed out or two-dimensional. That creates a different audience response from maximum plasticity from lighting coming from the side.

The *mass* of a setting makes a statement about the play and its characters. Scenery that towers over the actors and appears massive in weight differs in effect from scenery that seems miniscule in scale relative to the human form. Perhaps in no other art are such devices so available and full of potential for the artist.

MODEL ANALYSIS

You can analyze a production by using the following outline as a guide and answering the questions.

- *Genre.* What genre was the play? How did it exhibit the characteristics of tragedy, comedy, melodrama, and so on?
- *Plot.* How did the plot work? Where in the play did the exposition occur? Where was the climax? Where were the crises? What instances of foreshadowing, discovery, and reversal were present? Was the plot a significant part of the play or not? Why?
- *Protagonist.* Who was the protagonist? How did his or her actions and decisions move the plot? Was the protagonist active or passive?

■ *Character.* How did the playwright draw the characters? Were they three-dimensional? If so, did you find any of them identifiable with your own life and feelings?

■ *Thought.* What themes did the play pursue? In what ways did the playwright or the production make you aware of the point of view being presented?

■ *Theatre form.* In what theatre form was the play produced? What effect on your response to the play did the form create? Would you have had a different response if the production had utilized a different physical arrangement—for example, thrust, arena, or proscenium?

■ *Visual elements.* In what ways did the settings, costumes, and lighting reinforce the message and style of the play? How did the visual elements provide historical or structural information to the audience?

■ *Language.* How did the playwright's language and the actors' speech create meaning for you?

■ *Reaction.* How did the previous elements combine to create a reaction in you? In other words, what drew your attention? What is your emotional response to the production, and what caused that reaction?

FURTHER READING

Brockett, Oscar G. *The Essential Theatre* (5th ed.). New York: Holt Rinehart & Winston, 1992.

Cameron, Kenneth M., Patti P. Gillespie, and Kenneth M. Camerson. *The Enjoyment of the Theatre* (4th ed.). Boston, MA: Allyn & Bacon, 1996.

Dean, Alexander, and Lawrence Carra. *Fundamentals of Play Directing.* New York: Holt, Rinehart & Winston, 1990.

Hartnoll, Phyllis, and Peter Found (Eds.). *The Concise Oxford Companion to the Theatre* (2nd ed.). New York: Oxford University Press, 1992.

Sporre, Dennis J. *The Art of Theatre.* Englewood Cliffs, NJ: Prentice Hall, 1993.

Sporre, Dennis J. and Robert C. Burroughs. *Scene Design in the Theatre.* Englewood Cliffs, NJ: Prentice Hall, 1990.

At the Concert Hall— Music and Opera

Everyone has favorite forms of music, such as tejano, reggae, rock, rhythm and blues, rap, gospel, or classical. Occasionally a favorite tune or musical form had an earlier life: A rock tune was first an operatic aria; an ethnic style comprises styles from other ethnic traditions. Whatever the case, music is music. It consists of rhythms and melodies that differ only in the ways they are put together.

Music often has been described as the purest of the art forms because it is free from the physical restrictions of space that apply to the other arts. However, the freedom enjoyed by the composer becomes a constraint for listeners because, arguably, music requires more active and constant attention than any other art, for the simple reason that music's characteristics must be captured in a fleeting moment. Paintings or sculptures stand still; they do not change or disappear, despite the length of time it takes to find or apply some new characteristic. Such is not the case with music. Like any skill, the ability to hear perceptively is enhanced by repetition and training.

THE BASIC LANGUAGE OF MUSIC

Understanding vocabulary and identifying its application in a musical work is critical to comprehending musical communication. As in all communication, meaning depends on each of the parties involved; communicators and respondents must assume responsibility for facility in the language utilized.

The seven basic elements of the musical language are: (1) sound, (2) rhythm, (3) melody, (4) harmony, (5) tonality or key, (6) texture, and (7) form. We discuss them next.

Sound

Music designs sound and silence. In the broadest sense, sound is anything that excites the auditory nerve: sirens, speech, crying babies, jet engines,

falling trees, and so on—noise, perhaps. Musical composition, although it can even employ "noise," usually depends on controlled and shaped sound, consistent in quality. We distinguished music from other sounds by four basic properties: pitch, dynamics, tone color, and duration.

PITCH

Pitch is a physical phenomenon measurable in vibrations per second. So when we describe differences in pitch we describe recognizable and measurable differences in sound waves. A pitch has a steady, constant frequency. A faster frequency produces a higher pitch; a slower frequency, a lower pitch. If a sounding body—a vibrating string, for example—is shortened, it vibrates more rapidly. Musical instruments designed to produce high pitches, such as the piccolo, therefore tend to be small. Instruments designed to produce low pitches tend to be large—for instance, bass viols and tubas. In music, a sound that has a definite pitch is called a tone.

Earlier, in discussing pictures, we discussed color. Color comprises a range of light waves within a visible spectrum. Sound also comprises a spectrum, one whose audible pitches range from 16 to 38,000 vibrations per second. We can perceive 11,000 different pitches! Obviously, that exceeds practicality for musical composition. Therefore, by convention, musicians divide the sound spectrum into roughly 90 equally spaced frequencies comprising seven and a half octaves. The piano keyboard, consisting of eighty-eight keys (seven octaves plus two additional tones) representing the same number of equally spaced pitches, serves as an illustration. Each octave consists of tones labeled A, B, C, D, E, F, and G. Thus, on the piano keyboard there appear seven As, seven Bs, seven Cs, and so on. The distance in frequency from any of these tones to its next higher octave is exactly double. The seven basic tones of an **octave** (A–G) are further divided so that an octave actually consists of thirteen equally spaced pitches called a **chromatic scale.** This is nothing more than a conventional arrangement or organization of the frequencies of the sound spectrum. Not all music conforms to these conventions. European music prior to approximately 1600 does not, nor does Eastern music, which makes use of quarter tones. Even some contemporary Western music departs from these conventions. Listen to tracks 1–3 on the music CD. These examples are from cultures whose music does not conform to the Western conventions of pitch and scale, or tonality.

DYNAMICS

Degrees of loudness or softness in music are called dynamics. Any tone can be loud, soft, or anywhere in between. Dynamics describes the decibel level of tones, and depends on the physical phenomenon of amplitude of vibration. Greater force employed in the production of a tone results in wider sound waves and causes greater stimulation of the auditory nerves. The size of the sound wave, not its number of vibrations per second, changes. Composers indicate dynamic level with a series of specific notations:

SYMBOL	TERM	DEFINITION
pp	pianissimo	very soft
p	piano	soft
mp	mezzo piano	moderately soft
mf	mezzo forte	moderately loud
f	forte	loud
ff	fortissimo	very loud

The notations of dynamics that apply to an individual tone, such as *p, mp,* and *f,* also may apply to a section of music. Changes in dynamics may be abrupt, gradual, wide, or small. The terms crescendo (becoming louder), decrescendo (becoming softer), and sforzando ("with force"; a strong accent immediately followed by *p*—piano).

As we listen to and compare musical compositions, we can consider the breadth of dynamics in the same sense that we consider the breadth of palette in painting.

TONE COLOR

Tone color, or timbre (pronounced TAM-ber), is the characteristic of tone that allows us to distinguish a pitch played on a violin, for example, from the same pitch played on a piano. In addition to identifying characteristic differences among sound-producing sources, tone color characterizes differences in quality of tones produced by the same source. Here the analogy of tone color is particularly appropriate. A tone that is produced with an excess of air—for example by the human voice—is described as "white." The following table lists some of the various sources that produce musical tone and account for its variety of timbres:

SOURCE	EXAMPLES
Voice	Male: Tenor, Baritone, Bass
	Female: Soprano, Mezzo-Soprano, Contralto
Instrument	
Electronic	Synthesizer
Strings	Violin, Cello, Viola, Bass, Harp, Piano
Woodwinds	Flute, Piccolo, Oboe, Clarinet, Bassoon
Brasses	Trumpet, Horn, Trombone, Tuba
Percussion	Snare Drum, Timpani, Triangle, Cymbal, Piano, Harpsichord

The piano can be considered either a stringed or a percussion instrument because it produces sound by vibrating strings struck by hammers. The harpsichord's strings are set in motion by plucking.

Electronically produced music, available since development of the RCA synthesizer at the Columbia-Princeton Electronics Music Center in 1951, has become a standard source in assisting contemporary composers.

Originally electronic music fell into two categories: (1) the electronic alter-ing of acoustically produced sounds, which came to be labeled as **musique concrète** and (2) electronically generated sounds. However, advances in technology have blurred those differences over the years.

DURATION

Another characteristic of sound is duration, which is the length of time vibra-tion continues without interruption. Duration in musical composition is designed within a set of conventions called musical notation. This system consists of a series of symbols (notes) by which the composer indicates the relative duration of each tone. Musical notation also includes a series of sym-bols that denote the duration of silences in a composition. These symbols are called rests and have the same durational values as the symbols for duration of tone.

KEY TERM

RHYTHM Rhythm comprises recurring pulses and accents that create identifiable patterns. Without rhythm we have only an aimless rising and falling of tones. Earlier we noted that each tone and silence has duration. Composing music means plac-ing each tone into a time or rhythmical relationship with every other tone. As with the dots and dashes of the Morse code, we can "play" the rhythm of a musical composition without references to its tones. Each symbol (or note) of the musical notation system denotes a duration relative to every other symbol in the system. Rhythm consists of (1) beat, (2) meter, and (3) tempo.

BEAT

The individual pulses we hear are called beats. Beats may be grouped into rhythmic patterns by placing accents every few beats. Beats are basic units of time and form the background against which the composer places notes of various lengths (duration).

METER

Normal musical practice groups clusters of beats into repeating units called measures. When these groupings are regular and reasonably equal they comprise simple meters. When the number of beats in a measure equals three or two, it constitutes triple or duple meter. As listeners, we can distin-guish between duple and triple meters because of their different accent pat-terns. In triple meter we hear an accent every third beat—ONE two three, ONE two three—and in duple meter the accent is every other beat—ONE two, ONE two. If there are four beats in a measure, the second accent is weaker than the first—ONE two THREE four, ONE two THREE four. (Listen to CD track 15, Chopin's *Nocturne in E-Flat Major, Op. 9, No. 2*; http://www.prs.net/chopin.html; select "Nocturne in E-Flat Major, Op. 9, No. 2".) When accent occurs on normally unaccented beats, we have *syncop-ation*, as occurs in Duke Ellington's "It Don't Mean a Thing" (CD track 23) or Scott Joplin's "The Entertainer" (http://www.classicalarchives.com/midi-f-m.html#j); select "Joplin, Scott, *The Entertainer*"). Sometimes repetitive

patterning or strict metrical development does not occur, in which case the meter is irregular or complex. Listen to CD tracks 4, 5, 8, and 19 in sequence. In track 4, an example of Gregorian chant, the rhythm is free flowing with undistinguishable meter. The same is true of track 5, also a composition from the Middle Ages by Hildegard of Bingen. In contrast, Robert Morley's "Now is the Month of Maying" (track 8) is written in a strict, lively quadruple meter. Its repetitive pattern of **1, 2, 3, 4** is very obvious. On the other hand, Debussy's "Prelude to the Afternoon of a Faun" (track 19; http://www.prs.net/debussy.html; select "Prélude à l'après-midi d'un faune") changes meter so frequently that patterns virtually disappear (a faun—pronounced fawn—is a mythological creature with the body of a man and the horns, ears, tail, and sometimes legs of a goat).

A QUESTION TO ASK

What is the meter of this piece and what kind of response does it create in me?

TEMPO

Tempo is the rate of speed of the composition. A composer may notate tempo in two ways. The first is by metronome marking, giving the notes specific time values, such as eighth note (\flat) = 60. This means that the piece is to be played at the rate of 60 eighth notes per minute. Such notation is precise. The other method is less precise and involves terminology we can use in describing a musical piece:

Largo Grave (grave, solemn)	Very slow
Lento (slow) Adagio (leisurely)	Slow
Andante (at a walking pace) Andantino (somewhat faster than andante) Moderato (moderate)	Moderate
Allegretto (briskly) Allegro (cheerful, faster than allegretto)	Fast
Vivace (vivacious) Presto (very quick) Prestissimo (as fast as possible)	Very fast

The tempo may be quickened or slowed, and the composer indicates this by the words *accelerando* (accelerate) and *ritardando* (retard), slow down. A

performer who takes liberties with the tempo uses *rubato* (pronounced roo-BAH-toh).

Melody

Melody is a succession of sounds with rhythmic and tonal organization. Melody can be visualized as linear and essentially horizontal. Thus any organization of musical tones occurring one after another constitutes a melody. Two other terms, tune and theme, relate to melody as parts to a whole. For example, the tune made up of the first few notes of "The Star Spangled Banner" is also a melody—that is, a succession of tones. However, a melody is not always a tune. In general, the term *tune* implies singability, and there are many melodies that cannot be considered singable. A theme is also a melody. However, in musical composition theme specifically means a central musical idea, which may be restated and varied throughout a piece. Thus a melody is not necessarily a theme. Related to theme and melody is the motif or motive, a short melodic or rhythmic idea around which a composer may design a composition. For example, in Beethoven's "Symphony No. 5 in C Minor" (CD track 13; http://www.prs.net/beethovn.html; select "Symphony No. 5 in C–Op. 67, 1. Adagio, Allegro Vivace") the first movement develops around a motif of four notes.

In listening for how a composer develops melody, theme, and motive, two terms help describe what is heard: *conjunct* and *disjunct*. Conjunct melodies comprise notes close together, stepwise, on the musical scale. Disjunct melodies comprise notes widely separated on the musical scale. For example, the opening of "The Star Spangled Banner" is a disjunct melody. No specific formula determines conjunct or disjunct characteristics; there is no line at which a melody ceases to be disjunct and becomes conjunct. These are relative and comparative terms that assist in description. For example, the opening melody of "The Star Spangled Banner" might be described as more or less disjunct than some other melody.

KEY TERM

HARMONY Two or more tones sounded at the same time constitute **harmony**. Harmony is essentially a vertical arrangement, in contrast with the horizontal arrangement of melody.

However, harmony also has a horizontal property—movement forward in time. Listening for harmony is listening to how simultaneous tones sound together.

Two tones played simultaneously are an **interval;** three or more tones form a **chord.** One way of listening to intervals or chords consists of listening for their consonance or dissonance. Consonant harmonies sound stable in their arrangement. Dissonant harmonies are tense and unstable. Consonance and dissonance, however, are not absolute properties. Essentially they are conventional and, to a large extent, cultural. What is dissonant to one person's ears may not be so to someone else's. What is important in musical response is determining how the composer utilizes these two

properties. Most Western music is primarily consonant. Dissonance, on the other hand, can be used for contrast, to draw attention to itself, or as a normal part of harmonic progression.

As its name implies, harmonic progression involves the movement forward in time of harmonies. In discussing pitch we noted the convention of major and minor scales—that is, the arrangement of the chromatic scale into a system of tonality. Playing or singing a major or minor scale reveals a particular phenomenon: Movement up the scale is smooth and seems natural. But reaching the seventh tone of the scale, creates a strange circumstance. It seems as though the progression must continue on to the octave above the starting tone. (Try it. Sing or play on the piano a major scale and stop at the seventh tone. You feel uncomfortable. Your mind tells you to resolve that discomfort by returning to the octave.) That same sense of tonality—that sense of the tonic or first tone of a scale—applies to harmony. Within any scale a series of chords may be developed on the basis of the individual tones of the scale. Each of the chords has a subtle relationship to each of the other chords and to the tonic—that is, the "do" of the scale. That relationship creates a sense of progression that leads back to the chord based on the tonic.

The harmonic movement toward, and either resolving or not resolving to the tonic is called cadence. Musicians use cadence to articulate sections of a composition or surprise listeners by upsetting their expectations. A piece employing full cadences utilizes a harmonic progression that resolves naturally. It creates a sense of ending, of completeness. However, when something other than a full cadence occurs, the expected progression is upset and the musical development moves in an unexpected direction.

Listening to music of various historical periods or styles reveals that in some compositions tonal centers are blurred because composers frequently **modulate**—that is, change from one key to another. In the twentieth century, many composers, some of them using purely mathematical formulas to utilize equally all the tones of the chromatic scale, have removed tonality as an arranging factor and have developed atonal music, or music without tonality. A convention of harmonic progression is disturbed when tonality is removed. Nonetheless, harmonic progression and harmony—dissonant or consonant—still exist.

Tonality

Utilization of tonality or key has taken composers in various directions over the centuries. Conventional tonality, employing the major and minor scales and keys, as discussed previously relative to pitch, forms the basis for most sixteenth- to twentieth-century music, as well as traditionally oriented music of the twentieth century. In the early twentieth century, some composers abandoned traditional tonality, and a new atonal harmonic expression occurred. Atonal compositions seek the freedom to use any combination of tones without the necessity of having to resolve chordal progressions.

Texture

The aspect of musical relationships known as texture is treated differently by different sources. The term itself has various spatial connotations, and using a spatial term to describe a nonspatial phenomenon creates part of the divergence of treatment. Texture in painting and sculpture denotes surface quality—that is, roughness or smoothness. Texture in weaving denotes the interrelationship of vertical and horizontal threads in the fabric. When threads in fabric are close together, the texture is closed or tight. When they are far apart, the texture is loose or open. There really is no single musical arrangement that corresponds to either of these spatial concepts. The characteristic called *sonority* comes the closest. Sonority describes the relationship of tones played at the same time. A chord with large intervals between its members would have a more open, or thinner, sonority (or texture) than a chord with small intervals between its tones; that chord would have a tight, thick, or close sonority or texture. Sonority is a term that does not have universal applications; some sources do not mention it at all. Composers can vary textures within their pieces to create contrast and interest. Here are the three basic musical textures: monophony (muh-NAH-fo-nee), polyphony (puh-LIH-fo-nee), and homophony (huh-MAH-fo-nee).

MONOPHONY

A single musical line without accompaniment is monophonic. Many voices or instruments may play at the same time, as in Gregorian chant (CD track 4), but as long as they sing or play the same notes at the same time—that is, in unison—the texture remains monophonic. In Handel's *Hallelujah* chorus (CD track 10; http://www.prs.net/handel.html; select "Messiah, Part II, 44. Hallelujah—"), there occur instances in which men and women sing the same notes in different octaves (Listen for the text "For the Lord God omnipotent reigneth"). This still represents monophony.

POLYPHONY

Polyphony means many-sounding, and it occurs when two or more melodic lines of relatively equal interest are performed at the same time. This combining technique also is called *counterpoint*, an example of which is a very simple statement in Josquin Desprez's (day-PRAY) "Ave Maria . . . Virgo Serena" (CD track 6; http://www.prs.net/early.html#d; select "Desprez, Josquin, Ave Maria"); also, Palestrina's "Kyrie" from the Pope Marcellus Mass (CD track 7; http://www.prs.net/early.html#p; select "Palestrina, Missa Papae Marcelli, Kyrie"). When the counterpoint uses an immediate restatement of the musical idea, then the composer is utilizing *imitation*.

HOMOPHONY

Chords accompanying one main melody indicate homophonic texture. Here the purpose of the composer is to focus attention on the melody by supporting it with subordinate sounds. The Bach chorale on CD track 9, BWV.80, "Ein feste burg ist unser Gott" ("A Mighty Fortress Is Our God;

http://www.prs.net/bachsacr.html; select "BWV.80, 'Ein feste burg ist unser Gott,' 5. Und wenn die welt") illustrates this type of texture very well. In this example, all four voices sing together in simultaneous rhythm. The main melody is in the soprano, or top, part. The lower parts sing melodies of their own, which are different from the main melody, but, rather than being independent as would be the case in polyphony, they support the main melody and move with it in a progression of chords related to the syllables of the text.

CHANGES OF TEXTURE

Composers may change textures within a piece, as Handel does in the *Hallelujah* chorus. This creates an even richer fabric of sound.

Musical Form

The term *form* is a very broad one. In addition to the forms we identify momentarily, all of which are associated with what we call "classical" (serious or "high" art) music, we can also identify broader "forms" of music of which "classical" is only one—for example, the musical forms of jazz, pop/rock, and so on. As we will note in the chapter on style, "Classical" also refers to a specific style of music within the broad "classical" form.

Musical form, in terms of the organization of musical elements and relationships into successive events or sections, concerns itself principally with two characteristics, *variety* and *unity*. Variety creates interest by avoiding monotony, and composers can use variety in every musical characteristic previously discussed in order to hold attention or pique interest. However, because music has design, composers must also concern themselves with coherence. Notes and rhythms that proceed without purpose or stop arbitrarily make little sense to the listener. Therefore, just as the painter, sculptor, or any other artist must try to develop a design that has focus and meaning, the musician must attempt to create a coherent composition of sounds and silences—that is, a composition that has unity. The principal means by which an artist creates unity is repetition, usually of recognizable thematic material.

Thus, form can be seen as organization through repetition to create unity. Form may be divided into two categories: closed form and open form. These terms are somewhat similar to those concepts used in sculpture and painting. Closed form directs the musical eye back into the composition by restating at the end of the thematic section that which formed the beginning of the piece. Open form allows the eye to escape the composition by utilizing repetition of thematic material only as a departure point for further development, and by ending without repetition of the opening section. A few of the more common examples of closed and open forms follow.

CLOSED FORMS

Binary form, as the name implies, consists of two parts: the opening section of the composition and a second part that often acts as an answer to the first: AB. Each section is then repeated.

Ternary form is a three-part development in which the opening section is repeated after the development of a different second section: ABA.

Ritornello, which developed in the Baroque period, and *rondo*, which developed in the Classical period, employ a continuous development that returns to modified versions of the opening theme after separate treatments of additional themes. Ritornello alternates orchestral passages with solo passages. Rondo alternates a main theme in the tonic key with subordinate themes in contrasting keys.

Sonata form, or sonata-allegro form, takes its name from the conventional treatment of the first movement of the sonata (see below), and constitutes the form of development of the first movement of many symphonies (see below). The pattern of development is **ABA** or AABA. The first A section states two or three main and subordinate themes, known as the *exposition*. To cement the perception of section A, the composer may repeat it: AA. The B section, the *development*, takes the original themes and develops them with several fragmentations and modulations. The movement then returns to the A section; this final section is called the *recapitulation*. Usually, the recapitulation section does not repeat of the opening section exactly; in fact, it may be difficult to recognize in some pieces. Sometimes the movement ends with a brief closing section called a *coda*.

OPEN FORMS

The *fugue* is a polyphonic development of one, two, or sometimes three short themes. Fugal form, which takes its name from the Latin *fuga* (flight), has a traditional, although not a necessary scheme of development. Two characteristics are common to all fugues: (1) counterpoint and (2) a clear dominant-tonic relationship—that is, imitation of the theme at the fifth above or below the tonic. Each voice in a fugue (as many as five or more) develops the basic subject independent from the other voices, and passes through as many of the basic elements as the composer deems necessary. Unification results not by return to an opening section, as in closed form, but by the varying recurrences of the subject throughout (see p. 93).

The *canon* is a contrapuntal form based on note-for-note imitation of one voice by another. The voices are separated by a brief time interval—for example (the use of letters here does not indicate sectional development):

Voice 1:	a	b	c	d	e	f	g		
Voice 2:		a	b	c	d	e	f	g	
Voice 3:			a	b	c	d	e	f	g

The interval of separation is not always the same among the voices. A canon is different from a round, an example of which is "Row, row, row your boat." A round is also an exact melodic repeat, but a canon develops new material indefinitely; a round repeats the same phrases over and over. The interval of separation in the round stays constant—a phrase apart.

Variation form is a compositional structure in which an initial theme is modified through melodic, rhythmic, and harmonic treatments, each more elaborate than the last. Each section usually ends with a strong cadence, and the piece ends, literally, when the composer decides he or she has done enough.

The open and closed forms just discussed describe the internal structure of musical pieces. The term *form* is also used to refer to general types of musical compositions, which might be considered similar to the theatrical genres studied earlier. Unlike theatre genres, these forms are likely to be identified in the concert program, allowing the performance to be placed in the perspective of specific parameters. Here are some of the more common. Because many musical forms are period- or style-specific—that is, they grew out of a specific stylistic tradition, some of the descriptions include brief historical references. The first six are vocal forms; the second six are instrumental.

MASS

The mass is a sacred choral composition consisting of five sections: Kyrie, Gloria, Credo, Sanctus, and Agnus Dei (KEE-ree-ay; KRAY-doh; SAHNK-loos; AHN-yoos-day-ee-). These also form the parts of the mass ordinary—that is, the Roman Catholic church texts that remain the same from day to day throughout most of the year. The *Kyrie* text implores, "Lord, have mercy upon us. Christ, have mercy upon us. Lord, have mercy upon us." The *Gloria* text begins, "Glory be to God on High, and on earth peace, good will towards men." The *Credo* states the creed: "We believe in one God, the Father, the Almighty, maker of heaven and earth," and so on. *Sanctus* confirms, "Holy, holy, holy, holy, Lord God of Hosts: Heaven and earth are full of thy glory. Glory be to thee, O Lord Most High." The Agnus Dei (Lamb of God), implores "O Lamb of God, that takest away the sins of the world, have mercy upon us. O Lamb of God, that takest away the sins of the world, have mercy upon us. O Lamb of God, that takest away the sins of the world, grant us thy peace" (Example: Palestrina, "Kyrie" from the "Pope Marcellus Mass," CD track 7; http://www.prs.net/early.html#p; select "Palestrina, Missa Papae Marcelli, Kyrie"). The *requiem mass*, which often comprises a musical program, is a special mass for the dead.

CANTATA

A cantata is usually a choral work with one or more soloists and an instrumental ensemble. Written in several movements, it is typified by the church cantata of the Lutheran church of the baroque period (1600–1750) and often includes chorales and organ accompaniment. The word cantata originally meant a piece that was sung—in contrast to a sonata (see below), which was played. The Lutheran church cantata (exemplified by those of Johann Sebastian Bach) uses a religious text, either original or drawn from the Bible or familiar hymns—chorales. In essence, a cantata served as a sermon in music and was drawn from the lectionary (prescribed Bible readings for the day and

on which the sermon is based). A typical cantata might last twenty-five minutes and include several different movements—choruses, recitatives, arias, and duets (Example: J.S. Bach, "Cantata No. 80," "Ein' feste burg ist unser Gott," final chorale, CD track 9; BWV.80; http://www.prs.net/bachsacr.html; select "BWV.80, 'Ein feste burg ist unser Gott,' 5. Und wenn die welt").

MOTET

A motet (moh-TEHT) is a polyphonic choral work employing a sacred Latin text other than that of the mass. Together with the longer musical form of the mass, the motet was one of the two main forms of sacred music during the Renaissance (late fourteenth to sixteenth centuries).

OPERA

We give special treatment to this form of music later in the chapter.

ORATORIO

An oratorio is a large-scale composition using chorus, vocal soloists, and orchestra. Normally an oratorio sets a narrative text (usually biblical), but does not employ acting, scenery, or costumes. The oratorio was a major achievement of the Baroque period of 1600 to 1750. This type of musical composition unfolds through a series of choruses, arias, duets, recitatives, and orchestral interludes. The chorus of an oratorio is especially important and can comment on or participate in the dramatic exposition. Another feature of the oratorio is the use of a narrator, whose recitatives (vocal lines imitating the rhythms and inflections of normal speech) tell the story and connect the various parts. Like operas, oratorios can last more than two hours (Example: G.F. Handel, "Hallelujah Chorus" from the oratorio "Messiah," CD track 10; http://www.prs.net/handel.html; select "Messiah, Part II, 44. Hallelujah—").

ART SONG

An **art song** is a setting of a poem for solo voice and piano. Typically, it adapts the poem's mood and imagery into music. Art song is a distinctive form of music growing out of the Romantic style of the nineteenth century. That is to say, it has an emotional tendency, and its themes often encompass lost love, nature, legend, and the far away and long ago. In this type of composition, the accompaniment is an important part of the composer's interpretation and acts as an equal partner with the voice. In this form, stressed tones or melodic climaxes emphasize important words (Example: Franz Schubert, "The Erlking," CD track 14; http://www.prs.net/schubert.html; select "Erlkönig [the Erlking]" [without text]).

STYLE SPOT

Baroque: A diverse 17th-century style emphasizing ornateness and emotional appeal. See p. 128

FUGUE

The fugue is a polyphonic (two or more melodic lines of relatively equal importance performed at the same time) composition based on one main theme or subject. It can be written for a group of instruments or voices, or for a single instrument like an organ or harpsichord. Throughout the composition, different melodic lines, called "voices," imitate the subject. The top melodic line is the soprano and the bottom line, the bass. A fugue usually includes three, four, or five voices. The composer's exploration of the subject typically passes through different keys and combines with different melodic and rhythmic ideas. Fugal form is extremely flexible: The only constant feature is the beginning in which a single, unaccompanied voice states the theme. The listener's task, then, is to remember that subject and follow it through the various manipulations that follow (Example: J.S. Bach, "Little Fugue in G" BWV.578, http://www.prs.net/bach.html; select "Little Fugue in G, BWV.578").

SONATA

An outgrowth of the Baroque period (1600–1750), a sonata is an instrumental composition in several movements written for from one to eight players. After the Baroque period, the sonata changed to a form typically for one or two players. The trio sonata of the Baroque period had three melodic lines (hence its name). It actually uses four players (Example: Mozart's "Piano Sonata No. 11 in A, K. 331"—Rondo: alla Turca, CD track 12; http://www.prs.net/mozart.html; select "Sonata in A, K. 331, Rondo alla Turca"). This general type of musical composition should not be confused with *sonata form*, which is a specific form for a single movement of a musical composition (see the opening section on Musical Form, p. 89).

SYMPHONY

An orchestral composition, usually in four movements, a symphony typically lasts between twenty and forty-five minutes. In this large work, the composer explores the full dynamic and tonal range of the orchestral ensemble. The symphony is a product of the Classical period of the eighteenth century and evokes a wide range of carefully structured emotions through the contrasts of tempo and mood. The sequence of movements usually begins with an active fast movement, changes to a lyrical slow movement, then moves to a dancelike movement, and closes with a bold fast movement. The opening movement is almost always in sonata form (see above). In most classical symphonies, each movement is self-contained with its own set of themes. Unity in a symphony occurs partly from the use of the same key in three of the movements and also from careful emotional and musical complement among the movements (Examples: Hector Berlioz, "Symphonie Fantastique," fourth movement ["March to the Scaffold"], CD track 16; http://www.prs.net/midi-a-e.html#b; select "Symphonie Fantastique, Op. 14, 4. March to the Scaffold"; and Ludwig van Beethoven, "Symphony No. 5 in C minor," first movement, CD track

13; http://www.prs.net/beethovn.html; select "Symphony No. 5 in C–Op. 67, 1. Adagio, Allegro Vivace").

CONCERTO

A *solo concerto* is an extended composition for an instrumental soloist and orchestra. Reaching its zenith during the classical period of the eighteenth century, it typically contains three movements, in which the first is fast, the second, slow, and the third, fast. Concertos join a soloist's virtuosity and interpretive skills with the wide-ranging dynamics and tonal colors of an orchestra. In this way, the concerto provides a dramatic contrast of musical ideas and sound in which the soloist is the star. Typically, concertos present a great challenge to the soloist and a great reward to the listener, who can delight in the soloist's meeting of the technical and interpretive challenges of the work. Nonetheless, the concerto is a balanced work in which the orchestra and soloist act as partners. The interplay between orchestra and soloist provides the listener with fertile ground for involvement and discernment. Concertos can last from 20 minutes to 45 minutes. Typically, during the first movement, and sometimes the third, of a classical concerto, the soloist has an unaccompanied showpiece called a cadenza.

Common to the late Baroque period (1600–1750), the *concerto grosso* is a composition for several instrumental soloists and a small orchestra (in contrast to the solo concerto). In the Baroque style, contrast between loud and soft sounds and large and small groups of performers was typical. In a concerto grosso, a small group of soloists (two to four) contrasts a larger group called the *tutti* consisting of from eight to twenty players. Most often a concerto grosso contains three movements contrasting in tempo and character. The first movement is fast; the second, slow; and the third, fast. The opening movement, usually bold in expression, explores the contrasts between tutti and soloists. The slow movement is more lyrical, quiet, and intimate. The final movement is lively, lighthearted, and sometimes dance-like (Example: Antonio Vivaldi, "Spring" from the "Four Seasons—first movement, Allegro, CD track 11; http://www.prs.net/midi-t-z.html#v; select "Vivaldi, Antonio, The Four Seasons, No. 1 La Primavera [Spring] in E, 1. Allegro").

CONCERT OVERTURE

A concert overture is an independent composition for orchestra. It contains one movement, composed in sonata form (see p. 93). The concert overture is modeled after the opera overture, which is similarly a one-movement work, that establishes the mood of an opera. Unlike the opera overture, the concert overture is not intended as the introduction to anything. It stands on its own as an independent composition.

SUITE

A suite comprises a set of dance-inspired movements written in the same key but differing in tempo, meter, and character. An outgrowth of the Baroque period (1600–1750), a suite can employ solo instruments, small ensembles, or

an orchestra. The movements of a suite typically are in two parts, with each section repeated (AABB). The A section opens in the tonic key and modulates to the dominant (the fifth tone of the scale). The B section begins in the dominant and returns to the tonic. Both sections employ the same thematic material and exhibit little by way of contrast (Example: J.S. Bach, "English Suite #1 in A," BWV.806 http://www.prs.net/bach.html; select "English Suite #1 in A, BWV.806, 2. Allemande").

THE PERFORMANCE

Music contains a sensual attraction that is difficult to deny. At every turn music causes toes to tap and fingers to drum in purely physical response. This involuntary motor response is perhaps the most primitive of sensual involvement. If the rhythm is irregular and the beat divided or syncopated, one part of the body may do one thing and another part do something else. A certain part of sense response to music occurs as a result of the nature of the performance itself. As just noted, the scale of a symphony orchestra gives a composer a tremendously variable canvas on which to paint. Familiarization with this fundamental aspect of the musical equation is helpful here. Facing the stage in an orchestral concert, audience members see perhaps as many as one hundred instrumentalists facing back at them. The orchestral arrangement from one concert to another is fairly standard (Figure 33, below).

A large symphony orchestra can overwhelm listeners with diverse timbres and volumes; a string quartet cannot. Listeners' expectations and focus change as they perceive the performance of one or the other of these ensembles. For example, knowing that perceptual experience with a string quartet will not involve the broad possibilities of an orchestra, listeners can tune themselves in to seek the qualities that challenge the composer and performer within the particular medium. The difference between listening to an orchestra and listening to a string quartet is similar to the difference between viewing a museum painting of monumental scale and viewing the exquisite technique of a miniature.

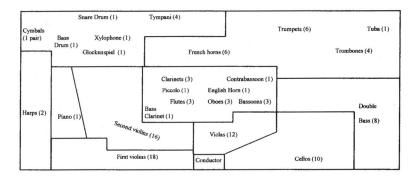

Figure 33 Typical seating plan for a large orchestra (about 100 instrumentalists), showing the placement of instrumental sections.

Textual suggestion can have much to do with sensual response to a musical work. For example, Debussy's *Prelude to the Afternoon of a Faun* (CD track 19; http://www.prs.net/debussy.html; select "Prélude à l'après-mìdi d'un faune") elicits images of Pan frolicking through the woodlands and cavorting with nymphs on a sunny afternoon. Of course, much of what the listener imagines has been stimulated by the title of the composition. Perception is heightened further by familiarity with the poem on which the symphonic poem is based. Titles and text in musical compositions may be the strongest devices a composer has for communicating directly with listeners. Images are triggered by words, and a text or title can stimulate imaginations and senses to wander freely and fully through the musical development. Johannes Brahms called a movement in his *German Requiem* "All Mortal Flesh Is as the Grass"; (*Ein Deutsches Requiem*, Op. 45, 2. *Denn alles Fleish es ist wie Gras*, http://www.prs.net/brahms.html; select "Orchestral Works, Ein Deutsches Requiem, Op. 45, 2. Denn alles Fleish es ist wie Gras"). That title stimulates philosophical and religious communication. Moreover, when the chorus ceases to sing and the orchestra plays alone, the instrumental melodies and harmonies stimulate images of fields of grass blowing in the wind.

In conclusion, response to music requires analysis of how each of the elements available has become a part of the channel of communication, as well as how the composer, consciously or unconsciously, has put together a work that elicits listener responses.

OPERA

Opera is a combination of music and drama in which music is not an equal or incidental partner but is the predominant element. Its unique status as an art form is why we treat it here as a separate entity. The supportive elements of an opera production, such as scenery, costumes, and staging, make it (although still a form of music) something apart from its musical brethren.

Traditions of opera are strong and deep. There have been attempts to make opera more like contemporary drama, with greater focus on plot, character development, and so on. Plays of the realistic style have been made into operas to make the form less exaggerated and implausible, a factor occasionally contributed to by singers who cannot act or who do not look the part.

Many devotees of opera regard it as the purest integration of all the arts. It contains music, drama, poetry, and, in the *mise-en-scène*, visual arts. Certainly one could even include architecture, because an opera house is a particular architectural entity, with its own specific requirements for stage space and machinery, orchestra pit, and audience seating space. Because of opera's integration of art forms, much of response to opera at the formal, technical, and sensual levels is discussed in the sections on visual art and theatre, as well as earlier in the discussion on music. We now discuss a few additional characteristics.

Opera is a form that involves sitting in the large auditorium that comprises an opera house and witnessing a musical and dramatic spectacle unfold on a stage perhaps 50 feet wide by 70 feet deep, filled with scenery rising 20

or 30 feet in the air, and peopled by a chorus of perhaps 100 singers, all fully costumed and singing over a full orchestra. The scope and spectacle of such an event is opera, or at least comprises the circumstances of the bulk of operatic repertoire. Some operas are much more intimate. Nonetheless, listening to the music of opera on the radio or from a recording, or watching the minuscule productions through the medium of television falls far short of the experience a live performance affords.

Types of Operas

In Italian, the word opera means *work*. In Florence, Italy, in the late sixteenth century, artists, writers, and architects eagerly revived the culture of the ancient Greece and Rome. Opera was an attempt by a group known as the *camerata* (Italian for fellowship or society) to recreate the effect of ancient Greek drama, in which, scholars believed, the words were chanted or sung as well as spoken. Through succeeding centuries, various applications of the fundamental concept of opera have arisen, and among these applications are four basic types of opera: (1) grand opera, (2) opera comique, (3) opera buffa, and (4) operetta.

Opera (without a qualifying adjective) is the serious or tragic opera that perhaps immediately comes to mind. This type also has been called *grand opera*, which implies to some an early operatic form consisting usually of five acts. *Opera seria* (OH-pair-ah SAY-ree-ah; serious opera), another name for tragic or grand opera, is generally highly stylized and treats heroic subjects, such as gods and heroes of ancient times.

Opéra comique (coh-MEEK), the second variety of opera, is any opera, regardless of subject matter, that has spoken dialogue.

The third type, *opera buffa* (BOO-fah), is comic opera (not to be confused with *opéra comique*), which usually does not have spoken dialogue. Opera buffa usually uses satire to treat a serious topic with humor (Example: Mozart's *Marriage of Figaro*).

The fourth variety is operetta. Operetta also has spoken dialogue, but it has come to refer to a light style of opera characterized by popular themes, a romantic mood, and often a humorous tone. It is frequently considered more theatrical than musical, and its story line is usually frivolous and sentimental.

The Libretto

The text of an opera, which is called the **libretto** (lih-BREH-to), is probably the single most important barrier to the appreciation of opera by American audiences. Because the large majority of operas in the contemporary repertoire are not of American origin, the American respondent usually has to overcome a language barrier to understand the dialogue and thereby the plot. The lack of English-translation performances results not from a desire for snobbery or exclusivity, but mostly from pure practicality. Performing operas in their original language makes it possible for the best singers to be heard around the world. Consider the complications that would arise if Pavarotti, for example, had to learn a single opera in the language of every

country in which he performed it. In addition, opera loses much of its musical character in translation. In terms of tone color, or timbre, alone, there are characteristics implicit in the Russian, German, and Italian languages that are lost when they are translated into English. Opera is, in a sense, the Olympic Games of vocal music; the demands made on opera singers call for the highest degree of skill and training of any vocal medium—tone placement, and the vowels and consonants requisite to that placement, become very important to the singer. It is one thing for a tenor to sing the vowel "eh" on high C in the original language. If the translated word to be sung on the same note employed an "oo" vowel, the technical demand is changed considerably. So the translation of opera from its original tongue into English constitutes a far more difficult and complex problem than simply providing an accurate translation for a portion of the audience that does not know the text—as important as that may seem.

Experienced opera-goers may study the score before attending a performance. However, every concert program contains a plot synopsis (even when the production is in English), so that even the neophyte can follow the plot. Opera plots, unlike mysteries, have few surprise endings, and knowing the plot ahead of time does not diminish the experience of responding to the opera. To assist the audience, opera companies often project the translated lyrics on a screen above the proscenium—much like subtitles in a foreign film.

Elements of Operas

The opening element in an opera is the overture. This orchestral introduction may have two characteristics. First, it may set the mood or tone of the opera. Here the composer works directly with sense responses, putting audience members into the proper frame of mind for what is to follow. In his overture to *I Pagliacci* (ee pahl-YAH-chee), for example, Ruggiero Leoncavallo creates a tonal story that tells what will come. Using only the orchestra, he indicates comedy, tragedy, action, and romance. Add to the "musical language" the language of body and mime, and even complex ideas and character relationships can be understood without words. In addition to this type of introduction, an overture may provide melodic introductions—passages introducing the arias and recitatives (see below) that will follow.

The plot unfolds musically through recitative, or sung dialogue. The composer uses *recitative* to move the plot along from one section to another; recitative has little emotional content to speak of, and the words are more important than the music. There are two kinds of recitative. The first is *recitativo secco* (ray-chee-tah-TEE-voh SEH-koh; dry recitative), for which the singer has very little musical accompaniment, or none at all. If there is accompaniment, it is usually in the form of light chording under the voice. The second type is *recitativo stromento* (stroh-MEHN-toh), in which the singer is given full musical accompaniment.

The real emotion and poetry of an opera lie in its arias. Musically and poetically, an aria is the reflection of high dramatic feeling. The great opera

songs with which we are likely to be familiar are arias (Example: Giusseppi Verdi (VAIR-dee), *Rigoletto*, aria "La Donna E Mobile," CD track 17).

In every opera there are duets, trios, quartets, and other small ensemble pieces. There also are chorus sections in which everyone gets into the act. In addition, ballet or dance interludes are not uncommon. These may have nothing to do with the development of the plot, but are put in to add more life and interest to the dramatic production, and in some cases to provide a segue or transition from one scene into another.

OPERATIC VOICE CLASSIFICATIONS

Coloratura Soprano	Very high range; capable of executing rapid scales and trills
Lyric Soprano	Fairly light voice; cast in roles requiring grace and charm
Dramatic Soprano	Full, powerful voice, capable of passionate intensity
Lyric Tenor	Relatively light, bright voice
Dramatic Tenor	Powerful voice, capable of heroic expression
Basso Buffo	Cast in comic roles; can sing very rapidly
Basso Profundo	Extremely low range capable of power; cast in roles requiring great dignity

Bel canto, as its name implies, is a style of singing emphasizing the beauty of sound. Its most successful composer, Giocchino Rossini, had a great sense of melody and sought to develop the art song to its highest level. In bel canto, singing the melody is the focus.

Richard Wagner (VAHG-nuhr; 1850–1925) gave opera and theater a prototype that continues to influence theatrical production—organic unity. Every element of his productions was integral and shaped to create a work of total unity. Wagner was also famous for the use of *leitmotif*, a common element in contemporary film. A leitmotif is a musical theme associated with a particular person or idea. Each time that person appears or is thought of, or each time the idea surfaces, the leitmotif is played.

MODEL ANALYSIS

You can analyze a musical selection by utilizing the following outline as a guide and answering the questions.

- *Form.* In what way does the program identify the form of the selection? In what specific ways does the selection meet the characteristics of that form? If the piece is an opera, what type of opera is it, and how does it meet those characteristics?
- *Sound.* How does the piece explore dynamics? How, using the specific musical terms—for example, pianissimo, forte, and so on—would you describe the progression of the piece from beginning to end? In what ways does the piece explore tone color?

- *Rhythm*. What is the meter of the piece? Do any changes occur? If so, where and how?
- *Tempo*. In what ways does the tempo of the piece effect your response? How, using the specific musical terms—for example, largo, andante, moderato, presto, and so forth—would you describe the progression of the piece from beginning to end?
- *Texture*. What textures does the piece explore? Where do changes in texture occur, if at all?
- *Ensemble*. What kind of ensemble played/sang the piece? Did its size have any effect on the way in which you listened to and perceived the piece?
- *Reaction*. How do the previous elements combine to create a reaction in you? In other words, what draws your attention? What is your emotional response to the piece, and what causes that emotional reaction?

FURTHER READING

Kamien, Roger. *Music: An Appreciation*. New York: McGraw-Hill, 1996.

Kramer, Jonathan D. *Listen to the Music: A Self-Guided Tour Through the Orchestral Repertoire*. New York: Schirmer Books, 1992.

Stanley, John. *An Introduction to Classical Music Through the Great Composers and Their Masterworks*. New York: Readers Digest, 1997.

Steinberg, Michael. *The Symphony: A Listener's Guide*. New York: Oxford University Press, 1995.

Zorn, Jay D. *Listen to Music:* Englewood Cliffs, NJ: Prentice Hall, 1994.

6

Dance

Every December, Tchaikovsky's "Nutcracker Ballet" rivals Handel's *Messiah* and television reruns of the Jimmy Stewart movie *It's a Wonderful Life*, as a holiday tradition. Nevertheless, ballet and dance in general seem remote from most people. Ballet, in particular, evokes strong personal opinions of like or dislike.

Yet, dance is one of the most natural and universal of human activities. Some form of dance appears in virtually every culture, regardless of location or level of development. Dance appears to have sprung from human religious needs. Even the Bible speaks of this art in important terms. Scholars are relatively sure the theatre of ancient Greece developed out of that society's religious and tribal dance rituals. Without doubt, dance is part of human communication at its most fundamental level, as illustrated by little children, who, before they begin to paint, sing, or imitate, begin to dance.

An expression in rhythmic movement, dance can be an individual experience, a group experience, and also a cultural mirror. When dance as a simple emotional expression develops into a *design—a planned pattern of rhythms, steps, gestures, and so on*—it becomes a specific dance. Several dances of the same type become a dance form such as ballet.

We will focus the rest of this chapter on looking at the different genres and aspects of dance. At the end, we will provide some guides and references for further exploration of this topic.

GENRES

Dance focuses on the human form in time and space. It can follow numerous directions and traditions, including ballet, modern, world concert/ritual, folk, jazz, tap, and musical comedy. The discussion that follows treats five of these: ballet, modern, world concert/ritual, folk, and jazz dance.

Although no textbook can adequately illustrate dance artworks, understanding a few general facts, concepts, and terms helps to prepare for the occasion when dance is experienced—live, on film, or on television. To begin, here are descriptions to help separate the three major generic divisions of dance.

BALLET Ballet comprises what can be called classical, or formal, dance; rich in tradition, it rests heavily on a set of prescribed movements and actions. In general, ballet is a highly theatrical dance presentation consisting of solo dancers, duets, choruses or *corps de ballets*. According to Anatole Chujoy in the *Dance Encyclopedia*, the basic principle in ballet is "the reduction of human gesture to bare essentials, heightened and developed into meaningful patterns." George Balanchine, the great twentieth-century choreographer, saw the single steps of a ballet as analogous to a single frame in a motion picture. Ballet, then, became a fluid succession of images, all existing within specialized codes of movement (http://www.geocities.com/Vienna/Choir/6862/dance.html). As with all dance and all the arts, ballet expresses basic human experiences and desires.

STYLE SPOT
Romanticism: A late 18th- and 19th-century style that reacted against classicism and focused on emotional appeal. See p. 130

Modern Dance

MODERN Modern dance is a label given to a broad variety of highly individualized dance works limited to the twentieth century, essentially American in derivation, and antiballet in philosophy. It began as a revolt against the stylized and tradition-bound elements of the ballet. The basic principle of modern dance probably could be stated as *an emphasis on natural and spontaneous or uninhibited movement*, in strong contrast with the conventionalized and specified movement of the ballet (http://www.danceonline.com/photo/in_performance/perform1.html). The earliest modern dancers found stylized ballet movement incompatible with their need to communicate in twentieth-century terms. As Martha Graham characterized it, "There are no general rules. Each work of art creates its own code." Nonetheless, in its attempt to be nonballetic, certain conventions and characteristics have accrued to modern dance, such as angularity and asymmetry to counter the largely rounded and symmetrical movements of ballet. Although narrative elements do exist in many modern dances, there is generally less emphasis on them than in traditional ballet. There also are differences in the use of the body, the use of the dance floor, and the interaction with the *mise-en-scène* or physical environment (see the Theatre section).

World Concert/Ritual Dance

Out of a plethora of scholarly arguments about how to label and define certain types of dance emerged the term "world dance." This name describes dances specific to a particular country. Within or alongside the category of world dance exists another label: *ritual dance*. In other words, among the dances classified as "world" there exist dances based in ritual—dances having ceremonial functions, formal characteristics, and particular prescribed procedures—which pass from generation to generation. Perhaps complicating the definition further, some of the dances falling in such a category have public presentation as their objective, and some have both ritualistic and public performance aims. Further, some ritual dances would never be performed for an audience because of their sacredness.

World concert/ritual dances typically center around topics important to single cultures—for example, "religion, moral values, work ethics or historical information relating to a culture" (Nora Ambrosio, *Learning About Dance*, p. 94). Some of the dances involve cultural communication, and others—such as those in the Japanese *Noh* and *Kabuki* traditions—are theatrical. World concert/ritual dance is an important element of many African and Asian cultures. At least in general terms, world concert/ritual dance can be differentiated from the next category, *folk dance*, although the boundaries are often blurred.

Folk Dance

Folk dance, somewhat like folk music, is a body of group dances performed to traditional music. It is similar to folk music in that its developers remain unknown; there are no choreographers of record for folk dances. The dances began as a necessary or informative part of certain cultures, and their characteristics are stylistically identifiable with a given culture. They developed over a period of years, without benefit of authorship, passing from one generation to another. They have their prescribed movements, rhythms, music and costume (http://www.cnmat.berkeley.edu/~ladzekpo/Ensemble.html). At one time or another they may have become formalized—that is, committed to some form of record. But they are part of a heritage, and usually not the creative result of an artist or group of interpretative artists, as is the case with the other forms of dance. Likewise, they exist more to involve participants than to entertain an audience.

Folk dancing establishes an individual sense of participation in society, the tribe, or a mass movement. John Martin in *The Dance* says: "The group becomes one in conscious strength and purpose, and each individual experiences a heightened power as part of it . . . [a] feeling of oneness with one's fellows which is established by collective dancing" (p. 26).

Jazz Dance

Jazz dance traces its origins to Africa prior to the arrival of African slaves on the American continent. Today it exists in a variety of forums including popular the-

atre, concert stage, movies, and television. The rhythms of African music found their way into dances performed for enjoyment and entertainment. The foundations they provided led to the Minstrel shows in which dances were performed by white entertainers in blackface. By the late twentieth century, jazz dance had evolved into a variety of styles of movement, lacking a precise definition other than that of a vital, theatrical dance rooted in jazz and the African heritage. Jazz dance relies heavily on improvisation and syncopation.

THE ASPECTS OF DANCE

Dance is an art of time and space that utilizes many of the elements of the other arts. In the *mise-en-scène* and in the line and form of the human body, dance involves many of the compositional elements of pictures, sculpture, and theatre. Dance also relies heavily on the elements of music—whether or not music accompanies the dance presentation. However, the essential ingredient of dance is the human body and its varieties of expression.

Formalized Movement

The most obvious repository of formalized movement in dance is ballet. All movement in ballet is based on five basic leg, foot, and arm positions (Figure 34, p. 105). In the first position, the dancer stands with weight equally distributed between the feet, heels together, and toes open and out to the side. In ballet, all movements evolve from this basic open position; the feet are never parallel to each other with both pointing straight forward. The fifth position is the most frequently used of the basic ballet positions. The feet are close together with the front heel touching the toe of the back foot. The legs and the feet must be well turned out to achieve this position correctly, and the weight is placed evenly on both feet. Each position changes the attitude of the arms as well as that of the legs and feet. From these five basic positions a series of fundamental movements and poses is developed; these are the core of every movement of the body in formal ballet, and these bodily compositions form a kind of theme and variation, interesting in that right alone.

In addition, it is possible to find considerable excitement in the bodily movements of formal ballet if for no other reason than the physical skills required for their execution. The standards of quality applied to a ballet dancer are based on the ability to execute these movements properly. Just as in gymnastics or figure skating, the strength and grace of the individual in large part determines his or her qualitative achievement. It goes without saying, however, that ballet is far more than just a series of gymnastic exercises.

Perhaps the most familiar element of ballet is the female dancer's toe work or dancing "on point." A special kind of shoe is required for toe work. Dancing on point is a fundamental part of the female dancer's development. It usually takes a minimum of two years of thorough training and development before a dancer can begin to do toe work. Certain kinds of turns are not possible without toe shoes and the technique for using them—for example, spinning on point or being spun by a partner.

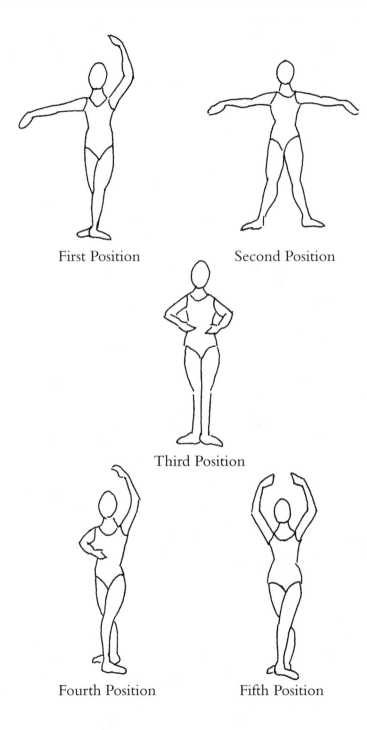

First Position Second Position

Third Position

Fourth Position Fifth Position

Figure 34 Basic positions in ballet.

This discussion of formalized movement focuses on ballet because ballet is the most familiar of the traditional, formalized dance forms. Ballet, however, is not alone in adhering to formalized patterns of movements. It is, in part, this formalized movement that differentiates among folk and other dances, such as the waltz and the mambo. All have formal or conventional patterns of movement. Perhaps only modern dance resists formal movement, and even then not completely.

Line, Form, and Repetition

The compositional elements of line, form, and repetition apply to the use of the human body in exactly the same sense that they apply to those elements in painting and sculpture—the latter especially. The body of the dancer can be analyzed as sculptural, three-dimensional form that reflects the use of line, even though the dancer is continually in motion. The body as a sculptural form moves from one pose to another and a stop action movie of a dance would permit analysis, frame by frame or second by second, of the compositional qualities of the human body. The human form can be analyzed as a composition of line and shape.

Dance, therefore, can be seen at two levels: first, as a type of pictorial communication employing symbols that occur only for a moment, and, second, as the design of transition with movement between these movements. Alert perception will recognize not only how lines and forms are created, but also how they are repeated from dancer to dancer and from dancer to setting.

Because a dancer moves through time, the concept of repetition becomes an important consideration in analyzing how a dance work is put together. The relationship of the movements to each other as the dance progresses from beginning to end reveals repeated patterns that, again, are analogous to theme and variation in music. Choreographers concern themselves with the use of the individual dancer's body as well as combinations of dancers' bodies in duets, trios, or the entire corps de ballet.

Watching a dance should focus on how movements, ensembles, scenery, and individual bodies explore diagonal, curved, or asymmetric lines in the same sense that responding to a painting or work of sculpture involves perceiving and evaluating how those same elements of composition have been explored by the artist.

Rhythm

Dance steps are related and coherent. Rhythm holds dance phrases together in the same sense as occurs in musical rhythm. Sequences of long and short motions occur that are highlighted by accents. In a visual sense, dance rhythms form spatial arrangements, up and down, back and forth, curved and linear, large and small. Rhythmic relationships also occur in the ebb and flow of dancers' energy levels. Energy calls to mind dynamics as it was discussed relative to music and theatre.

Mime and Pantomime

Within any dance form, modern dance included, there may be elements of bodily movement called **mime** and *pantomime*. Bodily movement is mimetic whenever it suggests the kinds of movements associated with people or animals. It is also mimetic if it employs any of the forms of conventional sign language, such as the Delsarte system (for further information on Delsarte contact http://www.people.cornell.edu/pages/jgv4/dance/hist.htm). The reference is two-thirds of the way through the article. If there are narrative elements in the dance and the dancer actually portrays a character in the theatrical sense, there also may be pantomimic action. Pantomime is the acting out of dramatic action without words. In the Romantic style of ballet, for example, pantomime helps to carry forward the story line. Audience members sense the emotions, feelings, and character relationships in the dancers' steps, gestures, movements, and facial expressions. Only when the movement of the dance is purely an emotional expression of the dancer is it free of mime or pantomime.

A QUESTION TO ASK
In what ways do the dancers' movements in this place create symbols, stimulate emotions, and transmit general ideas?

Theme, Image, and Story Line

Our consideration of the presence or absence of mime leads to a consideration of how dance communicates its idea content. There are three general possibilities. First, the dance may contain *narrative* elements; that is, it may tell a story. Second, the dance may communicate through *abstract ideas*. There is a specific theme to be communicated in this case, but no story line. The ideas are abstract and general and relate to some aspect of human emotion or the human condition. Modern dance, especially, tends to deal with human psychology and behavior. Social themes occur frequently, as do impressions or expressions from plays, poems, and novels. Religious themes as well as folk themes can be found in the wide treatments and explorations of subject ideas in modern dance. Modern ballet (that is, twentieth-century ballet) has dealt increasingly with abstract ideas. A variation of abstract idea content in dance is ethnic influence. It is interesting to note how elements of dance reflect sociocultural background. The third possibility is the absence of narrative or abstract communication. The work may be a **divertissement,** or diversion. Some ballets are divertissements.

Participating as an audience member for dance requires active involvement and determining the meaning involved in the themes, images, and story line of a dance requires evaluation of the feeling the choreographer is trying to establish. In addition, we should attempt to discover what the choreogra-

pher is trying to say through the elements of the dance. Are the dancers portraying a character, transmitting an emotion, or some combination?

Music

Music associates with dance as a matter of course. Most of the time music serves as a basis for the bodily movement of the dance artwork, although it is not necessary for a dance to be accompanied by music. However, it is impossible to have dance without one element of music—rhythm, as noted previously. Every action of a dancer's body has some relationship in time to every other movement, and those relationships establish rhythmic patterns that are musical regardless of the presence or absence of auditory stimuli.

Music accompanying a dance permits study of the relationship of the dance to the musical score. The most obvious relationship is the one between the gestures and footfalls of the dancers and the beat of the music. In some cases the two are in strict accord: The beat-for-beat relationship is one to one. In other cases there may be virtually no perceivable beat-for-beat relationship between the dancer's movements and the accent or rhythmic patterns of the musical score.

Another relationship is that of the dynamics of the dance to those of the music. Of prime importance in this relationship is the intensity, or force, of the dance movement. Moments of great intensity in a dance can manifest themselves in rapid movement and forceful leaps. Or they may be reflected in other qualities. Discerning how the actual performance employs dynamics is another part of critical analysis, and the same kind of analysis occurs in dance as in theatre in plotting the dynamic levels and overall structure. For maximum interest there must be variety of intensity. Charting the relationship of the peaks and valleys of dynamics usually leads to the conclusion that the dynamic structure of a dance is similar to the dynamic structure of a play; it tends to be pyramidal: It builds to a high point and then relaxes to a conclusion. This applies whether or not narrative elements are present.

Mise-en-Scène

Because dance is essentially a visual and theatrical experience, part of the audience response must be to those theatrical elements of dance manifested in the environment of the presentation: in other words, the *mise-en-scène* or physical environment of the dance. Elements of verisimilitude in the *mise-en-scène*, and how those elements reflect or otherwise relate to the aural and visual elements of the dance, can be noted. A principal consideration here is the interrelationship of the dance with properties, settings, and the floor of the theatrical environment. The dance may use properties in significant or insignificant ways. As for settings, some dances employ massive stage designs. Others have no setting at all; they are performed in a neutral environment. Again, part of experiencing dance is finding the relationship of the elements of the setting to the rest of the dance.

A principal difference between formal ballet and modern dance lies in the use of the dance floor. In formal ballet, the floor acts principally as an

agent, from which the dancer springs and to which the dancer returns. But in modern dance, the floor assumes an integral role in the dance, and dancers regularly sit and roll on the floor—in short, interact with the floor. So consideration of the use of the floor in dance concerns not only whether or not it is employed as an integral part of the dance, but also how the use of the floor relates to the themes and ideas of the dance.

Crucial to understanding a dance is perception of how the choreographer utilizes space. Changing levels, directions, shapes, and floor patterns form a fundamental part of how dance works, and understanding a dance and responding to it involves active perception and evaluation of how the entirety of the physical space and the dancers' space interact and communicate.

In discussing the relationship of costume to dance, the section on costume design in theatre should be referenced to note the purposes of costume, because those purposes apply to the dance in the same manner that they apply to a theatre production. In some dances, costume will be traditional, conventional, and neutral. In others, costumes will be high in verisimilitude or lifelikeness. Costumes may help portray character, locality, and other aspects of the dance.

In addition, a costume must allow the dancer to do whatever the choreographer expects him or her to do. In fact, the costume may itself become an integral part of the dance itself. In Martha Graham's *Lamentation*, for example, a single dancer is costumed in what could best be described as a tube of fabric—no arms, no legs, just a large envelope of cloth (http://www.pathfinder.com/photo/gallery/arts/morgan/cap02.htm). Every movement of the dancer stretches that cloth so the line and form of the dancer is not the line and form of a human body, but rather the line and form of a human body enveloped in a moving fabric.

The final important element of the dance costume considered here is footgear. Dancers' footgear ranges from the simple, soft, and supple ballet slipper to the very specialized toe shoe of formal ballet (Example: http://www.geocities.com/Vienna/Choir/6862/dance.html), to street shoes, character oxfords, and a variety of representational or symbolic footwear in between. In addition, modern dance often is done in bare feet. The fundamental requirements of footgear are comfort and enough flexibility to allow the dancer to do whatever he or she must do. Footgear, whether it be toe shoe, ballet slipper, character oxford, or bare feet, must be appropriate to the surface of the stage floor. Great care must be taken to ensure the dance floor is not too hard, too soft, too rough, too slippery, or too sticky. The floor is so important that many touring companies take their own floor with them to ensure that dancers will be able to execute movements properly and safely. There have been cases in which professional dance companies refused to perform in local auditoriums because the floor was unsuitable or dangerous for the dancers.

Because the entire perception of a dance relies on the perception of the human body as a three-dimensional form, the work of the lighting designer is of critical importance in the art of dance. Perception of the human form in

space depends on how that body is lit. Certainly emotional and sense response is highly shaped by the nature of the lighting that plays on the dancer and the dance floor.

Costume, lighting, and set designers must strongly reinforce the mood of the dance. The principal means of expression of mood is color. In dance, lighting designers are free to work in much more obvious ways with color because they do not have to create patterns of light and shadow as high in verisimilitude as those of their counterparts in the theatre. As a result, they may not have to worry if the face of a dancer is red or blue or green, a characteristic that might be disastrous in a play. Thus, dance tends to employ stronger, more colorful, and more suggestive lighting than theatre. Colors will be more saturated, and the qualities of the human body, as a form, will be explored much more strongly in light.

The same is true of costumes and settings. Because dancers obviously do not portray roles realistically, their costumes can explore more abstract communication than might be possible in the theatre. On the other hand, scenic designers must be careful to utilize color in such a way that the dancers receive focus in the stage environment. In any but the smallest of stage spaces it is easy for the human body to be overpowered by the elements of the setting because the setting occupies more space. So scene designers, in contrast to lighting designers, must be careful to provide backgrounds against which dancers will stand out in contrast, unless, of course, a synthesis of the dancer with the environment is intended, as in the case, for example, of some of the works by choreographer Merce Cunningham. Nevertheless, scene designers use color as forcefully as they can to help reinforce the overall mood of the dance.

MODEL ANALYSIS

You can analyze a dance work by using the following outline as a guide and answering the questions.

- *Genre*. In what ways did the dance piece pursue the characteristics of a particular genre—for example, ballet, modern, or folk dance?
- *Formalized movement*. In what ways did elements of formalized movement shape the piece? What recognizable explorations of first, second, third, fourth, and fifth positions occurred?
- *Line, form, and repetition*. How did the dancers, individually and as a group, create visual forms and repetitions? What were these forms—for example, were they rounded, angular, vertical, horizontal, and so on, and how did they create an emotional or intellectual impact?
- *Rhythm*. What was the rhythmic structure of the piece?
- *Mime and pantomime*. What, if any, elements of mime and pantomime were in the dance? What, if any, was the story line or symbolism of the dancers' movements?
- *Idea content*. What kind of message or experience was the dance trying to communicate? Did it succeed? Why or why not?

- **Music.** How did the dance relate to the music that accompanied it? If there was no musical accompaniment, what effect did that have on your experience of the work?
- **Mise-en-scène.** What role did the elements of the mise-en-scène play in the dance? How did the settings, lighting, and costumes work in conjunction with the movements of the dancers to create a total experience? In what ways did changes in lighting enhance or detract from your experience of the piece?
- **Reaction.** How did the previous elements combine to create a reaction in you? In other words, what drew your attention? What is your emotional response to the dance piece, and what causes that reaction?

FURTHER READING

Ambrosio, Nora. *Learning About Dance*. Dubuque, IA: Kendall Hunt, 1999.

Benbow-Pfalzgraf, Taryn. *International Dictionary of Modern Dance*. New York: St James Press, 1998.

Highwater, Jamake. *Dance: Rituals of Experience* (3rd ed.). New York: Oxford University Press, 1996.

Ryman, Rhonda. *Dictionary of Classical Ballet Terminology*. Princeton, NJ: Princeton Book Company, 1998.

At the Cinema—Film

Like theatre, but without the spontaneity of "live" performers, cinema portrays life nearly as graphically as it is found on the streets. On the other hand, through the magic of sophisticated special effects, films can create new worlds plausibly in ways open to no other form of art.

Film, also, because of its status in popular culture, possesses a unique ability to fulfill the function of art, discussed earlier, to deliver social and political commentary. In this regard, film reminds us of how we can be influenced by works of art, sometimes subtly, and sometimes blatantly. For example, director James Cameron (*Titanic*, 1997) admitted that he made the movie as a Marxist-Socialist critique of America. Consequently, we need to reflect on the meanings and implications of the works we encounter and enjoy. Part of our task in developing critical perception of works of art includes indentifying how they can not only entertain us but create changes in our culture as well.

Cinema, the most familiar and most easily accessible art form, is usually accepted casually, and yet all of its elements come carefully crafted from editing techniques, camera usage, juxtaposition of image, and structural rhythms. As a result, film can rise from the realm of mere entertainment to the level of serious art. George Bernard Shaw, the Irish playwright once observed that "Details are important; they make comments." It may not be as easy as it seems to perceive the details of a film because, while the search proceeds, the entertainment elements of the film draw attention away from the search.

Briefly, film is aesthetic communication through the design of time and three-dimensional space compressed into a two-dimensional image. Once the principles of photography had evolved, and the mechanics of recording and projecting cinematic images understood, society was ready for pictures that could move, project color, and, eventually, talk.

A strip of film is actually a series of still pictures running the length of the strip. Each of these pictures, or *frames*, is about $\frac{4}{5}$ inch (22 mm) wide and $\frac{3}{5}$ inch (16 mm) high. The frames, in relation to each other, seem to show exactly the same scene. However, the position of the objects in each frame is slightly different. Film also contains sixteen frames per foot (30 mm). When it runs on a projecting device and passes before a light source at the rate of twenty-four frames per second (sixteen to eighteen frames per second for silent films), a magnifying lens enlarges the frames. Projected on a screen, the images appear to move. However, the motion picture, as film is popularly called, does not really move but only seems to. This is caused by an optical phenomenon called *persistence of vision*, which, according to legend, was discovered by the astronomer Ptolemy in the second century CE. The theory behind persistence of vision asserts that the eyes take a fraction of a second to record an impression of an image and send it to the brain. Once the impression is received, the eye retains it on the retina for about one-tenth of a second after the actual image has disappeared.

A film projector pulls the film between a light source and a lens in a stop-and-go fashion, with the film pausing long enough at each frame to let the eye take in the picture. Then a shutter on the projector closes, the retina retains the image, and the projection mechanism pulls the film ahead to the next frame. Perforations along the right-hand side of the filmstrip enable the teeth on the gear of the driving mechanism to grasp the film and not only move it along frame by frame but also hold it steady in the gate (the slot between the light source and the magnifying lens). This stop-and-go motion gives the impression of continuous movement. If the film did not pause at each frame, the eye would receive a blurred image.

The motion picture was originally invented as a device for recording and depicting motion, but the realization that film could record and present stories—in particular, stories that made use of the unique qualities of the medium—quickly followed (http://www.gen.umn.edu/faculty_staff/yahnke/film/cinema1.htm). As film art emerged, it coalesced into three distinct genres: narrative film, documentary film, and absolute film.

BASIC CINEMA TYPES

Narrative

Narrative film tells a story. In many ways it uses the techniques of theatre. It follows the rules of literary construction in that it begins with expository material, adds levels of complications, builds to a climax, and ends with a resolution of the plot elements. As in theatre, under the guidance of a director, actors portray the characters. The action takes place within a setting designed and constructed primarily for the story but allowing cameras to move freely.

Many narrative films pursue genre subjects—for example westerns, detective stories, horror stories, and so on. In these films the story elements are so familiar to the audience that they usually know the outcome of the plot

before it begins. The final showdown between the "good guy" and the "bad guy," the destruction of a city, and the identification of a murderer by a detective are all familiar plot scenarios that have become clichés or stereotypes; their use fulfills audience expectations. Film versions of popular novels and stories written especially for the screen form part of the narrative-film form, but because film is a major part of the mass entertainment industry, the narrative presented is usually material that will attract a large audience and thus assure a profit (More on film artists of the twentieth century: http://www.film100.com/cgi/direct.cgi?v.grif.945639496). Narrative films may also include elements from documentary and absolute film.

In a film of this genre the narrative can also be interpreted symbolically. Regardless of the story, principles of universality apply. *E.T.: The Extra-Terrestrial* (1982), for example, tells a story of fantasy that also symbolizes the innocence and beauty of childhood. E.T. says goodbye to his friend Eliot, and Eliot will likewise outgrow his childhood. The memories, however, remain.

Documentary

Documentary film is an attempt to record actuality using primarily either a sociological or a journalistic approach. It is normally not reenacted by professional actors and is often shot as the event occurs—at the same time and place as the occurrence. The film may use a narrative structure, and some of the events may be ordered or compressed for dramatic reasons, but its presentation gives the illusion of reality. Footage shown on the evening news, programming concerned with current events or problems, and television or film coverage of worldwide events such as the Olympics are all examples of documentary film. All convey a sense of reality as well as a recording of time and place (Example: Leni Riefenstahl; http://www.german-way.com/cinema/rief.html).

Absolute

Absolute film exists for its own sake: for its record of movement or form. It ignores narrative techniques, although it occasionally employs documentary techniques. Created neither in the camera nor on location, absolute film is constructed carefully, piece by piece, on the editing table or through special effects and multiple-printing techniques. It tells no story but exists solely as movement or form. Absolute film is rarely longer than twelve minutes (one reel) in length, and usually is not created for commercial intent but only as an artistic experience (For more on experimental film visit http://dmoz.org/Arts/Movies/Genres/Experimental_Film/).

BASIC FILM TECHNIQUES

EDITING Film is rarely recorded in the order of its final presentation. It is filmed in bits and pieces and put together, after all the photography is finished, as one puts together a jigsaw puzzle or builds a house. The force or strength of the final product depends upon the editing process, the manner in which the camera and

the lighting are handled, and the movement of the actors. Perhaps the greatest difference between film and the other arts is *plasticity*—the quality of film that enables it to be cut, spliced, and ordered according to the needs of the film and the desires of the filmmaker. If twenty people were presented with all the footage shot of a presidential inauguration, for example, and asked to make a film commemorating the event, twenty different films would result.

The Shot

The shot is the basic unit of filmmaking, and several varieties are used. The *master shot* is a single, uninterrupted, shot of an entire piece of action, taken to facilitate the assembly of the component shots of which the scene will finally be composed. The *establishing shot* is a long shot (see below) introduced at the beginning of a scene to establish the interrelationship of details, time, or place. A *long shot* is taken with the camera a considerable distance from the subject, a *medium shot* is taken nearer to the subject, and a *close-up*, even nearer. A close-up of two people within a frame is called a *two-shot*, and a *bridging shot* is one inserted in the editing of a scene to cover a brief break in continuity.

CUTTING *Cutting* is joining shots together during the editing process. A *jump cut* is a cut that breaks the continuity of time by moving forward from one part of the action to another that is obviously separated from the first by an interval of time, location, or camera position. A *form cut* jumps from one image to another—that is, from one object to a different one that has a similar shape or contour. Its purpose is to create a smooth transition from one shot to another. **Montage** (mahn-TAHZH) can be considered the most aesthetic use of the cut in film. It is handled in two basic ways: first as an indication of compression or elongation of time, and, second, as a rapid succession of images to illustrate an association of ideas.

Cutting within the frame is a method used to avoid the editing process altogether. It employs actor and/or camera movement and allows the scene to progress smoothly. For example, in a scene in John Ford's classic western, *Stagecoach*, the coach and its passengers have just passed through hostile territory without being attacked; the driver and his passengers all express relief. Ford cuts to a long shot of the coach moving across the desert and *pans*, or follows, the coach from right to left across the screen. This movement of the camera suddenly reveals in the foreground, and in close-up, the face of a hostile warrior watching the passage of the coach. In other words, the filmmaker has moved smoothly from a long shot to a close-up without needing the editing process. He has also established a spatial relationship.

Crosscutting constitutes an alternation between two separate actions related by theme, mood, or plot but occurring at the same time. A classic western cliché illustrates this technique. A wagon train is under attack, and the valiant settlers are running out of ammunition. The hero has found a

troop of cavalry, which rides frantically to effect a rescue. The film alternates between pioneers fighting for their lives and cavalry racing toward them. The film continues to cut back and forth between the two scenes, increasing in pace until the scene builds to a climax: the cavalry arrives in time to save the wagon train.

Directors choose to cut, or to cut within the frame because the results of each option creates psychological overtones that cause responses in the viewer. In the arena scene in *Gladiator* (2000), in which the protagonist must fight another gladiator while menaced by a tiger, director Ridley Scott cuts back and forth from Russell Crowe to the tiger and the other gladiator to create suspense. When he combines them all in one shot, however, he produces the maximum sense of danger.

A subtle form of crosscutting called *parallel development* occurs in *The Godfather, Part I*. At the close of the film, Michael Corleone acts as the godfather for his sister's son in church, while elsewhere, his men destroy their enemies. The film alternates between views of Michael at the religious service and sequences of violent death. The parallel construction draws ironic comparison, the juxtaposition of which suggests that audience members draw their own inferences. Meaning in the film is thereby deepened.

A QUESTION TO ASK

In what ways do the various types of cutting in this film contribute to the pace and meaning of the experience?

Dissolves

During the printing of a film negative, transitional devices can be worked into a scene. They are generally used to indicate the end of one scene and the beginning of another. The camera can cut to the next scene, but the transition is smoother if the scene fades out into black and the next scene fades in. This is called a *dissolve*. A *lap dissolve* occurs when the fade-out and the fade-in happen simultaneously, and the scenes momentarily overlap. A *wipe* is a form of transition in which an invisible line moves across the screen, eliminating one shot and revealing the next, much as a windshield wiper moves across the window of a car. Closing or opening the aperture of the lens creates an *iris-in* or *iris-out*. This technique is used effectively in *Star Wars, Episode I: The Phantom Menace.*

STYLE SPOT

Neo-Realism. A post–World War II film style stressing objectivity and lifelikeness. See p. 138

Focus

The manner in which the camera views a scene adds meaning to a film. If both near and distant objects appear clearly at the same time, the camera employs *depth of focus*. In this situation, actors can move without necessitating a change of camera position. If the main object of interest is photographed while the remainder of the scene is blurred or *out of focus*, the technique is called *rack* or *differential focus*. Filmmakers find this technique especially effective in channeling an audience's attention where the director wishes it.

Camera Movement

The movement of a camera as well as its position can add variety or impact to a shot or scene. Here are some of the possibilities for physical (as opposed to apparent) camera movements. The *track* is a shot taken as the camera moves in the same direction, at the same speed, and in the same place as the object photographed. A *pan* rotates the camera horizontally while keeping it fixed vertically. A *tilt* moves the camera vertically or diagonally. Moving the camera toward or away from the subject is called a *dolly shot*. Changing the focal length of the lens, as opposed to moving the camera is known as a *zoom shot*.

MODEL ANALYSIS

You can analyze a film using the following outline as a guide and answering the questions.

- *Genres*. What was the genre of the film? If it was a narrative film, how did the elements of plot work? Where did the crises, climax, and denouement occur? If it was an absolute film, what artistic elements such as composition were present, and how did the filmmaker utilize them to create specific effects? If the film was a documentary, what characteristics of that genre did the filmmaker explore?
- *Editing*. What elements of editing were utilized, and how did those elements control viewer response or affect the rhythm and pace of the film?
- *Shots*. What shots did the filmmaker seem to emphasize? How did that emphasis create a basic sense of spectacle in the film?
- *Cutting*. How did the editor make use of cutting to create rhythmic flow in the film? What specific effects did the cutting techniques have on the mood, structure, and meaning of the film?
- *Dissolves*. Did the filmmaker utilize any particular type of dissolve for specific effects? What were they?
- *Focus*. How did the use of focus seek to control your attention? Was it successful?
- *Camera movement*. In what ways did camera movement contribute to the overall effect of the film?
- *Reaction*. How did the previous elements combine to create a reaction in you? In other words, what drew your attention? What is your emotional response to the film, and what causes that reaction?

FURTHER READING

Arnheim, Rudolph. *Film as Art*. Berkeley: University of California Press, 1997.

Bobker, Lee R. *Elements of Film*. New York: Harcourt Brace Jovanovich, 1979.

Bordwell, David and Kristin Thompson. *Film Art: An Introduction*. Reading, MA: Addison-Wesley, 1996.

Cook, David. *A History of Narrative Film*. New York: Norton, 1981.

Giannetti, Louis. *Understanding Movies*. Englewood Cliffs, NJ: Prentice Hall, 1996.

Thompson, Kristin and David Bordwell. *Film History: An Introduction*. New York: McGraw Hill, 1994.

Style

WHAT IS STYLE?

Style is tantamount to the personality of a work of art. Within any medium—for example, painting, sculpture, architecture, music, and so on—artists make choices about employing the characteristics of that medium. The sum of their choices equals their style. In other words, style is the characteristics that identify an artwork with an individual, a historical period, a school of artists, or a nation.

Determining the style of an artwork requires analysis of the artist's arrangement of the characteristics of his or her medium. If the arrangement is similar to others', we might conclude that they exemplify the same style. For example, Bach and Handel typify the *Baroque* style in music (Examples: J.S. Bach, Prelude and Fugue in D, BWV.532; http://www.prs.net/bach.html; select "Prelude and Fugue in D, BWV.532"; and G.F. Handel, Organ Concerto, Op. 4 No. 6 in B Flat, first movement, Andante Allegro; http://www.prs.net/handel.html; select "Organ Concerto, Op. 4," etc.). Mozart and Haydn share the *classical* style (Examples: W.A. Mozart, *Piano Sonata No. 11 in A*, K. 331, CD track 12, http://www.prs.net/mozart.html; select "Piano Sonata No. 11 in A, K. 331, rondo alla turca"; and Franz Joseph Haydn, *Piano Sonata No. 20 in C*; http://www.prs.net/haydn.html; select *Piano Sonata No. 20 in C*). Listening to works by these composers leads to the conclusion that the ornate qualities of Bach are like those of Handel, and quite different from the concerns for simplicity of structure in Mozart and Haydn. A building such as the Parthenon, in the classical style (http://www.bluffton.edu/~sullivanm/acropolis/acropolis.html), will exhibit the same concern for structure as a piece of classical music, and a building such as the Versailles Palace, in the Baroque style (http://www.smartweb.fr/versailles/), will reflect the ornate complexity as its stylistic counterpart in music. A single style, therefore, might be found in an

individual work, several works within the same discipline or medium, and also among works of different media.

TIMELINE OF MAJOR STYLES

30,000 BCE
300 BCE 8,000 BCE 550 BCE 450 BCE 300 BCE 0

Paleolithic Mesopotamian
 Egyptian Archaic Greek Classicism Hellenistic
 Roman Classicism

700 1000 1100 1350 1500 1550

Byzantine Romanesque Gothic Renaissance High Renaissance Mannerism
Gregorian Chant Baroque

1600 1700 1800 1900

Baroque Rococo Neo-Classicism Romanticism
 Neo-Classical Theatre Music Classicism Realism
 Impressionism
 Naturalism
 Post-Impressionism

1900 1925 1950 1975 2000

Art Nouveau Abstraction Op Art Primary Structures
Symbolism 12-Tone Video Art
Verismo Bauhaus Hard Edge
 Neo-Classicism (Music) Minimalism
 Cubism Art Deco Neorealism (film) Neo-Expressionism
 Futurism Modernism Post-Modernism
 Jazz Absurdism Neo-Abstraction
 Prairie Style Serialism Musique-Actuelle
 Fauvism Epic Theatre Cyber Art
 Precisionism Abstract Expressionism
 Expressionism Aleatory
 Dada International Style
 Surrealism Rock 'n' Roll
 Pop Art

SOME SELECTED MAJOR STYLES IN VISUAL ART, ARCHITECTURE, THEATER, MUSIC, DANCE, AND FILM

This section lists and describes a few major styles for general reference. The styles are listed in chronological order. The URLs will lead you to examples of and, in some cases, further information about, the style.

Paleolithic

Paleolithic, Stone Age, or Ice Age art (30,000 BCE–8,000 BCE) comprises the earliest record of human creative activity. Among these works, Venus

figures are the most common. Venus figures are small female figurines easily recognizable by their consistent shape, which has tapering legs, wide hips, and sloping shoulders. These have been found in burial sites in a band stretching approximately 1,100 miles (1,770 kilometers) from western France to the central Russian plain. They may have been fertility figures or merely objects for exchange (Example: Woman from Willendorf; http://campus.northpark.edu/history/WebChron/Prehistory/Willendorf.html). Perhaps the most familiar examples of Paleolithic art are cave paintings, of which those of the Cave of Lascaux, France, are the most spectacular (http://www.culture.fr/culture/arcnat/lascaux/en).

Mesopotamian

Generally regarded as the earliest documented civilizations, those of the "Fertile Crescent" between the Tigris and Euphrates Rivers in what, today, is Iraq, comprised the civilizations of Mesopotamia (*c.* 8,000 BCE–100 BCE). These included Sumeria, Babylonia, and Assyria. Art in the styles of these civilizations tends to be fairly geometric, blocky, two-dimensional, and decorated with an easily recognizable ensemble of dress and hairstyle (Example: Sumerian statuettes http://www.oi.uchicago.edu/OI/MUS/HIGH/OIM_A12332.html).

Egyptian

The most familiar objects in Egyptian art (3,000 BCE–500 BCE) are the pyramids. The Egyptians, however, were also accomplished sculptors and painters. Egyptian painting was subordinate to sculpture. According to some sources, the Egyptians may not even have regarded it as an art form. Painting was, for the most part, a decorative medium that provided a surface finish to a work of sculpture. Sculptures in relief and in the round were painted. Flat surfaces were also painted, although such paintings often appear to be substitutes for relief sculpture. Egyptian artists had a formulaic approach to the human figure, although proportions varied from one period to another. The basic figure is the standing male, and his proportions dictated those of other figures. Figures are typically portrayed in profile, except for the eye, without any sense of deep space or perspective (Examples: artifacts from the Egyptian Museum; http://www.powerup.com.au/~ancient/museum.htm).

Archaic Style

Archaic style represents the Greek world of the mid-sixth century BCE. In architecture it employs post-and-lintel structure and predominates in temples with imposing vertical posts or columns capped by heavy lintels and a **pedimented** roof. *Fluted*, or vertically grooved, columns are also typical. This style has *Doric* features (Figure 14, p. 27). Archaic style in painting can be seen in Greek vases. Depictions of the human form appear in three-quarter position, between profile and full frontal. The human eye is depicted fairly realistically. This style also contains graduated registers (bands) that contain intricate and graceful geometric designs. Pottery of this style can be divided into two types—*black figure*, in

which the design appears in black against the light clay background (http://www.louvre.fr/img/photos/collec/ager/grande/e0635.jpg), and *red figure*, in which the figures appear in the natural red clay against a glazed black background (http://www.louvre.fr/img/photos/collec/ager/grande/g0103.jpg).

Archaic Greek style in sculpture mostly represents free-standing statues of nude youths, known as *kouroi* (http://harpy.uccs.edu/greek/archaicsculpt.html). They exhibit a stiff, fully frontal pose. The head is raised, eyes are fixed to the front, and arms hang straight down at the sides, with the fists clenched. The emphasis of these statues is on physicality and athleticism. The shoulders are broad, the pectoral muscles well developed, and the waist narrow. The legs show the musculature of a finely tuned athlete with solid buttocks and hardened calves. Features are simplified, and the posture, despite the movement of one foot into the forward plane, is rigid. Fully dressed female forms in this style are known as *kore*.

Greek Classicism

Greek classicism (mid-fifth century BCE) in architecture rests, as do all classical styles, on the principles of simplicity, harmony, restraint, proportion, and reason. It finds its best examples in temples like the Parthenon in Athens, Greece. This style is the foundation or prototype for buildings throughout the history of Western culture, and its balance comes from geometric symmetry and clean, simple lines. Many Greek temples of the classical style are *peripteral*—that is, surrounded by a single row of columns. It employs Doric and Ionic orders? (Example: The Parthenon, http://www.bluffton.edu/~sullivanm/acropolis/acropolis.html).

Greek classicism in painting is seen exclusively in vases. The geometric nature of the designs of vase paintings in this style remains from the earlier Archaic, but there is a new sense of idealized, but lifelike, reality in figure depiction. Foreshortening (the contracting of lines to produce an illusion of projection in space) occurs, giving the figures a sense of depth that in some cases is strengthened by the use of light and shadow. Four characteristics define the style: (1) the figures are portrayed in simple line drawings, (2) the palette or color scheme is monochromatic—for example, red on black or black on red, (3) the palette depends on earthen tones, and (4) the subject matter is idealized and heroic.

Greek classical style in sculpture began with the sculptors Myron and Polyclitus (http://harpy.uccs.edu/greek/classicalsc.html). The human figure is elegantly idealized, with subtle variation in fabric depiction. Balance departs from symmetry: The weight of the figure is slightly shifted to one leg, and the head turns gently away from the centerline. This produces an S-curve in the figure called *contrapposto* stance.

Greek classicism in theater also pursues the ideals of simplicity, harmony, restraint, proportion, and reason. The playwrights Aeschylus, Sophocles, and Euripides provide the only extant examples. Remains of Greek classical theaters dot the Mediterranean from Athens to Turkey and North Africa (Example: Theater at Epidaurus; http://www.culture.gr/2/21/211/21104n/e211dn02.html).

Hellenistic Style

Hellenistic style (fourth century BCE–c. second century CE) in sculpture encompassed a diversity of approaches reflecting an increasing interest in the differences between individual humans. Hellenistic sculptors turned away from idealization (Example: *Nike of Samothrace;* http://www.louvre.fr/img/photos/collec/ager/grande/ma2369.jpg).

In architecture, the style reflected a change in proportions toward slender and ornate Corinthian columns (Figure 14) and an approach designed to produce an overwhelming emotional experience (Example: Temple of the Olympian Zeus; http://lilt.ilstu.edu/drjclassics /sites/athens/OlympianZeus/olympianzeus.htm).

Roman Classicism

Roman classicism dates to the turn of the Common or Christian Era and the reign of Augustus Caesar. Although Rome did little more than copy Greek classical forms, in architecture they added one important element, which differentiates Roman classicism from Greek classicism. That element is the Roman, or semicircular, round, arch (Figure 4, p. 21). The Roman classical style also employs attached columns (Examples: The Pantheon, http://www.nga.gov /cgi-bin/pinfo?Object=168+0+none and aqueducts such as at Pont du Gard in southern France http://www.chch.school.nz/mbc/pontdu.htm).

Byzantine

Byzantine style (sixth–mid-fifteenth centuries) in architecture followed a variety of plans, although by the fifteenth century a Byzantine church had a typical form consisting of a central dome with a grouping of three apses at the East end of the building. The ground plan of later churches typically described a cross-in-square (Example: St. Sophia, Istanbul, Turkey; http://w4u.eexi.gr/~ippotis/sumagiasen.html).

Byzantine style in two-dimensional art reflects a diversity of approaches. Most commonly, it reflects the *hieratic style* (typically mosaics and manuscript illuminations). The word hieratic means *holy* or *sacred* and exhibits formal, almost rigid figures designed to inspire reverence and meditation and reflects a strict canon whereby the human body measures nine heads in height (seven heads gives a lifelike proportion. Example: San Vitale, Ravenna; http://web.kyoto-inet.or.jp/org/orion/eng/hst/byzantz/sanvital.html).

Gregorian Chant

Gregorian chant (named for Pope Gregory I [540–604]) comprises a body of sacred—that is, religious—music also called *chant, plainchant,* or *plainsong.* Chant was vocal and took the form of a single melodic line (monophony) using notes relatively near each other on the musical scale. The haunting, undulating character of early chants may indicate Near Eastern origins. Chants were sung in a flexible tempo with unmeasured rhythms following the natural accents of normal Latin speech.

Romanesque

Romanesque style (eleventh–early twelfth centuries) in architecture occupied Europe for a relatively short period of time. The curved arches over doorways and windows throughout Europe was like the Roman. Therefore, it was called *Romanesque*. With its arched doorways and windows, this style is massive, static, and comparatively light-less, reflecting the barricaded mentality and lifestyle generally associated with the Middle Ages (Example: St. Sernin at Toulouse, http://www.bc.edu/bc_org/avp/cas/fnart/arch/st_sernin.html).

Romanesque style in sculpture, although fairly diverse, has a frequent association with Romanesque architecture in that we find it mostly attached to buildings. Three characteristics of the style are: (1) It is associated with Romanesque architecture, (2) it is stone, (3) it is monumental (Example: Gislebertus, Last Judgment Tympanum, Autun Cathedral, France; http://infoeagle.bc.edu/bc_org/avp/cas/fnart/arch/romanesque/autun01.jpg).

Gothic

Gothic style (twelfth–thirteenth centuries) in architecture took many forms, but we know it best through the Gothic cathedral, exemplified by the pointed, lancet, or Gothic arch (Figure 4, p. 21). In its synthesis of intellect, spirituality, and engineering, the cathedral perfectly expresses the medieval mind. Gothic cathedrals use refined, upward-striving lines to symbolize humanity's upward striving to escape the bounds of earth and enter the mystery of space (the kingdom of heaven). The pointed arch represents not only a symbol of Gothic spirituality, but an engineering practicality. The control of stresses made possible by the Gothic arch allows for larger **clerestory windows** and more interior light. In Germany, a kind of Gothic construction called *hallenkirchen* has side aisles rising to the full height of the nave, unlike the traditional Gothic style wherein the aisles are lower than the nave in order to accommodate clerestory windows in upper walls of the nave (Example: Amiens Cathedral, France, http://www.mcah.columbia.edu/Amiens.html).

Gothic sculpture portrays serenity, idealism, and simple naturalism. It has a human quality portraying life as valuable, Christ as a benevolent teacher, and God as awesome in his beauty rather than in his vengeance. Visual images carry over a distance with greater distinctness, and the figures of Gothic sculpture—still predominantly associated with churches—are less entrapped in their material and standing away from their backgrounds than their predecessors (Example: Jamb statues, Chartres Cathedral, France; http://www.bluffton.edu/~sullivanm/chartreswest/centralportal.html).

Renaissance

Renaissance (fourteenth–fifteenth centuries). Renaissance (means *rebirth*) architecture sought to capture the forms and ideas of the ancient Greeks and Romans, and follow human rather than ecclesiastical principles and potentials. Three principle changes separate Renaissance style from its predecessors: (1) mechanical and geometric revival of Roman buildings, (2) decora-

tive detail appears on the façades of buildings, and (3) structural systems are hidden from view (Example: Leon Battista Alberti, Palazzo Rucellai, http://www.bluffton.edu/~sullivanm/rucellai/rucellai.html).

Painting in the Renaissance style has gravity and monumentality that makes figures seem larger than life. The use of deep perspective and modeling to create dramatic contrasts gives solidity to the figures and unifies the paintings. Atmospheric perspective enhances deep spatial naturalism. Figures are strong, detailed, and very human. At the same time, the composition carefully subordinates the parts of the painting to the whole. The works of Masaccio represent the origins of this style (http://www.kfki.hu/~arthp/bio/m/masaccio/biograph.html).

Renaissance sculpture reflects a newly developed skill in creating images of great verisimilitude but the goal of Renaissance sculptors, unlike the classical Greeks, was not to idealize human form but to portray it in a more complex, balanced, and action-filled dimension. Relief sculpture of this style found new ways of representing deep space through the systematic use of perspective. Free-standing sculpture dominated and exhibited a focus on anatomy. Renaissance sculpture's best examples are those of Donatello and Ghiberti (Example: Donatello, *David*; http://www.artchive.com/artchive/ftptoc/donatello_ext.html). For Renaissance artists visit http://artcyclopedia.com/history/early-renaissance.html; http://artcyclopedia.com/history/high-renaissance.html; and http://artcyclopedia.com/history/northern-renaissance.html).

High Renaissance

High Renaissance (late fifteenth to early sixteenth centuries) painting sought a universal ideal through impressive themes and styles. Figures become types rather than individuals as painters sought to capture classical qualities without copying classical works. The impact is stability without immobility, variety without confusion, and definition without dullness. Composition is meticulous and based almost exclusively on geometric devices such as a triangle or an oval. Composition is closed—that is, line, color, and form, keep the viewer's eye continually redirected into the work. This style was practiced by Leonardo da Vinci, Michelangelo, and Raphael (Example: Leonardo da Vinci, *Mona Lisa*; http://www.louvre.fr/img/photos/collec/peint/grande/inv0779.jpg).

High Renaissance sculpture also sought a universal ideal through impressive themes and styles. Figures become types rather than individuals and measurement became subordinate to judgment when establishing proportions. Surface texture takes on the soft luster of actual flesh in its high polish. The dominant figure of this style is Michelangelo (Example: Michelangelo; *David*: http://www.sbas.firenze.it/accademia/).

Mannerism

Mannerist (mid- to late sixteenth century) architecture utilizes discomfiting designs of superficial detail and unusual proportions, with strange juxtapositions of curvilinear and rectilinear items. Decorative detail is

applied to exterior wall surfaces in the Renaissance fashion, but flattened domes and shallow arches replace mathematical proportions (Example: Pierre Lescot, West Wing of the Louvre, Paris; http://www.usc.edu/schools/annenberg/asc/projects/comm544/library/images/016.html).

Mannerist painting takes its name from the mannered or affected appearance of the subjects in the paintings. These works are coldly formal and inward looking. Their oddly proportioned forms, icy stares, and subjective viewpoint can be puzzling yet intriguing when seen out of context. Mannerism has an intellectual component that distorts reality, alters space, and makes obscure cultural allusions. It contains anticlassical emotionalism and abandons classical balance and form while employing formality and geometry. Representative artists include Bronzino and Parmigianino (Example: Parmigianino, Madonna and Child with Angels; http://www.arca.net/uffizi/img/230.jpg).

Baroque

Baroque style (late sixteenth–seventeenth century) in architecture emphasizes the same contrasts between light and shade and the same action, emotion, opulence, and ornamentation as the other visual arts of the style. Because of its scale, however, architecture's effect becomes one of great dramatic spectacle (Example: Versailles Palace, France, http://www.chateauversailles.fr/en/).

Baroque style in painting appeals to the emotions and to a desire for magnificence through opulent ornamentation. At the same time, it employs systematic and rational composition in which ornamentation is unified through variation on a single theme. Realism (lifelikeness using selected details) is the objective. Color, grandeur, and dramatic use of light and shade (chiaroscuro) are fairly typical, although the style itself is quite diverse in application. In much of Baroque art, sophisticated organizational schemes carefully subordinate and merge one part into the next to create complex but unified wholes. Open composition symbolizes the notion of an expansive universe: The viewer's eye travels off the canvas to a wider reality. The human figure may be monumental or miniscule. Feeling is emphasized rather than form; emotion rather than intellect. This is the style of Rubens and Rembrandt (Example: Peter Paul Rubens, *Assumption of the Virgin*; http://www.nga.gov/cgi-bin/pinfo?Object=45848+0+none).

Baroque style in sculpture emphasizes splendor. Forms and space are charged with energy that carries beyond the confines of the work. As in painting, baroque sculpture invites participation rather than neutral observation. Feeling is the focus. Baroque sculpture tends to treat space pictorially, almost like a painting, to describe action scenes rather than single sculptural forms (Example: Pierre Puget; *Milo of Crotona*; http://www.louvre.fr/img/photos/collec/sculpt/grande/mr2075.jpg).

Baroque style in music extends from 1600 to 1750—slightly longer than in the other arts. The term Baroque originally referred to a large, irregularly shaped pearl of the kind often used in the extremely fanciful jewelry of the

post-Renaissance period, and music of this style is as luscious, ornate, and emotionally appealing as is its siblings of painting, sculpture, and architecture. Baroque composers brought to their music new kinds of action and tension—for example, quick, strong contrasts in tone color or volume, and strict rhythms juxtaposed against free rhythms. This is the music of Bach, Handel, and Vivaldi (Example: J.S. Bach, *Prelude and Fugue in G*, BWV.541; http://www.prs.net/bach.html#500; select Prelude and Fugue in G; BWV.541).

Rococo

Rococo style in architecture (eighteenth century), unlike most previous architectural styles, was principally a style of interior design. Its refinement and decorativeness applied to furniture and décor more than to exterior structure or even detail. At this time in history, the aristocracy lived principally in attached row houses and townhouses and, simply, had no exteriors to design. The result was a delicate style with pseudonatural effects typified by curved leg furniture, cornices, and gilded carvings creating a pleasant atmosphere of grace and propriety.

Rococo style in painting is essentially a decorous style exhibiting intimate grace, charm, and delicate superficiality. Its scenes portray lively effervescence and melodrama with predominant themes of love, friendship, sentiment, pleasure, and sincerity. A frivolous "naughtiness" often pervades paintings of this style (Example: Jean-Honoré Fragonard, *The Swing*; http://www.nga.gov/cgi-bin/pinfo?Object=45833+0+none).

Rococo style in sculpture, like painting, is decorous, intimate, graceful, charming, and delicately superficial. Cupids, nymphs, and Venus (the goddess of love) are frequent subjects, and their mythological character usually has a contemporary meaning. Love, friendship, sentiment, and pleasure are frequent themes. The scale of Rococo sculpture is less monumental than the Baroque. It often takes the shape of graceful porcelain and metal figurines that capture erotic sensuality and lively intelligence (Example: Étienne-Maurice Falconet, *Venus of the Doves*; http://www.nga.gov/cgi-bin/pinfo?Object=41443+0+none).

Neoclassicism (Classicism in Music)

Neoclassicism (eighteenth century [sixteenth century in theatre; early twentieth century in music]) in architecture sought to embrace the complex philosophical concerns of the eighteenth-century Enlightenment. The result is a series of styles and substyles. Neoclassicism offered a new way of examining the past. Eclectic as well as historical, architectural neoclassicism exhibits a variety of treatments of forms of Greek and Roman classicism—for example, clearly stated Doric, Ionic, and Corinthian porches with pedimented rooflines (Example: Thomas Jefferson, Monticello, http://www.monticello.org).

Neoclassicism in painting (eighteenth century) reflects a perception of grandeur in antiquity. Classical details appear selectively. Often, the style is characterized by starkness of outline, strong geometric composition, and smooth color areas and gradations reflecting the formality of the classical

tradition. The details of neoclassical paintings move toward the surface, appearing as if in a shallow picture box defined by simple architectural frameworks (Example: Jacques-Louis David, *The Oath of the Horatii*; http://www.louvre.fr/img/photos/collec/peint/grande/inv3692.jpg).

Neoclassicism in sculpture (eighteenth century), like painting, reflects a perception of grandeur in antiquity. It frequently manifests itself in life-sized portrait busts that exhibit acute psychological observation and accurate technical execution. Works in the style seem to pursue truth through lifelikeness (Example: Clodion, *Poetry and Music*; http://www.nga.gov/cgi-bin/pinfo?Object=41440+0+none).

Neoclassical theatre occurs simultaneously with Baroque style in music, visual art, and architecture (1550–1720). The term "neoclassicism" or "new" classicism refers to the attempt by the French literary Academy to recreate the dramatic structure of Greek classical playwrights such as Sophocles. Plays of this style had to be written according to specified "rules" thought to adhere to the "Unities" described by the Greek philosopher of the fourth century BCE, Aristotle. Specifically, the action of the play must occur in a single location and encompass no more than 24 hours. The major playwrights of this style were the tragedians Pierre Corneille and Jean Racine, with Molière providing comedies set in Baroque ambiance.

Musical classicism (eighteenth century) rejected what was seen as excessive ornamentation and complexity in Baroque music and aimed toward a broad audience appeal. The style, reflecting the ideals of general classicism, sought to achieve order, simplicity, and careful attention to form. The style is called *classical* rather than neoclassical because music had no classical (Greek or Roman) antecedents to which it could turn. It is, thus, classical in ideal rather than model. The classical style in music exhibits five basic characteristics: (1) variety and contrast in mood, (2) flexibility of rhythm, (3) a predominantly homophonic texture, (4) memorable melody, and (5) gradual changes in dynamics (Example: W.A. Mozart, *Symphony No. 40 in G*, K.550; http://www.prs.net/mozart.html).

Neoclassicism in music (twentieth century) is marked by emotional restraint, balance, and clarity. Neoclassical music utilizes forms and stylistic features of earlier periods, particularly the eighteenth century. It, however, does not merely revive earlier classical music. Rather it uses earlier techniques to organize modern harmonies and rhythms. Much neoclassical music is modeled on J.S. Bach, giving rise to the conclusion that neobaroque might also be a fair description. The two principal composers in this style are Stravinsky and Hindemith (Examples: Stravinsky, "Auguries of Spring," CD track 20; Hindemith, *Trauermusik*; http://www.prs.net/midi-f-m.html#h).

Romanticism

Romanticism (late eighteenth–nineteenth centuries) in architecture borrowed styles from other eras and produced a vast array of buildings that received Gothic motifs and reflected fantasy. This style has come to be known as "pic-

turesque." It exhibits eastern influence and whimsy. As part of the Age of Industry, Romantic architecture experimented with new, modern, materials such as glass and steel. It also, in seeking an "escape to the past" mentality, just as readily employed the common in Greek and Roman classicism—thus establishing the term, *Romantic Classicism*; a seeming oxymoron (Example: John Nash, Royal Pavilion, http://www.brighton-hove.gov.uk/bhc/pavilion/).

The Romantic style in painting has an emotional appeal. Its subjects tend toward the picturesque, including nature, Gothic images, and, often, the macabre. In seeking to break the geometrical principles of classical composition, Romantic compositions move toward fragmentation of images, with the intention of dramatizing, personalizing, and escaping into imagination. Such painting strives to subordinate formal content to expressive intent, and to express an intense introversion. As the writer Zola maintained, art in the Romantic style is "part of the universe as seen through a temperament" (Example: Théodore Géricault; *The Raft of the Medusa*; http://www.louvre.fr/img/photos/collec/peint/grande/inv0488.jpg).

Romanticism in theatre resulted in dazzling scenery, revivals, and production geared toward a mass audience. Reflecting the Romantic philosophy of the other arts, theatre of this style sought new forms and freedom from all classical restraints. Intuition rather than reason reigns. The plays of this style are rife with phony emotionalism, melodrama, and stage gimmickry. Stereotypical characters, sentimental plots, and exaggerated action form the backbone of Romantic theatre's predominant genre, melodrama.

In an era of Romantic subjectivity, music provided the medium in which many found unrivaled opportunity to express emotion. As in painting, spontaneity replaced control, but the primary emphasis of music in this style was beautiful, lyrical, and expressive melody. Phrases become longer, more irregular, and more complex than in classical style. Romantic composers emphasized colorful harmonies and instrumentation. Composers sought to disrupt the listener's expectations with more and more dissonance, often exploring it for its own sake. Exploration of musical color to elicit feeling is an important aspect of Romanticism in music. It is a style of great diversity in vocal and instrumental performance and a tremendous increase in the size and diversity of the orchestra (Example: Frédérick Chopin, *Étude in C#*, *Op. 10*; http://www.prs.net/chopin.html; select "Études Op. 10" No. 4 in C#).

Romantic ballet comprises what we understand to be ballet itself. Romantic ballet is classical ballet. Its fundamental characteristic is exhibition of "beautiful forms in graceful attitudes." It is a living painting or sculpture replete with "physical pleasure and feminine beauty," according to its principal aesthetician, Théophile Gautier (1811–1872). Choreographers of Romantic ballet sought magic and escape in fantasies and legends, of "moonbeams and gossamer." The classical or Romantic ballet repertoire still consists of the ballets *La Sylphide* (1832), *Giselle* (1841), *Swan Lake* (1877), and *The Nutcracker* (1892).

Realism

Realism in painting (mid-nineteenth century) seeks to make an objective and unprejudiced record of the customs, ideas, and appearances of contemporary society. By selectively choosing details, realism in painting goes beyond the obvious to a deeper sense of reality. This is done through spontaneity, harmonious colors, subjects from everyday life, and faithfulness to observed lighting and atmospheric effects (Example: Gustave Courbet: *Boats on a Beach, Etretat*; http://www.nga.gov/cgi-bin/pinfo?Object=52841+0+none).

Realism in the theatre (mid-nineteenth century) sought a truthful portrayal of the world. Objectivity was stressed, and knowledge of the real world was seen as possible only through direct observation (similar to painting). Thus, everyday life, with which the playwright was directly familiar, became the subject matter of drama. Focus was on human motives and experience.

Impressionism

Impressionism (mid- to late nineteenth century) in painting followed the realists' search for spontaneity, harmonious colors, subjects from everyday life, and faithfulness to observed lighting and atmospheric effects by seeking to capture the psychological perception of reality in color and motion. The concentration is on the effects of natural light on objects and atmosphere. Impressionists emphasize the presence of color within shadows and the result of color and light making an "impression" on the retina (Example: Auguste Renoir, *Bather Arranging Her Hair*; http://www.nga.gov/cgi-bin/pinfo?Object=46396+0+none).

Impressionism in music is an anti-Romantic style analogous to impressionism in painting. It freely challenges traditional tonality. The use of tone color in impressionist music has been described as "wedges of color." Oriental influence is also present. Melodic development occurs in short motifs and harmony moves away from traditional chordal harmonies. A chord is considered strictly on the merits of its expressive capabilities, apart from any idea of tonal progression within a key. Gliding chords—that is, repetition of a chord up and down the scale—is a hallmark of impressionism in music (Example: Claude Debussy, *Claire de Lune:* www.prs.net/debussy.html).

Naturalism

Naturalism in the theatre (late nineteenth century) is a style closely related to realism. It also insisted on truthful depiction of life, but naturalism went on to insist on the basic principle that behavior is determined by heredity and environment. Absolute objectivity, not personal opinion, was the naturalistic goal.

Naturalism in opera (late nineteenth century) was a counterreaction to Romanticism. It opposed stylization, although it maintained exotic settings, and included brute force and immorality. Its texts are in prose rather than poetry, and its settings appear lifelike.

Post-Impressionism

Post-impressionism in painting (late nineteenth century) is a collection of disparate styles. In subject matter post-impressionism is similar to impressionism—landscapes, familiar portraits, groups, and café and nightclub scenes imbued with a complex and profoundly personal significance. It is an "art for art's sake" philosophy full of subjective impressions. Post-impressionism seeks a return to form and structure in painting, and utilizes formal patterning with clean color areas (Examples: Vincent Van Gogh, *Girl in White;* http://www.nga.gov/cgi-bin/pinfo?Object=46222+0+none; Paul Gauguin, *Fatata te Miti (By the Sea);* http://www.nga.gov/cgi-bin/pinfo?Object=46341+0+none).

Art Nouveau

Art Nouveau architecture (late nineteenth to early twentieth centuries) is characterized by the lively, serpentine curve known as the "whiplash." Art nouveau incorporates organic and often symbolic motifs, usually languid-looking flowers and animals, and treats them in a flat, linear, and relief-like manner (Example: Antoni Gaudí, *Casa Batlló,* http://www.op.net/~jmeltzer/Gaudi/batllo.html).

Symbolism

Symbolism in the theatre (late nineteenth to mid-twentieth centuries) was antirealist. It is also known as neo-Romanticism, idealism, or impressionism. The idea behind symbolism is that truth can be grasped only by intuition, not through the senses or rational thought. Thus, ultimate truths can be suggested only through symbols, which evoke in the audience or reader various states of mind that correspond vaguely with the playwright's or writer's feelings.

Verismo

Verismo opera (early twentieth century) is similar to naturalism in that it pursues verisimilitude or true-to-life settings and events. It is hot-blooded and full of vitality, concentrating on the violent passions and common experiences of everyday people. Adultery, revenge, and murder are frequent themes.

Cubism

Cubism in painting (early twentieth century) violates all usual concepts of two- and three-dimensional perspective. Cubist artists sought to paint "not objects, but the space they engender." The area around the object becomes an extension of the object itself. Cubist space is typically quite shallow and gives the impression of reaching forward out of the frontal plane toward the viewer (Examples: Max Weber, *Interior of the Fourth Dimension;* http://www.nga.gov/cgi-bin/pinfo?Object=70385+0+none; Georges Braque,

Man with a Guitar: www.artchive.com/viewer/z.html). Although less well known, cubism also found an outlet in architecture. Excellent examples can be found in Prague, Czech Republic.

Futurism

Futurism in sculpture (early twentieth century) utilized new materials and technology to explore three-dimensional space. It sought to destroy the past to institute a totally new society and a new art. Its basis rests in the objects of "modern" life and focuses on noise, speed, and mechanical energy—exhilaration. Futurist works follow mechanistic lines and include representations of motion (Example: Umberto Boccioni, *Unique Forms of Continuity in Space*; http://www.moma.org/docs/collection/paintsculpt/c68.htm).

Jazz

Jazz (early twentieth century) began as a combination of elements from many cultures, including West African, American, and European. Mostly its creators were African American musicians who performed in the streets, bars, brothels, and dance halls of New Orleans and other southern cities. It is highly improvisational in nature and typically employs syncopated rhythm, a steady beat, and distinctive tone colors and performance techniques. It contains a number of substyles such as Dixieland, swing, bebop, cool jazz, free jazz, and jazz rock. Typically jazz is performed by small combos ranging from three to eight players or by "big bands" of ten to fifteen players (Example: Duke Ellington, "It Don't Mean a Thing," CD track 23). The rhythm section (piano, plucked double bass, and percussion) tends to be the backbone of the jazz ensemble.

Prairie Style

Prairie Style in architecture (early twentieth century) is singular to one architect, Frank Lloyd Wright (1867–1959). The style relies on strong horizontal lines, in imitation of the flatness of the American prairies, and insists on integrating the context of the building and creating indoor space that is an extension of outdoor space (Example: Frank Lloyd Wright, Frank Thomas House, http://www.bluffton.edu/~sullivanm/oakpark/oakpark5.html)

Expressionism

Expressionism (early twentieth century) in painting traditionally refers to a German movement that took place between 1905 and 1930. It also includes a variety of approaches aimed at eliciting in the viewer the same feelings the artist felt in creating the work. Any element—line, form, color—might be emphasized to elicit this response. Its treatment of subject matter ranges from representational to completely abstract or nonrepresentational (Example: Edvard Munch; *The Scream*; http://www.artchive.com/artchive/M/munch/scream.jpg.html).

Expressionism in music stressed intense subjective emotion. It is closely associated with Expressionism in painting, and explores inner feelings rather than outward appearances. Characteristic of the style in music is harsh dissonance and fragmentation, and the exploitation of extreme registers and unusual instrumental effects. Tonality and traditional chordal progressions are avoided.

Expressionism in the theatre, unlike its counterparts in visual art and music, proved merely an extension of realism or naturalism, but it did allow playwrights to express their reactions to the universe more fully. The subjective distortions characteristic of expressionism in visual art can be seen most clearly in similar appearing visualization in scenic design or stage settings.

Expressionism in film occurred primarily in post–World War I Germany and can best be illustrated by the films of Robert Wiene (pronounced veen) that contained macabre sets, bizarre lighting effects, and distorted properties to portray a menacing post-war German world.

Fauvism

Fauvism in painting (early twentieth century) is closely associated with expressionism. The word *fauves* is French for wild beasts and was applied by a critic. Violent distortion and outrageous coloring mark this style, along with two-dimensional surfaces and flat color areas (Example: Henri Matisse, *Blue Nude (Souvenir de Biskra)*; http://www.artchive.com/artchive/M/matisse/nu_bleu_iv.jpg.html).

Dada

Dada is an anti-art style (early twentieth century) that was a disillusioned reaction against the horrors of World War I. The word *dada* is French for hobbyhorse, but the Dadaists accepted it as two nonsense syllables, like a baby's first words. Dada was as much a political protest as an art movement (Example: Jean Arp, *Enak's Tears (Terrestrial Forms)*; http://www.artchive.com/artchive/A/arp/enaks_tears.jpg.html).

Surrealism

Surrealism in painting (early twentieth century) follows an early twentieth-century fascination with the subconscious mind. Surrealist works were thought to be created by "pure psychic automatism," as a way to discover the basic realities of psychic life by automatic associations. Supposedly a dream could be transferred directly from the unconscious mind of the painter to canvas without control or conscious interruption. Two directions of Surrealism emerged. The first comprises metaphysical fantasies that present fantastic scenes in a hard-edged, realistic manner. Giorgio de Chirico (kee-ree-koh) and Salvador Dalí represent this direction. These bizarre works reflect a world humans do not control. The second direction—the abstract—can be seen in the works of Joan Miró (HOH-ahn mee-ROH). (Example: Joan Miró, *Woman*: http://www.nga.gov/cgi-bin/pinfo?Object=56071+0+none).

Precisionism

Precisionism in painting (early to mid-twentieth century) is the arrangement of real objects into abstract groupings. These paintings often use the strong vibrant colors of commercial art and constitute a forerunner of Pop Art (Example: Stuart Davis, *Visa, 1951;* http://www.moma.org/collection/paintsculpt/davis.html).

Neo-Classicism (Music)

See "Neo-Classicism"—Eighteenth Century, p. 129

Abstraction

Abstract (early to mid-twentieth century) art is nonrepresentational. That is, it contains minimal reference to natural objects: objects in the world we perceive through our senses. Abstract art, in many ways, stands in contrast to impressionism and expressionism in that the observer can read little or nothing in the painting of the artist's feelings for anything outside the painting. Abstract painting explores the expressive qualities of formal design elements and materials in their own right, and these elements are assumed to stand apart from subject matter (Example: Piet Mondrian, *Broadway Boogie-Woogie;* http://www.moma.org/collection/paintsculpt/mondrian.broadway.html).

Abstraction in sculpture pursues the goals of all abstract art, and that is to explore beauty in form alone; no other quality is needed. Abstraction as a style in sculpture is less concerned with expressive content than other sculptural styles. The subject matter may, in fact, be representational, having abstract relationships to other styles of the past. Typical of this style are exquisitely finished surfaces and masterly technique (Example: Theodore Roszak, *Bi-polar in Red*; http://www.whitney.org/american_voices/535/index.html).

Twelve-Tone Music

Invented by Schoenberg in the 1920s, twelve-tone music (early to mid-twentieth century) is characterized by the abandonment of tonality in favor of a twelve-tone system. Perhaps more a compositional system than a style, its adherents believe that it offers a great diversity of style. It stimulates nontraditional approaches to melody, harmony, and form.

Bauhaus

Bauhaus style in architecture (early to mid-twentieth century) was a conscious attempt to integrate the arts into a unified statement. The Bauhaus philosophy sought to establish links between the organic and technical worlds and thereby to reduce contrasts between the two. The design principles of Bauhaus produced building exteriors that were completely free of ornamentation. Several juxtaposed, functional materials form the external surface, underscoring the fact that exterior walls are no longer structural, merely a climate barrier (Example: Walter Gropius, Harkness Commons, http://www.bluffton.edu/~sullivanm/tac/harvard.html).

Art Deco

Art Deco (early to mid-twentieth century) in architecture began between World Wars I and II. It is an individual decorative arts style that the public particularly liked and helped to make thousands of products commercial successes. The term *Art Deco* was coined from the name of the Exposition Internationale des Arts Décoratifs et Industriels Modernes, held in Paris in 1925. The term *moderne* also came from that title, and the two styles were applied to a variety of products and architecture. The style is characterized by slender forms, straight lines, and a sleekness expressive of modern technology. The style regained popularity in the 1970s and 1980s (Example: Lewis Wickes Hine, Empire State Building, http://www.esbnyc.com/).

Modernism

Modernism (early to late twentieth century) in architecture is a style blurred by the contributions of architectural firms rather than individual architects. What is considered modernism in architecture generally consists of the glass and steel rectangular skyscraper also identified as International Style. There is more, however, than the simple straight line and functional structure. Modern architecture consists of a variety of explorations of space and line including curvilinear treatments and highly symbolic exploration of form.

The modern movement in visual art owed much to the tremendous impact of the International Exhibition of Modern Art (called the Armory Show) in 1913. There, rather shocking European modernist works, for example, the cubists, were first revealed to the American public.

Modern dance defies accurate definition, it remains the most appropriate label for the nonballet tradition that Martha Graham came to symbolize. Modern dance also developed its own conventions: Ballet movements were largely rounded and symmetrical, while modern dancers emphasized angularity and asymmetry. Ballet stressed leaps and based its line on toework, while modern dance hugged the floor and dancers went barefoot (Example: Martha Graham, *Lamentation;* (http://www.pathfinder.com/photo/gallery/arts/morgan/cap02.htm). The early works of Graham and others tended to be fierce and earthy and less graceful. Beneath it all was the desire to express emotion. Martha Graham described her choreography as "a graph of the heart."

Absurdism

Absurdism in the theatre (early to mid-twentieth century) reflects the loss of faith of its adherents in religion, science, and humanity itself. It sees the world as meaningless and translates that into plays that seem so as well. It is an outgrowth of the philosophy of existentialism. Its major playwrights were Luigi Pirandello, Jean-Paul Sartre, and Albert Camus.

Serialism

Serialism in music (mid-twentieth century) is an extension of the twelve-tone system. Here, the techniques of the twelve-tone system are used to organize

musical dimensions other than pitch, for example, rhythm, dynamics, and tone color. Milton Babbitt is an example of a composer who used serialism.

Neorealism

Neorealism in film (mid-twentieth century) began as Italy recovered from World War II. Innovated by Roberto Rossellini, it used hidden cameras and mostly nonprofessional actors. It emphasized an objective viewpoint and documentary style and set the stage for film for years to come.

Epic Theatre

Epic theatre (mid-twentieth century) is singularly associated with Bertolt Brecht (1898–1956). Epic theatre draws heavily on expressionism and rests on complex theories about theatre and its relationship to life. It is a revolt against dramatic theatre and attempts to move the audience out of the role of passive spectator and into a more dynamic relationship with the play. It is a highly presentational theatrical style and frequently involves narration and changes of time and place that might be accomplished with nothing more than an explanatory sentence.

Abstract Expressionism

Abstract Expressionism in painting (mid-twentieth century) has two identifying characteristics. One characteristic is nontraditional brushwork, and the other is nonrepresentational subject matter. This approach leaves the artist free to reflect inner life and to create works with high emotional intensity. Absolute individuality of expression and the freedom to be irrational underlie this style (Example: Willem de Kooning; *Seated Woman;* http://www.moma.org/collection/drawings/dekooning_woman.html).

Aleatory (Chance Music)

Aleatory music (mid-twentieth century) relies on the elements of chance. In chance music, composers choose pitches, rhythms, and tone colors by random methods such as throwing coins. The composer may ask the performer to choose the ordering of the musical material or to invent it altogether. John Cage is the major composer of this type of music. Others, who followed Cage and introduced chance elements into their music were Pierre Boulez and Karlheinz Stockhausen.

International Style

International style in architecture (mid- to late twentieth century) typically consists of the glass and steel rectangular skyscraper, also referred to as "modern architecture" (Example: Mies van der Rohe and Philip Johnson, Seagram Building, http://www.bluffton.edu/~sullivanm/mies/miesseagram.html).

Rock and Roll

Rock and Roll (1950s) or Rock, as it later became known, includes a variety of substyles including Soul and Punk. Rock is typically vocal music with a hard, driving beat in quadruple meter with strong accents on the second and fourth beats. It often features electric guitar accompaniment and heavy amplification of sound and is usually written in a twelve-bar Blues form. It is an outgrowth of Rhythm and Blues and Country and Western. *Soul Music* is a variety of Rock and Roll emerging in the 1960s from African American performers and emphasizes emotionality, gospel, and the African American experience. *Punk*, or *New Wave*, is a primitive form of Rock and Roll. *Rhythm and Blues* (mid-twentieth century) is a dance music of African Americans that joins blues, jazz, and gospel styles. *Country and Western* (mid-twentieth century) is a folk-like, guitar-based style typically associated with rural white America.

Pop Art

Pop art (1950s) in painting concerned itself, above all, with representational images. The term *pop* was coined by the English critic Lawrence Alloway, and means, simply, that the subjects of these paintings are found in popular culture. The treatments of pop art also came from mass culture and commercial design (Example: Roy Lichtenstein, *Look Mickey*; http://www.nga.gov/cgi-bin/pinfo?Object=70272+0+none).

Hard Edge

Hard edge (1950s and 1960s), or hard-edged abstraction emphasizes flat color areas with hard edges that carefully separate one area from another. Essentially, hard edge is an exploration of design for its own sake (Example: Frank Stella, *Hyena Stomp*; http://www.tate.org.uk/servlet/AWork?id=13416.htm).

Minimalism

Minimalism in painting (1950s and 1960s) sought to reduce the complexity of both design and content as far as possible. Minimalist artists concentrated on nonsensual, impersonal, geometric shapes and forms. No communication was to pass between artist and respondent, no message was to be conveyed. Rather, the minimalists wanted to present neutral objects free of their own interpretations and leave response and meaning entirely up to the viewer (Example: Morris Louis, *Dalet Kaf*; http://www.mamfw.org/f_html/louis.html).

Minimalism in sculpture (1950s and 1960s) also sought to reduce the complexity of both design and content as far as possible. Minimalist sculptors concentrated on nonsensual, impersonal, geometric shapes and forms (Example: David Smith, *Circle I*; http://www.nga.gov/cgi-bin/pinfo?Object=56124+0+none).

Minimalism in music (1960s) was a reaction against the complexity of serialism and the randomness of aleatory music. Minimalist music has a steady pulse, clear tonality, and persistent repetition of short melodic patterns. It also employs a static quality in dynamics, texture, and harmony, the effect of which tends to be trance-like and hypnotic. Leading composers of minimalist music are Terry Riley, Philip Glass, and Steve Reich.

Op Art

Op art (late twentieth century) plays on the possibilities offered by optics and perception. Op art is an intellectually oriented and systematic style, very scientific in its applications. Based on perceptual tricks, the misleading images in these paintings capture the curiosity and pull the viewer into a conscious exploration of what the optical illusion does and why it does it (Example: Victor Vasarély, *Belatrix C*; http://www.si.umich.edu/Art_History/demoarea/details/NO057.html).

Primary Structures

Primary structures (late twentieth century) is a movement in sculpture that pursues two major goals: extreme simplicity of shapes and a kinship with architecture. A space-time relationship distinguishes primary structures from other sculpture. Viewers are invited to share an experience in three-dimensional space in which they can walk around and/or through the works. Form and content are reduced to their most minimal qualities (Example: Louise Nevelson, *Homage to the World*; http://www.diamondial.org/cgi-local/DiaImage.cgi?acc=66.192).

Video Art

Video art (late twentieth century) is a wide-ranging genre that emerged from the rebellions of the 1960s as a reaction against conventional broadcast television. Inexpensive portable recording and playback video equipment has made it possible for this art form to flourish. Video art has moved from a nearly photojournalistic form to one in which outlandish experiments exploit new dimensions in hardware and imagery (Example: Nam June Paik, *Egg Grows*; http://www.sfmoma.org/collections/media_arts/ma_coll_paik.html).

Neo-Expressionism

Neo-expressionism (late twentieth century) is a controversial movement that tends to record images that the rest of us repress. Typically, paintings of this style force the viewer to confront what may be considered repulsive images. Like the expressionists, neo-expressionists seek to evoke a particular emotional response in the viewer (Example: David Salle, *Demonic Roland*; http://www.broadartfoundation.org/collection/salle.html).

Postmodernism

Postmodernism (late twentieth century) in architecture (also called "revisionist") takes past styles and does something new with them. Much of the archi-

tectural language of this style derives from the past, taking, without copying, different themes from the past, but in an eclectic manner, seizing certain moments in history and juxtaposing them. Postmodern architecture focuses on meaning and symbolism, and embraces the past. Function no longer dictates form, and the postmodernist seeks to create buildings in the fuller context of society and the environment. Goals of postmodern architecture are social identity, cultural continuity, and sense of place (Example: Pompidou Centre, http://www.bc.edu/bc_org/avp/cas/fnart/arch/pompidou.html).

Postmodernism in visual arts is, likewise, highly individualistic, although some artists prefer to return art to the anonymity of pre-Renaissance times. One recognizable aspect of post-modernist styles appears to be a desire to return recognizable content or meaning to works of art. The artists following these paths were reacting to what they felt was a clutter and lack of content in previous styles. One common theme apparently shared by postmodernists is a basic concern for how art functions in society (See Neo-Expressionism, p. 140). Example: Joel Shapiro, *Untitled*; http://mfah.org/garden/artists/shapiro.html).

Postmodernism in dance, like the style in the other arts, seeks the interrelationships between art and life. Typically, it rejects traditional choreography and technique in favor of open-ended scores and ordinary movement.

Neo-Abstraction

Neo-abstraction (mid-1980s) is a conglomerate style, like postmodernism, comprising mostly individualistic approaches. Like the postmodernists, the neo-abstractionists borrow freely from others by modifying or changing the scale, media, or color of older works to give them a new framework and, hence, new meaning. Occasionally, the new meanings include sarcasm and satire and often comment on the decadence of American society in the 1980s (Example: Linda Benglis, *Knossos*; www.gihon.com/collection/benglis.html).

Musique Actuelle

Musique actuelle (1990s) is improvised music freely drawing on Jazz and Rock and eliciting vibrancy, liveliness, and personal expression. Its literal translation means "current," and it represents a number of subfactions from various localities. There always seems to be a strain of humor.

Cyber Art

Cyber Art (late twentieth century), in contrast to modern art (that sought to bring three-dimensional images together with the two-dimensional and to diminish the importance of representing real space so as to emphasize other types of reality), created artificial environments that viewers experience as real space. Also known as *cyberspace*, *hyperspace*, or *virtual reality*, cyber artists allow viewers, by donning a set of goggles containing a small video monitor for each eye, to move in the environment and, to a degree, control it.

APPENDIX A

101 Must-See Works of Architecture

CITY	ARCHITECTURAL WORK	DATE	ARCHITECT
Aachen, Germany	Palace Chapel of Charlemagne	792	Unknown
Agra, India	Taj Mahal	1630	Unknown
Amiens, France	Amiens Cathedral	1220	Unknown
Asheville, NC	Biltmore House	1888	Richard Morris Hunt
Athens, Greece	The Parthenon	448 BCE	Ictinus and Callicrates
	Propylaia	437 BCE	Mnesikles
	Temple of Athena Nike	425 BCE	Callicrates
	Temple of the Olympian Zeus	175 BCE	Cossutius
Barcelona, Spain	Casa Batlló	1904	Antonio Gaudi
	Casa Milá	1905	Antonio Gaudi
	Sagrada Familia Cathedral	1892	Antonio Gaudi
Bear Run, PA	Kauffman House, Falling Water	1936	Frank Lloyd Wright
Beijing, China	Imperial Palace	1420	Unknown
Berlin, Germany	Brandenburg Gate	1788	Karl Langhans
	Sans Souci Palace (Pottsdam)	1745	G. W. von Knobelsdorff
Brighton, England	Royal Pavilion	1815	John Nash
Cairo, Egypt	Pyramids	2500 BCE	Unknown
Chambord, France	Château of Chambord	1519	Unknown
Charlottesville, VA	Monticello	1770	Thomas Jefferson
Chartres, France	Chartres Cathedral	1145	Unknown
Chicago, IL	Carson Pirie Scott Building	1899	Louis Sullivan
	Robie House	1909	Frank Lloyd Wright

CITY	ARCHITECTURAL WORK	DATE	ARCHITECT
Córdoba, Spain	Great Mosque	785	Unknown
Dessau, Germany	The Bauhaus	1925	Walter Gropius
Epidauros, Greece	Theatre at Epidauros	3rd c. BCE	Unknown
Florence, Italy	Baptistery of St. Michael	1060	Unknown
	Florence Cathedral	1296	De Cambio/Brunelleschi
	Foundling Hospital	1421	Filippo Brunelleschi
	Palazzo Rucellai	1446	Leone Battista Alberti
Granada, Spain	Alhambra	1380	Unknown
Himeji City, Japan	Himeji Castle	1601	Unknown
Istanbul, Turkey	Hagia Sophia	532	Anthemius of Tralles & Isidorus of Miletus
	Mosque of Ahmed I	1609	Unknown
	Topkapi Palace	15th c.	Unknown
Jerusalem	Dome of the Rock	687	Unknown
Kuala Lumpur City	Petronas Twin Towers	1995	Cesar Pelli & Associates
London	Chiswick House	1725	Lord Burlington & William Kent
	Houses of Parliament	1836	Sir Charles Berry
	St. Paul's Cathedral	1675	Sir Christopher Wren
Luxor, Egypt	Temple of Luxor	1300 BCE	Unknown
Madrid, Spain	Escorial	1563	Juan de Herrera
Machu Picchu, Peru	Machu Picchu ruins	15th c.	Unknown
Melk, Austria	Benedictine Monastery	1702	Jakob Prandtauer
Milan, Italy	Milan Cathedral	1386	Unknown
Montreal, Canada	Habitat	1967	Moshe Safdie et al.
Moscow, Russia	Cathedral of St. Basil	1554	Barna and Postnik
Munich, Germany	Nymphenburg Palace	1664	Unknown
New York, NY	Empire State Building	1930	Shreve, Lamb & Harmon Associates
	Guggenheim Museum	1942	Frank Lloyd Wright
	Lever House	1950	Gordon Bunshaft
	Seagram Building	1958	Mies van der Rohe and Philip Johnson
	United Nations Building	1949	W. K. Harrison et al.
	Woolworth Building	1911	Cass Gilbert
Nîmes, France	Maison Carrée	20 BCE	Unknown
	Pont du Gard	1st c. BCE	Unknown
Nottinghamshire, England	Wollaton Hall	1580	Robert Smythson
Orange, France	Roman Theatre	1st c.	Unknown
Paestum, Italy	Temple of Poseidon	550 BCE	Unknown
Palenque, Mexico	Mayan Temple	7th c.	Unknown
Paris, France	Church of the Invalides	1680	Jules Hardouin-Mansart
	Eiffel Tower	1887	Gustave Eiffel

CITY	ARCHITECTURAL WORK	DATE	ARCHITECT
Paris, France	Louvre Museum (Lescot Wing)	1546	Pierre Lescot
	Notre Dame de Paris Cathedral	1163	Unknown
	The Panthéon	1755	Jacques-Germain Soufflot
	The Opéra	1861	Charles Garnier
	Pompidou Center	1971	Renzo Piano & Richard Rogers
	Sacre Coeur Basilica	1876	Paul Abadie
	Abbey Church of St. Denis	1140	Unknown
Pisa, Italy	Pisa Cathedral and Baptistry	1053	Unknown
Poissy-sur-Seine, France	Savoye House	1929	Le Corbusier
Pompeii, Italy	House of the Vettii	1st c.	Unknown
Prague, Czech. Rep.	Prague Castle	9th c.	Unknown
Ravenna, Italy	S. Apollinare in Classe	533	Unknown
	S. Vitale	526	Unknown
Reims, France	Reims Cathedral	1225	Unknown
Rome, Italy	Arch of Constantine	312	Unknown
	Arch of Titus	81	Unknown
	Basilica of Constantine	310	Unknown
	Baths of Caracalla	211	Unknown
	Church of Santa Maria Maggiore	432	Unknown
	Colosseum	72	Unknown
	Il Gesù	1575	Giacomo Della Porta
	Pantheon	118	Unknown
	Sta. Constanza	350	Unknown
	St. Peter's Cathedral	1546	Michelangelo/Della Porta
	The Tempietto	1502	Donato Bramante
	Temple of Fortuna Virilis	2nd c. BCE	Unknown
Ronchamp, France	Notre-Dame-du-Haut	1950	Le Corbusier
Salisbury, England	Salisbury Cathedral	1220	Unknown
	Stonehenge	4000 BCE	Unknown
Staffelstein, Germany	Vierzehnheiligen Church	1743	Neumann
Toulouse, France	St. Sernin	1080	Unknown
Twickenham, England	Strawberry Hill	1749	Horace Walpole et al:
Urbino, Italy	Palazzo Ducale	1466	Luciano Laurana & Francesco di Georgia
Venice, Italy	Doge's Palace	1345	Unknown
	St. Mark's Cathedral	1063	Unknown
Versailles, France	Versailles Palace	1669	Le Vau & Hardouin-Mansart

CITY	ARCHITECTURAL WORK	DATE	ARCHITECT
Vicenza, Italy	Villa Rotonda	1567	Andrea Palladio
Vienna, Austria	St. Charles Borromaeus	1716	Johann Fischer von Erlach
Vijayanagar, India	Pampapati Temple	17th c.	Unknown
Woodstock, England	Blenheim Palace	1705	Sir John Vanbrugh
Wüzburg, Germany	The Kaisersaal	1719	Balthasar Neumann

APPENDIX B

201 Masterworks of Painting and Sculpture

CITY	MUSEUM OR LOCATION	ARTIST	WORK
Amsterdam, Neth.	Rijksmuseum	Rembrandt	The Night Watch
		Van Gogh	Harvest at La Crau (The Blue Cart)
	Stedelijk Museum	Malevich	Suprematist Painting (Eight Red Rectangles)
Antwerp, Belgium	Cathedral of Our Lady	Rubens	The Raising of the Cross
Athens	Acropolis Museum	Anonymous	Kritios Boy
		Anonymous	Nike Adjusting Her Sandal
		Anonymous	Peplos Kore
	National Archeological Museum	Anonymous	Harp Player from Keros
Autun, France	Cathedral of Saint-Lazare	Giselbertus	Last Judgment Tympanum
Baltimore, MD	Baltimore Museum of Art	Matisse	Blue Nude (Souvenir de Biskra)
Berlin	Pergmonmuseum	Anonymous	Pergamon Altar
	Staatliche Museen du Berlin	Anonymous	Ishtar Gate
		Anonymous	Nefertiti
Brussels	Musées Royaux des Beaux-Arts	Breugel the Elder	Landscape with the Fall of Icarus
Boston	Museum of Fine Arts	Copely	Mrs. Ezekiel Goldthwait
		Turner	The Slave Ship
Cairo	Egyptian Museum	Anonymous	Funerary Mask of Tutankhamun

CITY	MUSEUM OR LOCATION	ARTIST	WORK
Chartres, France	Chartres Cathedral	Anonymous	Jamb Statues
Chicago	Art Institute of Chicago	Kandinsky	Improvisation No. 30 (Warlike Theme)
		de Kooning	Excavation
		Monet	The River
		Reynolds	Lady Sarah Bunbury Sacrificing to . . .
		Poussin	Landscape with Saint John on Patmos
		Seurat	A Sunday Afternoon on the Island of La Grande Jatte
		Toulouse-Lautrec	At the Moulin dela Galette
		Wood	American Gothic
	University of Chicago Oriental Institute	Anonymous	Guardian figure, Palace of Sargon II
Colmar, France	Musée Unterlinden	Grünewald	Isenheim Alterpiece
Cologne, Germany	Cologne Cathedral	Anonymous	Gero Crucifix
Delphi, Greece	Archeological Museum	Anonymous	Charioteer
Detroit, MI	Detroit Institute of Arts	van Ruisdael	The Jewish Cemetary
Dijon, France	Chantreuse de Champmol	Claus Sluter	Well of Moses
Florence, Italy	Baptistry of San Giovanni	Ghiberti	Gates of Paradise (East Doors)
		Andrea Pisano	Life of John the Baptist (South Doors)
	Church of San Lorenzo	Michelangelo	Tomb of Giuliano de' Medici
	Church of Santa Maria del Carmine	Masaccio, Masolino, & Lippi	Brancacci Chapel Frescoes
	Church of Santa Maria Novella	Masaccio	Trinity with the Virgin, St. John . . .
	Galleria dell'Accademia	Michelangelo	David
	Galleria degli Uffizi	Botticelli	Primavera The Birth of Venus
		Cimabue	Virgin and Child Enthroned
		Parmigianino	Madonna with the Long Neck
	Monastery of San Marco	Fra Angelico	Annunciation
	Museo nazionale del Bargello	de Bologna	Mercury
		Donatello	David

CITY	MUSEUM OR LOCATION	ARTIST	WORK
Florence, Italy	Museo dell'Opera del Duomo	Donatello	Mary Magdalen
Ghent, Belgium	Cathedral of Saint-Bavo	J. & H. van Eyck	Ghent Altarpiece
Hisdesheim, Germany	Abbey Church of Bishop Saint Michael	Anonymous	Doors of Berward
Istanbul	Kariye Muzesi	Anonymous	Funerary Chapel
Kansas City, MO	Atkins Museum of Art	Degas	Ballet Rehearsal
Los Angeles	J. Paul Getty Museum	Fra Bartolomeo	Holy Family
London	British Museum	Anonymous	Judgement Before Osiris/Book of the Dead
		Anonymous	Parthenon sculptures
	Courtauld Institute Galleries	Manet	A Bar at the Follies-Bergère
	National Gallery	Hogarth	The Marriage Contract
		Jan van Eyck	Portrait of Giovanni Arnolfini and His Wife
		Leonardo da Vinci	Virgin and Saint Anne with the Christ Child
		Uccello	The Battle of San Romano
	Tate Gallery	Gainsborough	The Market Cart
		Lichtenstein	Whaam!
		Moore	Recumbent Figure
		Nevelson	Black Wall
		Turner	The Fighting "Téméraire" . . .
		Smith	Cubi XIX
		Warhol	Marilyn Diptych
Madrid	Museo del Prado	Bosch	Garden of Delights
		Breugel the Elder	The Triumph of Death
		Goya	Third of May, 1808
		van der Weyden	Deposition
		Velázquez	Las Meninas
	Museo Reina Sofia	Picasso	Guernica
Mexico City	Ministry of Education Building	Rivera	Night of the Rich
Milan, Italy	Monastery of Santa Maria delle Grazie	Leonardo da Vinci	The Last Supper
Munich	Alte Pinakothek	Altdorfer	Battle of Alexander and Darius on the Isis
		Dürer	Four Apostles

CITY	MUSEUM OR LOCATION	ARTIST	WORK
Munich	Staatliche Antikensammlungen	Anonymous	Dying Warrior
Naples	Museo Archelologico Nazionale	Polykleitos	Spear Bearer
New York	Frick Collection	Constable	The White Horse
		Fragonard	The Meeting
	Solomon R. Guggenheim Museum	Braque	Violin and Palette
	Metropolitan Museum of Art	Bronzino	Portrait of a Young Man
		Anonymous	Dipylon Vase
		Anonymous	Unicorn at the Fountain Tapestry
		Bingham	Fur Traders Descending the Missouri
		Clodion	Satyr and Bacchante
		David	The Death of Socrates
		Dürer	Four Horsemen of the Apocalypse
		El Greco	View of Toledo
		Gaughin	la Orana Maria
		Klee	Hammamet with Its Mosque
		Noguchi	Kouros
		Pissarro	A Cowherd on the Route du Chou, Pontoise
		Pollock	Autumn Rhythm (Number 30)
	Museum of Modern Art	Boccioni	Unique Forms of Continuity in Space
		Brancusi	Bird in Space
		Calder	Lobster Trap and Fish Tail
		de Chirico	The Nostalgia of the Infinite
		Dali	The Persistence of Memory
		Davis	Lucky Strike
		Dubuffet	Cow with the Subtile Nose
		Ernst	Woman, Old Man, and Flower
		Giacometti	City Square

CITY	MUSEUM OR LOCATION	ARTIST	WORK
New York	Museum of Modern Art	Johns	Target with Four Faces
		Léger	Three Women
		Lipchitz	Man with a Guitar
		Maillol	The Mediterranean
		Malevich	Suprematist Composition: White on White
		Miró	Painting
		Mondrian	Composition in White, Black, and Red
		Picasso	Les Demoiselles d' Avignon
		Rothko	Number 10, 1950
		Sheeler	American Landscape
		Van Gogh	The Starry Night
	Whitney Museum	Stella	"Die Fahne Hoch"
Oslo, Norway	Nasjonal-galleriet	Munch	The Scream
Ottawa, Canada	The National Gallery of Art	Daumier	The Third-Class Carriage
Padua, Italy	Arena Chapel	Giotto	The Lamentation
Parma, Italy	Parma Cathedral	Correggio	Assumption of the Virgin
Pasadena, CA	The Norton Simon Museum	Degas	Little Dancer Fourteen Years Old
Paris	Arc de Triomphe (Place de l'Étoile)	Rude	The Marseillaise
	Musée du Louvre	Anonymous	Barbarini Ivory
		Anonymous	Harbaville Triptych
		Corot	Volterra
		Leonardo da Vinci	Mona Lisa
			The Madonna of the Rocks
			Virgin and Child with St Anne
		Anonymous	Nike of Samothrace
		Anonymous	Aphrodite of Melos (Venus de Milo)
		David	Oath of the Horatii
		Delacroix	Liberty Leading the People
		Dürer	Self-Portrait with a Sprig of Eryngium
		Géricault	Raft of the "Medusa"

CITY	MUSEUM OR LOCATION	ARTIST	WORK
Paris	Musée du Louvre	Gros	Napoleon in the Plague House at Jaffa
		Ingres	Odalisque
		Puget	Milo of Crotona
		Rubens	Henri IV Receiving the Portrait of Marie . . .
		Van Dyck	Charles I at the Hunt
		Watteau	The Pilgrimage to Cythera
	Musée de l'Opéra	Carpeaux	The Dance
	Musée d'Orsay	Bonheur	Plowing in the Nivernais
		Manet	Le Déjeuner sur l'Herbe
		Millet	The Gleaners
		Renoir	Moulin de la Galette
	Centre Georges Pompidou	Le Corbusier	Still Life
Philadelphia	Philadelphia Museum of Art	Brancusi	Mlle Pogany
		Duchamp	Nude Descending a Staircase
		Picasso	Self-Portrait with Palette
		Renoir	Bathers
	University of PA Museum	Anonymous	Bull Lyre, Tomb of Art Queen Puabi
Pittsburgh, PA	Museum of Art	Kiefer	Midgard
Pisa, Italy	Baptistry	Nicola Pisano	Pulpit
	Pisa Cathedral	Giovanni Pisano	Pulpit
Ravenna, Italy	Church of San Vitale	Anonymous	Emperor Justinian and His Attendants
Richmond, VA	State Capitol Building	Houdon	George Washington
Rome	Church of San Luigi dei Francesci	Caravaggio	Calling of Matthew
	Church of San Pietro in Vincoli	Michelangelo	Tomb of Julius II
	Church of Santa Maria della Vittoria	Bernini	Saint Teresa of Avila in Ecstasy
	Galleria Borghese	Bernini	David
		Canova	Maria Paulina Borghese as Venus Victrix
	Galleria Nazionale d'Arte Antica	Holbein (Younger)	Henry VIII
	Museo Capitolino	Epigonos (?)	Dying Gaul

CITY	MUSEUM OR LOCATION	ARTIST	WORK
Rome	Museo Nazionale Romano	Myron	Discus Thrower
	Musei Vaticani	Hagesandros	Laocoön and His Sons
	Palazzo dei Conservatori	Anonymous	Constantine the Great
	Piazza Navona	Bernini	Four Rivers Fountain
	Saint Peter's, Vatican	Bernini	Baldacchino
		Michelangelo	Pietá
	Sistine Chapel	Michelangelo	Sistine Chapel Frescoes
	Stanza della Segnatura, Vatican	Raphael	The School of Athens
St Louis, MO	Saint Louis Art Museum	Beckmann	Christ and the Woman Taken in Adultery
		O'Keeffe	Dark Abstraction
San Francisco	San Francisco Museum of Modern Art	Matisse	The Woman with the Hat
Sienna, Italy	Museo dell'Opera del Duomo	Duccio	Madonna Enthroned
	Sienna Cathedral	Simone Martini	Annunciation (Altarpiece)
	Museo dell'Opera del Duomo	Pietro Lorenzetti	Birth of the Virgin
Toledo, OH	Toledo Museum of Art	Cranach (Younger)	Martin Luther and the Wittenberg Reformers
Venice, Italy	Galleria dell'Accademia	Giorgione	The Tempest
		Tintoretto	St Mark Freeing a Christian Slave
	Santa Maria Gloriosa dei Frari	Titian	Assumption of the Virgin
Vienna	Kunshistorisches Museum	Brueghel (Elder)	Return of the Hunters
		Holbein (Younger)	Jane Seymour
		Cellini	Saltcellar of Francis I
		Anonymous	Gemma Augustea
		Vermeer	Allegory of the Art of Painting
	Österreichische Galerie	Klimt	The Kiss
	Naturhistorishes Museum	Anonymous	Woman from Willendorf
Washington, DC	Hirshorn Museum	Vasarély	Arcturus II
		Rodin	The Burghers of Calais
	National Gallery of Art	Boucher	Venus Consoling Love
		Falconet	Madame de Pompadour as the Venus of the Doves

CITY	MUSEUM OR LOCATION	ARTIST	WORK
Washington, DC	National Gallery of Art	El Greco	St Jerome
		Raphael	The Alba Madonna
		Cassatt	Maternal Caress
		Gainesborough	Portrait of Mrs. Richard Brinsley Sheridan
		Lorraine	Landscape with Merchants
		Morisot	In the Dining Room
		Rembrandt	Self-Portrait
		Vermeer	The Girl with a Red Hat
Youngstown, OH	The Butler Institute of American Art	Homer	Snap the Whip

APPENDIX C

258 Major Architects, Artists, Choreographers, Composers, and Playwrights

ARTIST	DATE	DISCIPLINE	STYLE
Aeschylus	5th c. BCE	Theatre	Greek Classical Tragedy
Alberti, Leon Battista	15th c.	Architecture	Renaissance
Altdorfer, Albrecht	16th c.	Painting	Renaissance
Antoine, Andre	20th c.	Theatre	Naturalism
Aristophanes	4th c. BCE	Theatre	Greek Classical Comedy
Arp, Jean	20th c.	Painting	Dada
Babbit, Milton	20th c.	Music	12-Tone
Bach, J.S.	17th–18th c.	Music	Baroque
Balanchine, George	20th c.	Dance	Eclectic
Bartók, Béla	19th–20th c.	Music	Nationalism/Eclecticism
Beaumarchais, Pierrede	18th c.	Theatre	Neoclassical
Beckett, Samuel	20th c.	Theatre	Absurdism
Beckmann, Max	20th c.	Painting	Expressionism
Beethoven, Ludwig Von	18th–19th c.	Music	Classical
Berg, Alban	19th–20th c.	Music	Expressionism
Berlioz, Hector	19th c.	Music	Romantic
Bernini, Alan Lorenzo	17th c.	Sculpture	Baroque
Boccioni, Umberto	20th c.	Ptg/Sculpture	Futurism
Bologna, G. da	16th c.	Sculpture	Mannerism
Bonheur, Rosa	19th c.	Painting	Romanticism
Borromini, Francesco	17th c.	Architecture	Baroque
Bosch, Hieronymous	16th c.	Painting	Late Gothic
Botticelli, Sandro	15th c.	Painting	Renaissance
Brahms, Johannes	19th c.	Music	Romantic
Bramante, Danato	16th c.	Architecture	High Renaissance
Brancusi, Constantin	20th c.	Sculpture	Expressionism
Brecht, Bertolt	20th c.	Theatre	Epic Theatre
Bruegel, Pieter the Elder	16th c.	Painting	Renaissance

ARTIST	DATE	DISCIPLINE	STYLE
Brunelleschi, Filippo	15th c.	Architecture	Renaissance
Calder, Alexander	20th c.	Sculpture	Abstraction
Caravaggio	16th–17th c.	Painting	Baroque
Cartier-Bresson, Henri	20th c.	Photography	Paris School
Carter, Elliott	20th c.	Music	Personal
Cassatt, Mary	19th c.	Painting	Impressionism
Cézanne, Paul	19th c.	Painting	Post-Impressionism
Chagall, Marc	20th c.	Painting	Fantasy
Chardin, Pierre	18th c.	Painting	Rococo/Genre
Chekhov, Anton	19th c.	Theatre	Realism
Chirico, Giorgio de	20th c.	Painting	Fantasy
Christo	20th c.	Sculpture	Ephemeral/Environment
Chopin, Frédéric	19th c.	Music	Romantic
Cimabue	13th c.	Painting	Gothic
Clodion (Claude Michel)	18th c.	Sculpture	Rococo
Coltrane, John	20th c.	Music	Free Jazz
Congreve, William	17th c.	Theatre	English Restoration
Constable, John	19th c.	Painting	Romanticism
Copland, Aaron	20th c.	Music	Eclectic
Corneille, Pierre	17th c.	Theatre	Neoclassicism
Corot, Jean-Baptiste-Camillo	19th c.	Painting	Romanticism
Corelli., Arcongilo	17th–18th c.	Music	Baroque
Courbet, Gustav	19th c.	Painting	Realism
Cranach, Lucas the Elder	16th c.	Painting	Renaissance
Cunningham, Merce	20th c.	Dance	Modern
Daguerre, Louis Jacques Mandé	19th c.	Photography	Romanticism
Dali, Salvador	20th c.	Painting	Surrealism
Daumier, Honoré	19th c.	Painting	Romanticism
David, Jacques-Louis	18th c.	Painting	Neoclassicism
Davis, Miles	20th c.	Music	Cool Jazz/Fusion
Debussy, Claude	19th–20th c.	Music	Impressionism
Degas, Edgar	19th c.	Painting/Sculpture	Impressionism
Delacroix, Eugène	19th c.	Painting	Romanticism
Desprez, Josquin	15th–16th c.	Music	Renaissance
Donatello	15th c.	Sculpture	Renaissance
Dubuffet, Jean	20th c.	Painting	Expressionism
Duccio	14th c.	Painting	Gothic
Duchamp, Marcel	20th c.	Painting	Fantasy
Duncan, Isadora	19th–20th c.	Dance	Modern
Dürer, Albrecht	16th c.	Painting/Printmaking	Renaissance

ARTIST	DATE	DISCIPLINE	STYLE
Dvořák, Antonin	19th c.	Music	Romantic
Dyck, Anthony van	17th c.	Painting	Baroque
El Greco	16th c.	Painting	Mannerism/Baroque
Ellington, Duke	20th c.	Music	Jazz/Swing
Ernst, Max	20th c.	Painting	Dada
Euripides	4th c. BCE	Theatre	Greek Classical Tragedy
Eyck, Jan van	15th c.	Painting	Late Gothic/Netherlandish
Fra Angelico	15th c.	Painting	Renaissance
Fragonard, Jean-Honoré	18th c.	Painting	Rococo
Frankenthaler, Helen	20th c.	Painting	Color Field
Gabrieli, Andrea	16th c.	Music	Renaissance
Gabrieli, Giovanni	16th–17th c.	Music	Renaissance
Gainsborough, Thomas	18th c.	Painting	Eng. Landscape/ Portraiture
Gaudí, Antoni	19th–20th c.	Architecture	Art Nouveau
Gauguin, Paul	19th c.	Painting	Post-Impressionism
Géricault, Théodore	19th c.	Painting	Romanticism
Gershwin, George	20th c.	Music	Eclectic
Ghiberti, Lorenzo	15th c.	Sculpture	Renaissance
Giacometti, Alberto	20th c.	Sculpture	Surrealism
Giotto	14th c.	Painting	Gothic
Goethe, Johann Wolfganyde	18th c.	Theatre	Romanticism
Gogh, Vincent van	19th c.	Painting	Post-Impressionism
Goldsmith, Oliver	18th c.	Theatre	English Restoration
Goya, Francisco	19th c.	Painting	Romanticism
Graham, Martha	20th c.	Dance	Modern
Gropius, Walter	20th c.	Architecture	Bauhaus
Grünewald, Mattias	16th c.	Painting	Renaissance
Hals, Franz	17th c.	Painting	Baroque
Handel, G.F.	17th–18th c.	Music	Baroque
Hanson, Duane	20th c.	Sculpture	Environments
Haydn, Franz Josef	18th c.	Music	Classical
Hildegard of Bingen	12th c.	Music	Medieval
Hilliard, Nicholas	16th c.	Painting	Renaissance
Hogarth, William	18th c.	Painting/ Printmaking	Humanitarianism
Holbein, Hans the Younger	16th c.	Painting	Renaissance
Horton, Asudata Dafora	20th c.	Dance	Jazz Dance
Houdon, Jean-Antoine	18th c.	Sculpture	Neoclassicism
Hrosvitha	10th c.	Theatre	Medieval
Humphrey, Doris	20th c.	Dance	Modern
Ibsen, Henrik	19th c.	Theatre	Realism
Indiana, Robert	20th c.	Painting	Pop Art

ARTIST	DATE	DISCIPLINE	STYLE
Ingres, Jean-August-Dam	19th c.	Painting	Romanticism
Ionesco, Eugene	20th c.	Theatre	Absurdism
Ives, Charles	20th c.	Music	Experimental
Jefferson, Thomas	18th c.	Architecture	Neoclassicism
Johns, Jasper	20th c.	Painting	Pop Art
Joplin, Scott	19th–20th c.	Music	Ragtime
Kandinsky, Vasily	20th c.	Painting	Expressionism
Kelly, Elsworth	20th c.	Painting/Sculpture	Color Field
Klee, Paul	20th c.	Painting	Surrealism
Kokoshka, Oskar	20th c.	Painting	Expressionism
Lange, Dorothea	20th c.	Photography	Photo-Journalism
Le Corbusier	20th c.	Architecture	International
Leonardo da Vinci	15–16th c.	Painting	High Renaissance
Lichtenstein, Roy	20th c.	Painting	Pop Art
Liszt, Franz	19th c.	Music	Romantic
Lorenzetti, Pietro	14th c.	Painting	Gothic
Lorraine, Claude	17th c.	Painting	Baroque
Machaut, Guillaume de	14th c.	Music	Ars Nova
Maeterlinck, Maurice	20th c.	Theatre	Symbolism
Mahler, Gustav	19th–20th c.	Music	Romantic
Malevich, Kasimir	20th c.	Painting	Suprematism
Mamet, David	20th c.	Theatre	Realism
Manet, Edouard	19th c.	Painting	Realism
Man Ray	20th c.	Photography	Photograms
Mansart, François	17th c.	Architecture	Baroque
Mantegna, Andrea	15th c.	Painting	Renaissance
Marivaux, Pierre	17th–18th c.	Theatre	Rococo
Marlowe, Christopher	16th c.	Theatre	Elizabethan/ Renaissance
Martini, Simone	14th c.	Painting	Gothic
Masaccio	15th c.	Painting	Expressionism
Matisse, Henri	20th c.	Painting	Renaissance
Menander	3rd c. BCE	Theatre	Greek New Comedy
Mendelssohn, Felix	19th c.	Music	Romantic
Michelangelo	16th c.	Painting/Sculpture/ Architecture	High Renaissance
Mies van der Rohe	20th c.	Architecture	Modern
Miller, Arthur	20th c.	Theatre	Realism
Millet, Jean-François	19th c.	Painting	Romanticism
Miró, Joan	20th c.	Painting	Surrealism/Abstraction
Moliére	17th c.	Theatre	Neoclassicism
Mondrian, Piet	20th c.	Painting	Abstraction
Monet, Claude	19th c.	Painting	Impressionism
Monteverdi, Claudio	16th–17th c.	Music	Baroque
Moore, Henry	20th c.	Sculpture	Abstraction

ARTIST	DATE	DISCIPLINE	STYLE
Morley, Thomas	16th c.	Music	Renaissance
Morrisot, Berthe	19th c.	Painting	Impressionism
Mozart, Wolfgang Amadeus	18th c.	Music	Classical
Munch, Edward	19th c.	Painting	Expressionism
Mussorgsky, Modest	19th c.	Music	Romantic
Myron	5th c. BCE	Sculpture	Greek Classical
Nash, John	19th c.	Architecture	Romanticism
Nevelso, Louise	20th c.	Sculpture	Constructions
Neumann, Balthazar	18th c.	Architecture	Baroque
Nijinsky, Vaslav	19th c.	Dance	Romanticism
Nikolai, Alwin	20th c.	Dance	Modern
O'Keefe, Georgia	20th c.	Painting	Realism
Oldenburg, Claes	20th c.	Sculpture	Primary Structure
O'Neill, Eugene	20th c.	Theatre	Realism/Expressionism
Paik, Nam June	20th c.	Sculpture-Performing Arts	Performance/Video
Palestrina, Giovanni	16th c.	Music	Renaissance
Palladio, Andrea	16th c.	Architecture	Mannerism
Parker, Charlie (Bird)	20th c.	Music	Jazz/Bebop
Parmigianino	16th c.	Painting	Mannerism
Paxton, Sir Joseph	19th c.	Architecture	Romanticism
Petipa, Marins	19th c.	Dance	Romanticism
Pfaff, Judy	20th c.	Sculpture	Installations
Piano, Renzo	20th c.	Architecture	Post-Modernism
Picasso, Pablo	20th c.	Painting/Sculpture	Abstraction/Cubism
Pirandello, Luigi	20th c.	Theatre	Absurdism
Pisano, Nicola	13th c.	Sculpture	Gothic
Plautus	3rd–2nd c. BCE	Theatre	Roman Comedy
Pollock, Jackson	20th c.	Painting	Action Painting
Polyclitus	5th c. BCE	Sculpture	Greek Classical
Porta, Giacomo della	16th c.	Architecture	Proto-Baroque
Poussin, Nicolas	17th c.	Painting	Baroque
Praxiteles	4th c. BCE	Sculpture	Greek Classical
Primus, Pearl	20th c.	Dance	Jazz Dance
Puccini, Giacomo	19th c.	Music	Romantic
Pucelle, Jean	14th c.	Painting	Gothic
Puget, Pierre	17th c.	Sculpture	Baroque
Purcell, Henry	17th c.	Music	Baroque
Rabe, David	20th c.	Theatre	Realism
Racine, Jean	17th c.	Theatre	Neoclassicism
Raphael	15th c.	Painting	High Renaissance
Rauschenberg, Robert	20th c.	Sculpture	Constructions
Ravel, Maurice	19th–20th c.	Music	Impressionism
Reich, Steve	20th	Music	Minimalism
Rembrandt van Rijn	17th c.	Painting	Baroque

ARTIST	DATE	DISCIPLINE	STYLE
Renoir, Pierre-Auguste	19th c.	Painting	Impressionism
Richardson, Henry	19th c.	Architecture	Pre-Modern
Rodin, August	19th c.	Sculpture	Impressionism
Rogers, Richard	20th c.	Architecture	Post-Modernism
Rothko, Mare	20th c.	Painting	Color Field
Rouault, Georges	20th c.	Painting	Expressionism
Rousseau, Henri	19th c.	Painting	Romanticism
Rubens, Peter Paul	17th c.	Painting	Baroque
Ruisdael, Jacob van	17th c.	Painting	Baroque
St. Denis, Ruth	20th c.	Dance	Modern
Schoenberg, Isadore	19th–20th c.	Music	Expressionism
Schubert, Franz	19th c.	Music	Romantic
Schumann, Clara	19th c.	Music	Romantic
Schumann, Robert	19th c.	Music	Romantic
Segal, George	20th c.	Sculpture	Environments
Seurat, Georges	19th c.	Painting	Post-Impressionism
Shakespeare, William	16th c.	Theatre	Elizabethan/ Renaissance
Shaw, George Bernard	19th–20th c.	Theatre	Realism
Shepard, Sam	20th c.	Theatre	Realism
Sheridan, Richard Brinsley	18th c.	Theatre	English Restoration
Sluter, Claus	14th–15th c.	Sculpture	Gothic
Smetana, Bedrich	19th c.	Music	Romantic
Smith, Tony	20th c.	Sculpture	Primary Structure
Smithson, Robert	20th c.	Sculpture	Environmental Sculpture
Sophocles	5th c. BCE	Theatre	Greek Classical Tragedy
Steichen, Edward	19th–20th c.	Photography	Photo-Secession
Stella, Frank	20th c.	Painting	Futurism/Abstract Expressionism
Stieglitz, Alfred	20th c.	Photography	Photo-Session
Stravinsky, Igor	19th–20th c.	Music	Neoclassicism
Strindberg, August	20th c.	Theatre	Expressionism
Sullivan, Louis	19th–20th c.	Architecture	Pre-Modern
Taylor, Paul	20th c.	Dance	Modern
Tchaikovsky, Peter Ilyich	19th c.	Music	Romanticism
Terence	2nd c. BCE	Theatre	Roman
Tharp, Twyla	20th c.	Dance	Modern
Tintoretto	16th c.	Painting	Mannerism
Titian	16th c.	Painting	High Renaissance
Toulouse-Lautrec, Henride	19th c.	Painting	Post-Impressionism
Turner, J.M.W.	19th c.	Painting	Romanticism
Uccello, Paolo	15th c.	Painting	Renaissance
Vau, Louis le	17th c.	Architecture	Baroque
Vaserély, Victor	20th c.	Painting	Op Art

ARTIST	DATE	DISCIPLINE	STYLE
Velázquez, Diego	17th c.	Painting	Baroque
Veneziano, Domenico	15th c.	Painting	Renaissance
Verdi, Guissepi	19th c.	Music	Romantic
Vermeer, Jan	17th c.	Painting	Baroque
Vivaldi, Antonio	17th–18th c.	Music	Baroque
Voltaire	18th c.	Theatre	Neoclassicism
Wagner, Richard	19th c.	Music	Romantic
Warhol, Andy,	20th c.	Painting	Pop Art
Watteau, Antoine	18th c.	Painting	Rococo
Webern, Anton	19th–20th c.	Music	Expressionism
Weyden, van der, Roger	15th c.	Painting	Late Gothic/ Netherlandish
Williams, Tennessee	20th	Theatre	Realism
Williams, William	20th c.	Painting	Abstract Expressionism
Wilson, August	20th c.	Theatre	Realism
Wilson, Lanford	20th c.	Theatre	Realism
Wilson, Robert	20th c.	Painting/Theatre	Performance Art
Wren, Sir Christopher	17th–18th c.	Architecture	Baroque
Whistler, James McNeill	19th c.	Painting	Impressionism
Wright, Frank Lloyd	20th c.	Architecture	Modern/Prairie
Wycherly, William	17th c.	Theatre	English Restoration

GLOSSARY

A

ABA: in music, a three-part structure that consists of an opening section, a second section, and a return to the first section.

absolute music: music that is free from any reference to nonmusical ideas, such as a text or a program.

Abstract: any art that does not represent observable aspects of nature or transforms forms into a pattern that looks like something other than the original model.

abstraction: a thing apart, that is, removed from real life.

accelerando: in music, a gradual increase in tempo.

accent: in music, a stress that occurs at regular intervals of time. In the visual arts, any device used to highlight or draw attention to a particular area, such as an accent color. See also focal point.

adagio: musical term meaning "slow and graceful."

additive: in sculpture, those works that are built. In color, the term refers to the mixing of hues of light.

aerial perspective (atmospheric perspective): indication of distance in painting through the use of light and atmosphere.

aesthetic distance: combination of mental and physical factors that provides the proper separation between a viewer and an artwork; it enables the viewer to achieve a desired response. See detachment.

affective: relating to feelings or emotions, as opposed to facts. See cognitive.

aleatory: Deliberate incorporation of chance in the composition, whether using chance methods to determine one or more elements or allowing performers to utilize chance variations in performing the work.

allegretto: musical term denoting a lively tempo, but one slower than allegro.

allegro: musical term meaning brisk or lively.

alto: in music, the lowest female voice.

andante: musical term meaning a medium, leisurely, walking tempo.

andantino: musical term meaning a tempo a little faster than andante.

appoggiatura: in music, an ornamental note or series of notes above and below a tone of a chord.

aquatint: intaglio printmaking process in which the plate is treated with a resin substance to create textured tonal areas.

arabesque: classical ballet pose in which the body is supported on one leg, and the other leg is extended behind with the knee straight.

arcade: a series of arches placed side by side.

arch: in architecture, a structural system in which space is spanned by a curved member supported by two legs.

aria: in opera or oratorio, a highly dramatic melody for a single voice.

articulation: connection of the parts of an artwork.

art song: vocal musical composition in which the text is the principle focus. See song cycle.

assemblé: in ballet, a leap with one foot brushing the floor at the moment of the leap and both feet coming together in fifth position at the finish.

asymmetry: a sense of balance achieved by placing dissimilar objects or forms on either side of a central axis. Also called "psychological balance." See symmetry.

atmospheric perspective: see aerial perspective.

atonality: avoidance or tendency to avoid tonal centers in musical composition.

B

balletomane: term used by ballet enthusiasts to refer to themselves. A combination of ballet and mania.

balloon construction: construction of wood using a skeletal framework. See skeleton frame.

baroque: seventeenth- and eighteenth-century style of art, architecture, and music that is highly ornamental and appeals to the emotions.

barre: wooden railing used by dancers to maintain balance while practicing.

barrel vault (tunnel vault): series of arches placed back to back to enclose space.

battement jeté: ballet movement using a small brush kick with the toe sliding on the floor until the foot is fully extended about 2 inches off the floor.

bearing wall: construction in which the wall supports itself, the roof, and floors. See monolithic construction.

beats: in music, the equal parts into which a measure is divided.

binary form: musical form consisting of two sections.

biomorphic: representing life-forms, as opposed to geometric forms.

bridge: in music, transitional material between themes or sections of a composition.

C

cadence: in music, the specific harmonic arrangement that indicates the closing of a phrase.

canon: musical composition in which each voice imitates the theme in counterpoint.

cantilever: architectural structural system in which an overhanging beam is supported only at one end.

capital: transition between the top of a column and the lintel.

chaîné: series of spinning turns in ballet utilizing a half turn of the body on each step.

chamber music: vocal or instrumental music suitable for performance in small rooms.

changement de pied: in ballet, a small jump in which the positions of the feet are reversed.

character oxfords: shoes worn by dancers that look like ordinary street shoes, but are actually specially constructed for dance.

chiaroscuro: light and shade. In painting, the use of highlights and shadow to give the appearance of three-dimensionality to two-dimensional forms. In theatre, the use of light to enhance the plasticity of the human body or the elements of scenery.

chord: three or more musical tones played at the same time.

choreography: composition of a dance work; the arrangement of patterns of movement in dance.

chromatic scale: musical scale consisting of half steps.

classic: specifically referring to Greek art of the fifth century BCE.

classical: adhering to traditional standards. May refer to Greek and Roman art or any art in which simplicity, clarity of structure, and appeal to the intellect are fundamental.

clerestory: the topmost zone of a wall with windows, when it extends above any abutting aisles or secondary roofs. Provides direct light into the central interior space.

coda: passage added to the end of a musical composition to produce a satisfactory close.

cognitive: facts and objectivity as opposed to emotions and subjectivity. See affective.

collography: printmaking process utilizing assorted objects glued to a board or plate.

composition: arrangement of line, form, mass, and color (or any of the technical characteristics of an art form) in a work of art.

conjunct melody: in music, a melody comprising notes close together in the scale.

consonance: the feeling of a comfortable relationship between elements of a composition, in pictures, sculpture, music, theatre, dance, or architecture. Consonance may be both physical and cultural in its ramifications.

conventions: customs or accepted underlying principles of an art.

Corinthian: specific order of Greek architecture employing an elaborate leaf motif in the capitals.

corps de ballet: chorus of a ballet ensemble.

counterpoint: in music, two or more independent melodies played in opposition to each other at the same time.

crescendo: an increase in loudness.

curvilinear: formed or characterized by a curved line.

D

decrescendo: a decrease in loudness.

demi-hauteur: ballet pose with the leg positioned at a 45-degree angle to the ground.

demi-plié: in ballet, a half bend of the knees in any of the five positions.

denouement: section of a play's structure in which events are brought to a conclusion.

detachment: intellectual as opposed to emotional involvement. The opposite of empathy.

diatonic minor: standard musical minor scale achieved by lowering by one half step the third and sixth of the diatonic or standard major scale.

disjunct melody: in music, melody characterized by skips or jumps in the scale. The opposite of conjunct melody.

dissonance: occurrence of inharmonious elements in music or the other arts. The opposite of consonance.

divertissement: dance, or a portion thereof, intended as a diversion from the idea content of the work.

dome: architectural form based on the principles of the arch in which space is defined by a hemisphere used as a ceiling.

Doric: Greek order of architecture having no base for its columns and only a simple slab as a capital.

drypoint: intaglio process in which the metal plate is scratched with a sharp needlelike tool.

dynamics: range and relationship of elements such as volume, intensity, force, and action in an artwork.

E

eclecticism: style of design that combines examples of several different styles in a single composition.

elevation: in dance, the height to which a dancer leaps.

empathy: emotional-physical involvement in events to which one is a witness but not a participant.

engraving: intaglio process in which sharp, definitive lines are cut into a metal plate.

en pointe: see on point.

entablature: upper section of a building; it is usually supported by columns and includes a lintel.

entrechat: in ballet, a jump beginning in fifth position in which the dancer reverses the legs front and back one or more times before landing in fifth position. Similar to changement de pied.

ephemeral: transitory, not lasting.

etching: intaglio process in which lines are cut in the metal plate by an acid bath.

étude: a study; a lesson. A musical composition, usually instrumental, intended mainly for the practice of some point of technique.

F

farce: theatrical genre characterized by broad slapstick humor and implausible plots.

faun: pronounced fawn, a mythological creature with the body of a man, and the horns, ears, tail, and (sometimes) legs of a goat.

fenestration: exterior openings, such as windows and archways, in an architectural façade.

ferroconcrete: reinforced concrete that utilizes metal reinforcing embedded in the concrete.

fluting: vertical ridges in a column.

focal point (focal area): major or minor area of visual attraction in a picture, sculpture, dance, play, or building.

foreground: area of a picture, usually at the bottom, that appears to be closest to the respondent.

form: shape, structure, configuration, or essence of something.

forte: musical term meaning loud.

found object: object taken from life that is presented as an artwork.

fresco: method of painting in which pigment is mixed with wet plaster and applied as part of the wall surface.

fugue: originated from a Latin word meaning "flight." A conventional musical composition in which a theme is developed by counterpoint.

full round: sculptural works that explore full three-dimensionality and are meant to be viewed from any angle.

G

galliard: court dance done spiritedly in triple meter.

genre: category of artistic composition characterized by a particular style, form, or content.

Geodesic dome: A dome-shaped framework constructed from short, straight, lightweight bars that form a grid of polygons.

geometric: based on patterns such as triangles, rectangles, circles, ellipses, and so on. The opposite of biomorphic.

gestalt: a whole. The total elements in an entity.

glyptic: sculptural works emphasizing the qualities of the material from which they are created.

Gothic: style of architecture based on a pointed-arch structure and characterized by simplicity, verticality, elegance, and lightness.

gouache: watercolor medium in which gum is added to ground opaque colors and mixed with water.

grande seconde: ballet pose with the leg in second position in the air.

grand jeté: in ballet, a leap from one foot to the other, usually with a running start.

grand plié: in ballet, a full bend of the knees with the heels raised and the knees opened wide toward the toes. May be done in any of the five positions.

grave: in music, a tempo marking meaning "slow."

groin vault: ceiling formation created by the intersection of two tunnel or barrel vaults.

H

harmony: relationship of like elements, such as musical notes, colors, and repetitional patterns. See consonance and dissonance.

homophony: musical texture characterized by chordal development of one melody. See monophony and polyphony.

hue: spectrum notation of color; a specific pure color with a measurable wavelength. There are primary hues, secondary hues, and tertiary hues.

I

icon: artwork whose subject matter includes idolatry, veneration, or some other religious content.

identification: see empathy.

impasto: a painting technique of applying pigment so as to create a three-dimensional surface.

intaglio: printmaking process in which ink is transferred from the grooves of a metal plate to paper by extreme pressure.

intensity: the degree of purity of a hue. In music, theatre and dance, that quality of dynamics denoting the amount of force used to create a sound or movement.

interval: difference in pitch between two tones.

Ionic: a Greek order of architecture that employs a scroll-like capital with a circular column base.

J

jeté: in ballet, a small jump from one foot to the other, beginning and ending with one foot raised.

K

key: system of tones in music based on and named after a given tone—the tonic.

kouros: archaic Greek statue of a standing nude youth.

L

labanotation: system for writing down dance movements.

largo: in music, a tempo notation meaning large, broad, very slow, and stately movement.

legato: in music, a term indicating that passages are to be played with smoothness and without a break between the tones.

lento: musical term indicating a slow tempo.

libretto: words, or text, of an opera or musical.

linear perspective: creation of the illusion of distance in a two-dimensional artwork through the convention of line and foreshortening—that is, the illusion that parallel lines come together in the distance.

linear sculpture: sculptural works emphasizing two-dimensional materials.

lintel: horizontal member of a post-and-lintel structure in architecture.

lithography: printmaking technique, based on the principle that oil and water do not mix, in which ink is applied to a piece of paper from a specially prepared stone.

M

magnitude: scope or universality of the theme in a play.

manipulation: sculptural technique in which materials such as clay are shaped by skilled use of the hands.

melodrama: theatrical genre characterized by stereotyped characters, implausible plots, and emphasis on spectacle.

melody: in music, a succession of single tones.

mime: in dance or theater, actions that imitate human or animal movements.

mise-en-scène: complete visual environment in theater or dance, including setting, lighting, costumes, properties, and physical structure of the theater.

modern dance: form of concert dance relying on emotional use of the body, as opposed to formalized or conventional movement, and stressing human emotion and the human condition.

modulation: change of key or tonality in music.

monolithic construction: variation of bearing-wall construction in which the wall material is not jointed or pieced together.

monophony: musical texture employing a single melody line without harmonic support.

montage: in the visual arts, the process of making a single composition by combining parts of other pictures so the parts form a whole, and yet remain distinct.

motive (motif): in music, a short, recurrent melodic or rhythmic pattern. In the other arts, a recurrent element.

musique concrète: twentieth-century musical approach in which conventional and recorded sounds are altered electronically or otherwise and recorded on tape to produce new sounds.

N

naturalism: a style in the arts that rests on accurate, nonemotional recreation of elements from real life.

neoclassicism: various artistic styles that borrow the devices or objectives of classic or classical art.

Nonobjective: without reference to reality or observable nature; may be differentiated from "abstract."

O

objet d'art: French term meaning "object of art."

octave: in music, the distance between a specific pitch vibration and its double; for example, concert A equals 440 vibrations per second (v.p.s.), one octave above that pitch equals 880, and one octave below equals 220 v.p.s.

on point: in ballet, a specific technique utilizing special shoes in which the dancer dances on the points of the toes.

opera bouffa: comic opera.

opus: single work of art.

P

palette: in the visual arts, the composite use of color, including range and tonality.

pas: in ballet, a combination of steps forming one dance.

pas de deux: dance for two dancers, usually performed by a ballerina and her male partner.

pediment: typically triangular roof piece, or window or door cap characteristic of the Greek and Roman styles.

pendentive: a curved triangular segment leading from the corners of a rectangular structure to the base of a dome.

perspective: representation of distance and three-dimensionality on a two-dimensional surface. See also aerial perspective and linear perspective.

photojournalism: photography of actual events that have sociological significance.

piano: musical term meaning "soft." Also a keyboard musical instrument.

pirouette: in ballet, a full turn on the toe or ball of one foot.

plasticity: the capability of being molded or altered. The accentuation of three-dimensionality of form through chiaroscuro.

platemark: ridged or embossed effect created by the pressure used in transferring ink to paper from a metal plate in the intaglio process.

polyphony: see counterpoint.

port de bras: technique of moving the arms correctly in dance.

post-and-lintel: architectural structure in which horizontal pieces (lintels) are held up by vertical columns (posts); similar to post and beam structure, which usually utilizes wooden posts and beams held together by nails or pegs.

post-tensioned concrete: concrete using metal rods and wires under stress or tension to cause structural forces to flow in predetermined directions.

precast concrete: concrete cast in place using wooden forms around a steel framework.

presto: musical term signifying a rapid tempo.

prestressed concrete: see post-tensioned concrete.

program music: music that refers to nonmusical ideas through a descriptive title or text. The opposite of absolute music.

prototype: model on which something is based.

pyramidal structure: in theatre and dance, the rising of action to a peak, which then tapers to a conclusion.

R

realism: artistic selection and use of elements from life; contrasts with naturalism, in which no artistic selection is utilized.

recitative: sung dialogue in opera, cantata, and oratorio.

rectilinear: in the visual arts, the formed use of straight lines and angles.

reinforced concrete: see ferroconcrete.

relevé: in ballet, the raising of the body to full height or half height during the execution of a step or movement.

relief printing: process in printmaking by which the ink is transferred to the paper from raised areas on a printing block.

representational: objects that are recognizable from real life.

requiem: mass for the dead.

rhythm: relationship, either of time or space, between recurring elements of a composition.

ribbed vault: structure in which arches are connected by diagonal as well as horizontal members.

ritardando: in music, a decrease in tempo.

rondo: form of musical composition employing a return to an initial theme after the presentation of each new theme.

ronds de jambe à terre: in ballet, a rapid semicircular movement of the foot in which the toe remains on the floor and the heel brushes the floor in first position as it completes the semicircle.

rubato: a style of musical performance in which liberty is taken by the performer with the rhythm of the piece.

S

saturation: in color, the purity of a hue in terms of whiteness; the whiter the hue, the less saturated it is.

scale: in music, a graduated series of ascending or descending musical tones. In architecture, the mass of a building in relation to the human body.

serigraphy: printmaking process in which ink is forced through a piece of stretched fabric, part of which has been blocked out—for example, silk-screening and stenciling.

skeleton frame: construction in which a skeletal framework supports the building. See balloon construction and steel cage construction.

song cycle: group of art songs combined around a similar text or theme.

sonority: in music, the characteristic of texture resulting from chordal spacing.

staccato: in music, the technique of playing so that individual notes are detached and separated from each other.

static: devoid of movement or other dynamic qualities.

steel cage construction: construction using a metal framework. See skeleton frame.

stereotype: standardized concept or image.

style: individual characteristics of a work of art that identify it with a particular artist, nationality, historical period, or school of artists.

stylization: reliance on conventions, distortions, or theatricality; the exaggeration of characteristics that are fundamentally verisimilar.

substitution: sculptural technique utilizing materials transformed from a plastic, molten, or fluid into a solid state.

subtractive: in sculpture, referring to works that are carved. In color, referring to the mixing of pigments as opposed to the mixing of light.

symbolism: suggestion through imagery of something that is invisible or intangible.

symmetry: balancing of elements in design by placing physically equal objects on either side of a central axis. See asymmetry.

sympathetic vibration: physical phenomenon of one vibrating body being set in motion by a second vibrating body.

symphony: large musical ensemble: a symphony orchestra. Also, an extended musical composition for orchestra usually consisting of three or four movements.

syncopation: in a musical composition, the displacement of accent from the normally accented beat to the offbeat.

synthesizer (also called Moog synthesizer): electronic instrument that produces and combines musical sounds.

T

tempera: opaque watercolor medium, referring to ground pigments and their color binders such as gum, glue, or egg.

tempo: rate of speed at which a musical composition is performed. In theatre or dance, the rate of speed of the overall performance.

terra-cotta: earth-brown clay used in ceramics and sculpture.

tessitura: general musical range of the voice in a particular musical composition.

texture: in art, the two-dimensional or three-dimensional quality of the surface of a work. In music, the melodic and harmonic characteristics of a composition.

theatricality: exaggeration and artificiality; the opposite of verisimilitude.

theme: general subject of an artwork, whether melodic or philosophical.

timbre (tone color): quality of a sound that distinguishes one instrument or voice from another.

toccata: a composition usually for keyboard instrument intended to display technique.

tonality: in music, the specific key in which a composition is written. In the visual arts, the characteristics of value.

tondo: a circular painting.

tone color: see timbre.

tonic: in music, the root tone (do) of a key.

triad: a musical chord consisting of three tones.

tunnel vault: see barrel vault.

tutu: many-layered bell-shaped crinoline skirt worn by a ballerina.

V

value (value scale): in the visual arts, the range of tonalities from white to black.

variation: repetition of a theme with minor or major changes.

verisimilitude: appearance of reality of lifelikeness in any element of the arts.

virtuoso: referring to the display of impressive technique or skill by an artist.

vivace: musical term denoting a vivacious or lively tempo.

W

woodcut: relief printing executed from a design cut in the plank of the grain.

wood engraving: relief printing made from a design cut in the butt of the grain.

INDEX

177